The HAWEATERS

VANESSA FARNSWORTH

Signature
EDITIONS

Cover design by Doowah Design.
Photo of Vanessa Farnsworth by Michael Farnsworth.

This book was printed on Ancient Forest Friendly paper.
Printed and bound in Canada by Hignell Book Printing Inc.

We acknowledge the support of the Canada Council for the Arts and the Manitoba Arts Council for our publishing program.

Library and Archives Canada Cataloguing in Publication
Title: The haweaters / Vanessa Farnsworth.
Names: Farnsworth, Vanessa, 1968- author.
Identifiers: Canadiana (print) 20200184431 | Canadiana (ebook) 2020018444X | ISBN 9781773240695
 (softcover) | ISBN 9781773240701 (HTML)
Classification: LCC PS8611.A7565 H38 2020 | DDC C813/.6—dc23

Signature Editions
P.O. Box 206, RPO Corydon, Winnipeg, Manitoba, R3M 3S7
www.signature-editions.com

For my mother,
who brought me this story

Haweater (haw-eet-ter) n. A nickname originally given to the first European settlers of northern Ontario's Manitoulin Island who staved off starvation by eating hawthorn berries (or hawberries, as they are locally known). Now commonly refers to anyone born on the island.

JUNE 1877

Based on a true story.

1

CONFLAGRATION

Boyd leaves the government road and wonders, not for the first time, how anything riddled with so many stumps and displaced boulders can be considered a road by anyone who has ever seen one. It's pathetic. Hopeless. A twisted ankle or busted kneecap waiting to happen.

Boyd is in the process of proving his own theory when he makes the daring decision to evaluate his recent life choices, beginning with today's resolution to stumble along this bone-rattler of a road when on any other day God himself would've parted the skies to remind him that the only viable passage over the Manitoulin is through the freshly planted fields or along the Indian trails that snake through the bush.

And Boyd would've heeded God's reminder because normally he has sense enough to travel along one of those tried-and-true routes. Boyd is also well aware that he normally possesses the wisdom to mind his own ever-loving business, but when you're one of a handful of lawmen on this entire godforsaken island, there are times when wisdom must bow down to duty.

On this bright summer morning, Boyd is on official business and he feels strongly that his duty forbids him from taking any shortcuts. From approaching Bryan through his oats. From arriving like a neighbour while performing his duties as an officer of the court. His mind is

firm on that until it goes blank. It does this sometimes when he sees or hears something that he cannot fully assimilate.

Like Eleanor Bryan.

Boyd has arrived at Bill Bryan's homestead and he immediately spots the missus out heaving and huffing in her vegetable patch. Her hair is wild and her face is stern. She's pitching dung from her rickety wheelbarrow onto a great stinking pile of the same and Boyd slows his pace. Partly this is because of the stench, but mostly it's because there's something about this woman that never fails to freeze the thoughts in his brain. This is what's happening now.

Boyd has learned certain things about Eleanor Bryan over the years, the most important of which is that her soul is carved from granite. He tangled with her once. He can't rightly remember over what, but Boyd vowed then and there that it would never happen again. He would rather be trapped in a sack full of starving rats than go another round with Bryan's she-devil of a wife. A woman that wretched goes a long way to explaining why Bill Bryan is the way he is. Stubborn. Hateful. Ancient. And Bill is the reason Boyd is here. Well, actually, Charlie is the reason Boyd is here, but to get to Charlie, Boyd must go through his father and to get to Bill, Boyd must first pass by Bryan's wretched wife and her stinking mountain of dung. Such is the fate God dealt him today.

Luckily, Eleanor and her dung pile are located near the side of the house that's away from the road. Even better, it's away from Boyd, which is just about the smallest mercy God could've granted, but it's mercy just the same.

Even so, Boyd wouldn't be Boyd if he could help but notice Eleanor's forearms. With each pitch of the fork, they're exposed like the sun at noon. It's not decent, by anyone's measure, to see so much of a woman's flesh, but it would be unlike Eleanor to aim a thought at decency. She'd say it's a luxury only the rich can afford and she'd more likely than not spit when she said it, mentally busting him upside the head.

Boyd has been staring at Eleanor's arms for longer than would be considered wise for anyone who is not actually an owl. An alarm goes

off in the lawman's head as he realizes the mistake his eyes have been making. He casts them skyward, earthward, then all around.

He's got to focus. There'll be hell to pay if anyone spots his attention stalling on another man's wife. The bush families will get the wrong impression. Because they always do. It's not as if there isn't enough hardship on this island without setting fire to the harshest of rumours each and every time the opportunity arises. The kind of rumours that must be answered by a gunshot or a beating or an "accidental" drowning.

Boyd pivots. He looks southwest to George Amer's homestead. There's not a single soul visible there. No, harm won't be coming from that direction. Nor will it be coming from the Porter place, which Boyd is facing now. He can hear the unmistakable shrieks and squawks of roughhousing children, but his eyes can't locate a single raucous one of them. Nor can he see Porter himself, who is likely off toiling in the fields, or his ninny of a wife, who is more likely than not to be busying herself with women's work in the kitchen or the garden or even the barn. Sure enough she's not tending to her countless young. The woman never does, so far as Boyd can tell.

The lawman gives his brow a reassuring rub. There's currently no one within eyeball distance of the Bryan homestead. It's just him and Eleanor and Eleanor's youngest, Arthur, who is just now shuffling into view. He's inching along a row of spinach, splashing water from a bucket in an effort to keep the tattered greens from shrivelling further. But the tyke isn't quite strong enough to hold the bucket steady and so some of the water is belching onto the path.

What must Arthur be now? Eight, maybe, or is the boy ten? He's small for his age even if he is only eight. Boyd puts that down to the boiled bark and hawberries. A boy can't build bulk on that. He won't ever be fit for fieldwork. Boyd supposes he could make a fine preacher one day if he ever catches the spirit. He dismisses the thought. You've got to be born God-fearing. It's not the sort of thing you catch later in life and it's certainly not the sort of thing you catch from the wretched heathens this boy has been saddled with as parents.

Boyd silently chastises himself. He needs to calm his mind and pick up his pace if he's to say what he needs to say to Bill Bryan and be back to his own homestead in The Slash before his wife notices the lowness of the woodpile outside the kitchen door. Time is of the essence and yet here he is dawdling over the age of a boy he's seen barely a dozen times in all the years since the Bryans settled in Tehkummah.

How many years? Four comes to mind. That's probably about right.

Eleanor raises her head and squints. She spots Boyd, who is once again loping along the road, feeling as daft as a beagle. He waves, but Eleanor doesn't return the gesture nor does she whistle him over for her version of a neighbourly chat. Instead she points in the direction of the back field as if ordering him to vacate her presence without delay.

That's just as well. A blotchy green bruise covers much of Eleanor's right forearm. It's the reason Boyd has been staring despite what gossips might later claim. That bruise had been purple-black when Boyd first spotted it a week back. Eleanor had told him she'd acquired it slipping from the ladder on her way down from the loft, but there's no chance that's true. Her eyes darted every which way as she told her tale. There's no better way to give away her own lie than that and didn't she just know it. There was challenge in the way she looked at Boyd, as if daring him to dispute everything she'd just said, but he didn't. There would have been no percentage in his doing so. How a man disciplines his wife is no concern for the law. It's no concern for anyone but Bryan himself and, let's face it, if Eleanor had been his wife, Boyd would surely have taken a strap to her as many times as was necessary to get her to behave like a proper woman. There's no other way to get a woman such as that to develop a civil demeanour.

Enough. Boyd fixes his eyes on the terrain in front of him. He can feel Eleanor's eyes on him, but pretends not to notice as he trudges past Bryan's slapdash of a shanty, surprised, as always, to see it still standing. What a tragedy it is. There are more cracks than wood to that miserable excuse for a shelter. By rights it should've collapsed that first harsh winter on the island and been replaced by something sturdier. That's the usual way of things. Bill Bryan should've at least made the attempt,

but he did no such thing. As a result, there's been no end to the suffering that has befallen his loved ones, if they can even rightly be called that.

Again, enough. We are all, every last one of us, at the mercy of the choices we make. Boyd has been thinking a lot about this lately and not just because he chose, like a fool, to risk a maiming by trudging along such a laughable excuse for a road. No, it's the conversation he's moments away from having with Bill Bryan that may very well end up being the day's greatest folly.

Boyd sharpens his mind as he tromps through the stump-pocked field of oats. His destination is in no way in doubt. He can hear the huffing and grunting of labour just beyond the rise. There's a snort followed by a thump, then the unmistakable jangling of chains. Boyd doesn't need to guess what Bill Bryan is up to. It's what they're all up to when they aren't tending their crops: clearing the land of endless brush and boulders and trees in an effort to open up enough farmable ground to grow their grain, pasture their animals and, more importantly, fulfill the requirements set out by the land agent to qualify for the patent on their land.

It's not enough they paid good money for it. No, not on this island. Here you also have to clear a ridiculous number of acres in addition to paying the purchase price and you have to do it within a Christly brief number of years or the very same people who sold you the land will hand you your hat as they pass your homestead on to the next sucker down the line with no credit for your labours and no recognition for being the first to plant crops in unproven ground. There will be nothing left but aching bones and a discombobulated spirit and a stain on a man's character that will never fully fade even if he lives to be a thousand. It's a fool's bargain if ever there was one.

If only the bush families had known then what they all know now: that it's back-breaking work to clear this land. It's difficult enough for a young man but, at Bryan's age, it must seem less like a chore and more like a torment. Boyd almost feels sorry for the old man, but then he finds Bryan and his teenaged son Charlie working along the property line and those feelings fade. It's duty that brings him here, not camaraderie.

Boyd glances around. Rocks of all sizes and colours have been piled into small mountains along the beginnings of a snake fence that will one day separate this property from George Amer's. For now it stretches along not even half the necessary distance, leaving plenty of space for livestock to travel freely between the two properties. There's no end to the headaches that's caused and no end to the headaches it's going to cause either.

Boyd halts amongst the tangle of felled trees and ragged stumps, telling himself that it's best not to advance just yet. The Bryan men have a pair of oxen chained to a stump and Charlie is applying a switch to the haunch of the dominant beast. The air fills with snapping and cracking and pop, pop, popping and a low rumble registers in Boyd's feet. Old Man Bryan, who is facing the opposite direction from Boyd, calmly steps away from the stump's unpredictable bulk, which is stuttering free of the heavy clay. Soon the worst of the task is complete and the stump lies exposed like a giant, calcified spider.

Boyd decides that now is a good time to announce himself. "A hundred down, a thousand left to go, my friend."

Bryan's shoulders tighten and he turns to face the lawman with a hard look on his face. Charlie stops switching the ox and also turns, his look even harder.

Charlie. Now there's a lesson in patience. Boyd would've preferred to encounter Bryan alone. It takes little enough to set Charlie off and you can never tell what the trigger will be. Sometimes it's a simple statement of fact misconstrued in such a way as the speaker could never have imagined. At other times, a smile is all it takes. Even knowing this, Boyd tries to force one onto his lips. The expressions that greet him leave Boyd to conclude that the Bryans take his attempt as some sort of a dare. He wasn't honestly expecting otherwise.

Let's try this again. "That late winter did none of us any favours. It'd be nice to get some rainfall in the coming weeks, otherwise I allow it'll be rough harvest."

Bryan snorts and ratchets himself up to his full height. The old man has aged a lot in the four years Boyd has known him. His unruly

grey-white hair and patchy beard contribute to this impression. What a sad wreck of a man he's become. His voice, when he finally speaks, is gravel. "As you say. Though I believe we've pulled a hell of a lot more than a hundred stumps this past month alone. Not the sort of thing a man loses count of."

Bryan rubs his hands down the front of trousers fashioned from repurposed flour sacks. They're held together by so many patches and mends there's little left of the original sack cloth.

Bryan swats a cloud of flies away from his face and continues. "Still got corn to go in. Insurance crop. Not two years since we filled our fields with legumes. Glad to see the last of them. Only so many beans a man can sell or eat. Amazing what you learn when you got no choice but to learn it."

Boyd chuckles, but quickly realizes the old man has meant this as a complaint. He straightens his face. "I reckon the soil's improving then."

Bryan nods. "Enough for oats. Maybe even wheat next year. We'll see. Trying not to hope too high. Land's so cursed it could be Irish. Not seen anything like it in this here country. For sure it wasn't like this down in Erin nor anywhere else south of the lake. Collingwood. Owen Sound. Milton. All farmable soil so far as I know."

Charlie grunts and shakes his head, but offers no comment. Instead he switches the oxen towards the burn pile, leaving Boyd and his father to wonder at the object of his contempt. All of life, would be Boyd's guess, as he watches the freshly liberated stump lurching and twisting behind the burly oxen. Boyd half-hopes the hulking stump catches a ridge and spins, crushing Charlie's spine or breaking his leg.

That thought isn't in the least bit helpful.

Boyd pokes meaningfully at the dirt with the toe of his boot. He already knows the truth of what Bryan is saying. This land is so burnt out that not five days after a rain, the cracks start settling in. There's no worse soil than that. It's so hard it can break a plough blade without the help of rocks or roots and that makes it no good for growing anything but heartache. Boyd knows it just as Bryan does, but acknowledging that would take this conversation somewhere Boyd doesn't want it to

go. He tries to switch tracks. "Maybe not cursed, but certainly aiming in that direction. I dare say it's like that all over the Manitoulin. It's a mixed bag of problems any direction you look. Some men have got clay, others swamp. You've got no choice but to dash ahead with whatever God has given you. I reckon there's no other way on this island. Just do me the favour of letting me know when your potatoes are of harvestable size. I could use double what I got from you last year."

Bryan plucks a tobacco pouch and pipe from his shirt pocket, then pauses as if translating what Boyd has said into a language he can understand. He nods and stuffs a pinch of tobacco into his pipe, then offers up his stubbornly delayed response. "Spoken like a true Irishman."

Boyd doesn't dare chuckle this time. Instead he watches as the ox-dragged stump tears up the ground something fierce. At least that stretch of ground will be easier to plough. This thought reminds Boyd that his own crops need tending. He leans towards Bryan. "We should really be talking in private. There are things that need saying in full, official things that are best not overheard by those not speaking nor being spoken to."

Boyd nods in Charlie's direction for emphasis. Old Man Bryan says nothing while he finishes stuffing the pipe's bowl and lifts its stem to his lips. He strikes his knife blade against the flint just once before the edge of the cloth fires. Boyd is impressed.

Bryan is not. "I hear you, though your caution is unnecessary. Tell you that in the interest of truth." Bryan presses the flickering orange fabric to the bowl and takes several quick puffs before nodding. "But I'll never have it said I denied a man a request I was capable of granting, even one that seems as unreasonable as this."

Boyd stalls. Now surely *that* is meant to be a joke, for Bryan is well-known for doing exactly the opposite of what he's now claiming. Boyd has seen it himself on many occasions and has heard about it even more from men who were spitting angry. But there's no smile on Bryan's lips nor anything else to suggest joviality. No, Bryan is simply drawing smoke deep into his lungs and exhaling it in long, turbulent clouds. He raises his hand in a half-hearted wave and calls out to his son, who is at

the burn pile, unhooking the chains from the stump. "Enough for today, Charlie. Other things need doing before the sun grows old. I'll finish up with Boyd here. Who knows, you may even escape this day without another fine."

Charlie looks up and locks eyes with Boyd. At first there's a question on his face, but it's quickly replaced by contempt. He turns back to the oxen and snaps the reins, steering the lumbering beasts in a wide arc that initially leads away from Boyd and the old man.

The lawman turns back to Bryan, not at all sure if Charlie is obeying his father's command or doing the opposite. "Do you think he heard what you said?"

Bryan shrugs and once again exhales. This time the smoke comes out in a long billowing stream that undulates as he once again hails his son. "What's say you head on down to Michael's Bay and grab a sack of shorts. Still got credit down there. Don't let the boys at the mill tell you otherwise. Just be back by sundown. Water still needs hauling."

Charlie makes a big show of looking between the reins clutched in one hand and the switch in the other. He drops them both and storms over to a cluster of saplings where he snaps up a burlap sack. Slinging it over his shoulder, he tromps off through the back pasture without once looking back. That's typical of Charlie. If rage were a scent, the stench would be unbreathable.

Boyd can't help but comment. "I allow that boy's got a mean temper. I know you know that, but it needs saying just the same."

Bryan's eyes are on his retreating son, whose stride doesn't vary regardless of whether his feet land on rocks or roots or level ground even though the soles of his tattered boots offer little protection. He might as well be walking barefoot through a field full of tacks for all the good they're doing him.

The old man turns and exhales smoke from his nostrils like some mythical dragon. He examines Boyd's face with a practised slowness. "So now what's the complaint? And who is the villain that spoke it?"

Boyd takes a quick, tight breath. "I reckon that villain would have to be me and the complaint, as you call it, is about a handgun Charlie

showed me a good six, maybe seven days past. And gave me to believe it will have Amer's name on it soon. I told him then – and I'm telling you now – he needs to lose the weapon before it gets him into hot quarters. I'm duty bound to tell you it's not legal for Charlie to have such a thing as that and it's not wise either, not when you consider the acrimony between your two families."

Bryan leans in close to Boyd and Boyd leans away, but not because he feels in any way intimidated. No, it's because Bryan's breath reeks of sour milk, rancid meat, tobacco and something a little more ominous. Something only the devil himself can name. It rises to unbearable levels when Bryan speaks. "You'd be referring to the beating? The Amer boy had it coming. For what is no business of yours. Not really any business of mine, but unlike you I know why it happened and that beating was called for. Wasn't never no need for the courts. Definitely wasn't no need for the fine. No need for your involvement on any level."

Boyd suddenly realizes he hasn't been drawing breath and gulps in air. "I couldn't look the other way. Once the matter was brought to me formally, I was bound to see it through to the end."

Bryan yanks the pipe from his lips. "Looking away was exactly what you could've done. Had no problem looking the other way when Amer up and paid the boy's fine. Don't recall you once asking him nor Charlie nor anyone else why Amer would do such a thing, seeing as how he was the one who insisted on the charges being brought in the first place."

There's a dangerous dare in Bryan's eyes, one that Boyd tries to side-step. "It's not for me to know."

"That the best you can give me?"

"What would you have me give you?"

Bryan waves his pipe in the space between them. "How's about some justice? How many times have I told you that Amer works on Sundays in violation of the law? Always chopping wood and pulling fish from the creek in full view of the bush families. Hunting, too. Not a Sunday goes by that we don't hear the report of a firearm somewhere on his land. Anyone around here can tell you the truth of what I'm saying."

Bryan jabs the pipestem between his lips and takes several quick sucks.

Boyd's sigh is almost a laugh. "I'll confess here and now that you never once struck me as a religious man, Bill Bryan."

Bryan waves him off. "Not about religion. About what the law allows and it don't allow that."

Boyd considers biting his tongue, but words escape before wisdom can stop them. "It may dispirit you to know that the law you're so blithely quoting also doesn't allow for you to pasture your animals in your neighbours' grain and yet I hear with alarming regularity that's exactly what you've been doing more often than not."

Bryan gnaws on his pipestem, smoke leaking from his lips. "One of Amer's many lies."

"He's not the only one who's been making the charge."

Bryan narrows his eyes and continues to study Boyd's face. He gives his pipe a few sucks, which draw no smoke, then palms the bowl and frowns. "You should know by now not to trust a word that comes out of Porter's mouth. Tells tales both sides of the fence. Wants violence. Won't be satisfied 'til it arrives."

"Any particular reason?"

"Some people don't need no reason."

True enough. "Still, I'm hearing the tales from more than just those two. There comes a point when I'm bound to act."

Bryan's eyes darken. "Is that what you're doing here now? Acting?"

Boyd raises his hands in mock surrender and shakes his head. "I'm here about the pistol, I told you as much already. The other is just me telling you what tomorrow brings should you see fit to not alter your conduct."

Bryan holds his pipe sideways and peers into the bowl. He knocks it a few times against the heel of his hand, turns it, then pulls out his flint. When he speaks again it's with something akin to resignation. "Boy oversteps sometimes. Talk to him about it regular. Nothing more I can do than that. Got his own mind. Not like to be heeding me any more than a boy his age is ever likely to heed his own father. It's the way of the world."

Boyd's nod is a surrender. This is likely the best he's going to get from
Bryan and he knows it. Still, he's said what he had to say and now he can
head back home knowing he's done his duty. Only that's when he spots
the thing he would rather not have spotted. Boyd hangs his head and
points. "Then there's that."

Boyd is pointing to where the blackened ends of the snake fence are
resting awkwardly on the dividing line between Bryan's property and
Amer's. Charred rails stretch along the ground a good twenty feet be-
yond the blackened fence end. Boyd might as well address that travesty
while he's here and maybe save himself a trip back this way in the near
soonness. "The fire that burned straight through the boundary fence.
Was that also Charlie's doing?"

Bryan doesn't bother to look to where Boyd is pointing. He knows
full well what the lawman is referring to, Boyd can see it in the way the
old man is holding his face blank. Bryan gives an elaborate shrug. "Calm
when the boy lit the burn pile. Wind went and whipped up something
fierce and drove the flames clear into Amer's field. Couldn't be helped.
No one present will ever say different."

No one present. Meaning Bryan and Charlie and not another liv-
ing soul. The Lord himself would sob like an injured child when faced
with a man like Bryan. Boyd can't disguise his irritation. "I'll allow that
maybe the wind couldn't be helped, but what about Laban? Word is
he nearly ran himself ragged hauling water up from the creek to douse
those flames. Dash it, Bryan, didn't it occur to Charlie or yourself to
pitch in? You were the ones, after all, who started the conflagration. It
seems to me you were the ones who were duty bound to help put it out."

Bryan changes his mind about relighting his pipe. Instead he taps
out the spent tobacco on the choppy surface of a stump. "Not possible.
Once the flames spread across the line, the whole thing became Amer's
problem. Wants to send his useless son to put it out, so be it. Though
to my mind, sending his dog to piss on it would've been more effectual."

"There's no need for the vulgarity."

Bryan stuffs his tobacco pouch into one pocket and the knife and
flint into the other. "Me over there or Amer over here isn't anything

anybody should be encouraging. Especially when that anybody is claiming he wants to avoid bloodshed. That's not a threat, mind you. Just an honest accounting of where things stand."

Boyd stretches the tension from his back. He really doesn't want to be having this discussion and wouldn't be having it except that he'd been on his way back to his homestead yesterday when he encountered Charlie for the second time in less than a week. The boy came striding out of the woods with a couple of rabbits slung over his shoulder and an aggression in his stride that would've made a wolf think twice. Although Boyd didn't see the handgun that time around, those rabbits ended up dead somehow. The ensuing conversation had been troubling enough to prompt Boyd to leave off his morning chores and traverse the three miles between his homestead and here to make sure Charlie wasn't about to do something that couldn't later be undone.

Boyd now regrets having made the attempt. He'd been appointed Justice of the Peace no more than a month past and these endless disputes are running him ragged. Seriously, how is he supposed to keep two families from killing each other when little else occupies their thoughts? He can't be watching their every move. He's got chores of his own to attend to, chores that aren't getting done while he's standing here like a fresh-born fool.

Bryan breaks into his thoughts. "It's my burn pile you should be considering, not some fence that can easily be repaired."

Boyd can't help but wonder why. He turns to look at the burn pile and continues to wonder. Nothing about it strikes him as notable. No, it looks like the dozen or so he passed on his way over here. He looks back to Bryan, who's being conspicuously silent as he saunters over to the abandoned oxen and reaches down for the reins. When he turns back, his thumb is pointing behind him. "You don't see a single burn pile anywhere on Amer's side, do you?"

Boyd surveys what he can see of Amer's land and has to admit that what Bryan is saying is true. Nowhere can he see any evidence of a burn pile, although the significance of that is currently eluding him.

Bryan pats the neck of the lead ox. "And yet you know in your guts you should be seeing several of them, or at least black marks where those piles once were. That is, if Amer is doing what the law demands and burning all the wood extraneous to his needs."

This again. For all the trouble lumber has caused in Tehkummah, Boyd is rapidly coming to the opinion that the forests themselves ought to be made illegal. His response is terse. "That's not necessarily the case."

"It necessarily is. Amer has cleared what? Fifty, sixty acres in the past two years. That house of his took a lot of timber to build, I'll give him that. Barns, too. And his hired man has knocked together an impressive number of fences. But that still leaves massive amounts of wood unaccounted for."

"There's nothing on the books that says he has to account for it."

Bryan's face flames red and he looks for all the world as if he's about to explode. Instead he snaps the reins and the oxen start to trudge, chains jangling on the ground behind them. The old man raises his voice above the racket. "You're clearing your land same as me. You know how many trees you've downed and how many stumps you've pulled. And if you're following the law you claim to uphold then you know what it takes to burn it all."

Boyd surely does, but he also knows that when Bill Bryan has worked up a full head of steam, stopping him is likely to be as successful as trying to stop a fully stoked locomotive with an outstretched hand. It's best to just let the old man run himself dry.

Bryan's voice is almost a shout. "Now maybe you're selling some of your crops to Lyon. I can see it. Sell my oats to him and was selling him my legumes previous to that. But timber is different. Once you pay the stumpage tax, there's no profit in it. Certainly not enough to account for Amer's grand estate. But then you know that, don't you?"

Know what exactly? Boyd's temper is starting to get the better of him and he can see he's going to have to end this conversation quickly before he says or does something that will place him in the awkward position of having to arrest himself. "What exactly is it that you'd have

me do? Do you want me to swear out a warrant against Amer for avoiding the tax by selling logs illegally to Lyon? Is that it?"

Bryan simultaneously raises his hand and shakes his head. "Didn't say nothing about no warrant. Just impose a fine equal to the tax Amer would've paid had he been following the law."

Boyd uses the toe of his boot to work a rock out of the pitted ground. He lines it up, then kicks it at a stump not ten feet dead ahead. His aim is off. The rock clips the edge of the stump and ricochets down a gopher hole. Boyd tilts his head. "What proof do you have that Amer's even doing what you say he is? And don't say the lack of burn piles because that's proof of nothing so far as the law is concerned. There is no blessed way to convict a man on what isn't there."

The oxen abruptly jerk to the left and Bryan just as abruptly yanks them back in line. He's surprisingly spry for his advancing years, Boyd has to admit that much, even if every day he expects to get word that some part of the old man has finally given out like machinery that's been in service for too many years.

But Bryan is in no mood to be pacified. "Lyon's men were gossiping over Amer's misdeeds at the lumber camp this past winter. Common knowledge amongst them. They tell you what they told me and you'll know straight off I've been telling you the truth."

Boyd scans the terrain. Bryan's land is dominated by sugar maples, basswood, ironwood, even some birch. There's not much in the way of commercial value here. It's Amer who has all the cedar and there's no doubt the man has a dozen schemes for transforming all that viable timber into profit, some of which may even be legal. Boyd curses the sky. He thought being Justice of the Peace was going to be all about facts and reason and applying the law as it's written. He's quickly learning it has more to do with jealousy and pettiness and the inability of men such as Bryan to control their dark emotions.

Well, Boyd has no intention of pursuing the old man's accusations further. The question is, how best to tell Bryan that without further inflaming his ire? Let's try this: "I didn't think you were running afoul of the truth, but I can practically guarantee that if I were to track down

every one of those lumbermen, to a man they'd say their memories aren't
so good on the subject. Sure, they may talk big in the camps, but when it
comes down to it, not one of those men will be willing to go up against
one of the few employers around here who can afford to hire them. And
besides, the law you're referring to was recently changed."

This is true. He should've said it straight off. It's a testament to how
tired Boyd is that he didn't.

Bryan stops coaxing the oxen forward. For a few seconds, this is his
only reaction. Then he creases his brow and tugs the reins, moving in
so close that Boyd would be able to testify to the exact shade of Bryan's
eyes should it ever come to that.

"Changed how?"

Boyd stares at the lead ox as if intending to address his reply to it.
One weary beast to another. Admittedly, that could be his best shot at a
positive response. Here goes nothing. "The stumpage tax only applies to
the selling of pine now, so although it may be a sore disappointment for
you to learn this, Amer is free to sell all the non-pine logs he wishes to
whomever he so pleases without being subject to any tax. Since I believe
there isn't much pine around these parts, I have no reason to believe
Amer is breaking any law."

Boyd believes correctly. Pine accounts for maybe one out of every
hundred trees in this township. Head north, there's more. Now, if he
were being totally honest, Boyd would admit that it's come to his atten-
tion that speculators have been buying up those northern lots for the
purpose of illegally profiting from the sale of pine logs – and he'd further
admit that Amer was named as one of those speculators – but there's no
way Boyd is going to mention that to Bryan or anyone else until he's had
the chance to investigate the veracity of those claims.

Bryan bends down and snatches his pipe from its resting place on
the stump, dropping it into his pocket with the rest of his parapher-
nalia. His voice is thunder. "Since when?"

"Since a few weeks past."

"This official?"

"I saw the papers myself this Tuesday past."

Boyd's eyes drift back to the lead ox. It's the brass knobs covering the tips of the oxen's horns that keep drawing his attention. They're bold, ornate, even ostentatious, and not the sort of thing Boyd would've thought Bryan could afford. He wonders where they came from.

"So he gets away with it."

Boyd snaps his attention back to the old man. "Dash it, Bryan, it's not a matter of Amer getting away with anything. It's a matter of a bad law changing for the good of us all. Surely you can see that."

Surely Bryan can't. He snaps the reins and the oxen start to trudge past Boyd. "How much did that cost Amer?"

Boyd contemplates the sky. It is truly mystifying where all of this animosity is coming from. Amer is, so far as Boyd knows, an upright citizen. He is generous and community-minded and a born leader of men. It's Bryan, if anyone, who's the villain here and one that Boyd sees wisdom in containing. "You're seeing this all wrong, Bill. The change in the law benefits every last one of the bush families. We can all now sell our timber for a decent profit. That alone will make the difference between survival and starvation for most everyone around here."

Bryan leads his team a good twenty feet past Boyd before clucking and pulling up on the reins. His back is to the lawman until, abruptly, it isn't. "Don't recall seeing you at the lumbering camps this past winter."

Boyd is momentarily tongue-tied. It's not like Bryan to bring up a topic such as this unless he intends to use it as a weapon. Boyd reckons the best response is likely a cautious one. "The harvest saw me through. Consequently, I didn't need to hire myself out to Lyon or any other man. Hopefully that's the start of a positive trend."

Not cautious enough. Bryan's eyes betray his heart and it's a small, cold, dead one so far as Boyd can tell.

"Didn't see Amer neither. Rumour has it he was lining his pockets in Owen Sound. Suspect you know what I'm talking about, seeing as how you two came here from the Corkscrew City together."

Well, now, doesn't that beat all. So it's going to be guilt by association with a man who has not been proven to have committed any offence except in the mind of a bitter old man? No sir, not if Boyd has anything

to say about it. "Curse you, Bill. I came to this island on my own for the betterment of my family. I'm no different from you in that respect. I only ever set foot in Owen Sound but once and that was to load all my earthly possessions on the ship that brought me here. You had best watch your words."

"Best we all watch our words. Doesn't change the fact Amer fled Owen Sound one step ahead of the law."

Boyd isn't totally sure what that means, but it's clear an insinuation is being made about Amer's character and he can't allow that to stand. "I don't know where you're getting your information, but I do know that Amer was the law in Owen Sound. If you weren't such an infernal wretch, you'd know that too."

Bryan's laugh cracks the air. "Amer thought he was the law. Government thought otherwise. Swooped in to clean out the crooks. Word is Amer snuck up here before he could be made to pay for his crimes. Now he only sneaks back when he thinks no one is looking. Someone is always looking."

Boyd raises his hand. "Enough. There's too much gossip in these backwoods and it serves no purpose other than to drive a wedge between neighbours. You shouldn't be listening to any of it and you certainly shouldn't be repeating it as factual unless you want to sound a fool."

Bryan clips Boyd's final words. "Always defending your man. I suppose that could be considered noble. But I'm betting it isn't. Amer's got something on you. Something that makes you blind in his direction."

Boyd says nothing.

Bryan, true to form, takes the lawman's silence as confirmation that his accusation has hit home. "No need to tell me I'm right. Know already in which direction your loyalties lie. So don't ever claim to be dealing fair where Amer's concerned."

That's it. Boyd has had more than enough. "So now I'm the villain here?"

Bryan shrugs and turns away. He snaps the reins and resumes his journey to the corral with the chains once again jangling against the rough ground. When he turns back, his voice is raised to the heavens.

"Moved to this island to get away from tyrants like Amer. Tolerated him for a while. Not no more. We're all worth the same in the bush. Only one who doesn't know that is Amer himself."

Bryan turns away for the last time and Boyd watches his stubborn retreat. He briefly considers throwing a rock at the old man just to see if he can hit him from this distance. Probably not. He couldn't even hit a stump from ten feet, so he shouts after him instead. "You best remember what I said about Charlie needing to lose that handgun before it dooms him. This is the only warning you're going to get from me."

Boyd isn't totally sure Bryan has heard him above the chains and the distance and the set of his mind. No matter. The lawman turns and stomps through the back pasture. He no longer feels the formality of his office requires him to avoid trudging through his neighbour's fields. He no longer feels anything but complete and utter contempt.

2

NOT ALL STORIES ARE TRUE

Andrew Porter slits open the sack of wheat and heaves it onto his shoulder. Grain slides out, first as a trickle, then as an avalanche. His son John is two-handing the grinder's crank. He pulls hard in an effort to start the stone spinning. Good boy. The sooner he gets it up to speed, the sooner they can get out of here. Within reason, that is. There's only so hard a boy that young can crank and only so fast a stone that heavy can turn while still producing a decent grind. These two things together mean that it's also only so soon Porter can realistically expect to depart Amer's barn and that's weighing down his mind like an anvil.

Amer won't stay gone forever. He'll show his face soon enough and Porter would rather not be here when he does. He wouldn't be here now except Amer has made himself indispensable by acquiring the only grinding stone this side of Michael's Bay and allowing the bush families to use it for the price of a sack of grain. As strategies go, it's brilliant and generous and most assuredly deceptive.

The truth is, if Michael's Bay wasn't such a long walk, Porter would take it regularly, but there are chores to be done and crops to be tended and not a moment to spare between sunrise and sunset. So he's here, now, at the mercy of a man who has proven time and again that he knows no mercy.

This is the anvil weighing down Porter's mind. It keeps him up at night and makes him wish he were anywhere but here. He's tried to live a God-fearing life. Now maybe there are some on the island who don't see it that way, who brand him a gossipmonger, a chinwag, a tattletale for doing no more than passing news around, but someone has to do it. There's no newspaper on this island and no way for news to travel efficiently except by mouth. What does it matter if it's Porter's mouth that carries the news from one homestead to the next? Is that reason enough to malign his character? Some say yes. He says no.

Porter returns his thoughts to the task at hand. He pours slowly now that the grain has risen to the rim of the hopper and he counts. It typically takes six full revolutions for the stone's weight to kick in and assist the grind and today is no exception. His son settles into the steady rhythm he'll maintain until the very last kernel scurries from the hopper. That won't be anytime soon. This is the second of a dozen sacks they'll be grinding today and Porter surveys them with a frown. Why has he brought so blessed many sacks? Has he never heard of moderation? Does he secretly want a confrontation with that ruffian Amer? Not so far as he knows, but sometimes Porter's thinking mind and his unthinking one don't communicate as well as they should, leading to exactly the kind of calamity he's just now trying to avoid.

Porter stops his thoughts and listens. He hears something and at first he's not certain what. Then he is. It's low talk and it's coming from outside the barn. Worse, it's growing louder as the speakers draw nearer and one of the speakers is without a doubt George Amer. He'd know that voice anywhere. Porter's heart sinks. He'll not be getting out of here as quickly as he hoped. No sir, it's becoming increasingly clear he's going to be forced to have the conversation he'd been hoping to avoid and it's his own fault. Why hadn't he come here sooner or gone to Michael's Bay instead? Why, in short, must he always be working against his own interests?

Why indeed. Porter pretends not to notice George Amer striding into the barn. Instead he makes like he's fascinated by each individual kernel raining from the sack to such a degree that he doesn't hear the

greeting extended to him by Amer's faithful farmhand Sam, who's trailing behind his master like a tethered pony. But pretending can only take him so far.

Amer stops abruptly, his back to Porter. "Been looking for you."

Porter knows this statement is directed at him even though Amer is facing towards a pegged harness on the opposite wall when he says it. Porter shrugs as if this isn't news. "Nothing new in you looking for me or anyone else around here, I should think. You sussing out the locality of people whose locality you have no right to know is surely what you do best or so I've heard it told."

Amer grunts and speaks as if to himself. "Should've known I'd find you here on my very own property speaking your tiresome riddles."

He should've, but he didn't, and that's down to Porter swearing his kids and his wife to secrecy before he left his homestead because he knew if Amer were to come across him while his ire was still higher than the clouds there'd be demands, threats, or worse. So Porter devised a plan to outsmart his adversary by taking the back way to Amer's barn and grinding his grain while Amer was out on the road looking for him. And it'd almost worked. If only he'd brought less wheat.

Porter looks at Amer square. "There's surely a lot of things you should've known, sir, but only a portion of which you actually do. I'm not at liberty to tell you what the rest of them are – nor am I inclined to tell you anything on any subject, if the truth be told – but keep poking around and you'll surely find a few of them out on your own, I should think."

He looks down. Amer's boots are so new the leather hasn't yet been soiled or creased or scuffed and he can guess why. He's heard the tales. Amer picked those boots up in Manitowaning this past week when he hiked up that way on some business no one seems able to name, but the rumours are thick. Some say he owns land up there under someone else's signature. That's likely true. There's no lower creature on this island than a land speculator and there's no lower creature on the island than Amer. It's a perfect match if ever there was one, everyone says so, and yet no one can rightly say that Amer is the speculator he appears to

be. If they could – if they were absolutely sure – the local men would've dealt with him in a way the law doesn't allow for and Porter would've helped them. But actions such as that need irrefutable proof and they have none of that just yet.

So Amer lives. And Porter must once again face him. "Well, sir, it shouldn't be a surprise for me to be here in your barn when there's no reason for me to believe I wouldn't be welcome. You yourself have made it known to all and sundry that the liberty to use your grinder is open to every bush family regardless of standing. Unless, of course, you've had your fill of me. If that's the case, sir, then say it straight and I'll take my grain elsewhere middling fast."

There's a little too much steel in Porter's voice. He was going for confidence, but overshot his mark like a child on his first hunt. He knows it and so does his son, who visibly stiffens. "Keep your eyes on the grind like you know they should be. It's best we not botch the flour this go 'round or your mother will surely entertain us both with one of her conniptions when we get home, mark my words."

John reluctantly complies. Porter attempts to pat the boy on the shoulder but misses. His mind is clearly elsewhere and that's down to Amer, who has plucked a hammer from his workbench and is inspecting its hitting end. He raises the tool to his shoulder. "Got no issue with you grinding your grain. Makes no sense for one family to hoard resources that can best serve the entire community."

Porter digests what Amer has said. On the surface, it's a noble thought. More noble than the man it came out of, but Porter senses there's another shoe and it's about to drop. He need not wait long. "You're welcome to be doing what you're doing so long as we can come to an agreement on the other thing."

John glances up from the wheel, his face awash in alarm. For pity's sake, the boy need not worry so. Porter has everything under control, he's certain of it, and if he's wrong, well, he'll get it that way. It's a simple matter of manoeuvring. He shoots his son a look and the boy rightly averts his eyes. That's more like it. Porter needs space to think. He hasn't quite worked out how he's going to handle Amer. He considers

pretending he has no idea what his neighbour is talking about, but that would be like waving a red flag in front of a charging bull and, halfwit though he may very well be sometimes, he's not halfwitted enough to do that. His best move is undoubtedly to deflect. "That reminds me, sir, I've been hearing talk that doesn't spark a good mood. Eliza herself tells me you stormed up to my place this morning while I was out in the fields and made something of a nuisance of yourself. That's not the sort of thing a man likes to hear when the sweat's still on his back, so I'll say this once and you'd best heed me: If you've got business with me then you take it up with me and not go bothering my wife with none of your nonsense. Eliza surely has enough on her plate without you coming around demanding answers she's not likely to have on subjects she's not likely to be thinking about, unlike some wives around here who spout opinions when none are needed."

That's how you deal with a man like Amer. You stand up to him, showing him your spine and your teeth and then you pray he sees wisdom in backing down. Most of the time that's exactly what happens. *Most of the time.*

Porter has his doubts that's how it will play out today, largely because Amer is gripping and re-gripping his hammer like a carpenter wondering which nail to hit first. Porter is guessing he's the most convenient nail. He can almost feel the hammer smashing into his skull repeatedly and enthusiastically. First the thud, then the pain, then the everlasting blackness.

Porter makes a quick calculation. He'll stand his ground. So, inevitably, will Amer, who is staring at his hammer as if he too is making a calculation about the thickness of Porter's skull or the reliability of the witnesses. Whichever it is, his adversary abruptly turns and nods. "Couldn't have known Eliza was innocent of recent goings-on without seeking what she knows from her own mouth. Meant her no grief. Will be sure to apologize next time I see her."

There won't be a next time, but Porter refrains from saying this. It's best not to turn things too sour unless absolutely necessary. For one, the hammer is still locked in Amer's hand. For another, it's a mighty long

walk down to the mill at Michael's Bay. For the love of God, he hates that Amer has made himself so indispensable.

Porter cusses softly as he shakes the last of the wheat from the sack and presses the limp burlap to John's chest. The boy grabs it, shakes it, then slings it over his shoulder while Porter looks hard at the knife he's about to use to slit open a fresh sack. It would be easy enough to put it to another use. Porter smiles to himself, wickedly, then points the tip at Amer's chest. "There's surely no decency in a man who sets about bullying a woman when he should be having words with her husband. We need to be clear on this, sir, or we'll end up speaking opposites. Eliza herself knows nothing about the business of men and if I know my wife like a husband surely should, I've no doubt she herself told you as much when she backed you out the door."

Eliza most definitely did not. As his wife tells it, she'd just finished churning butter when Amer unceremoniously pushed through the kitchen door and started in with a barrage of questions. Eliza calmly pulled the plunger from the churn, pushed it dripping into Amer's bloated belly, and marched him straight back outside, slamming the door behind him without saying so much as a single word.

Eliza had laughed at her nerve.

Porter's reaction had been starkly different. What made Amer think he could storm into a neighbour's home like that and start in on another man's wife like she's some common servant? Does he think he's Porter's master? Because he's no such thing. Porter owns his land, free and clear. He's no tenant and he's not subject to Amer's rules or control. Does Porter really have to tell him as much to his face?

Amer is closing in on Porter, the hammer locked in his fist. "She did make that clear in her own way. But you're familiar with the subject of which I speak. Don't tell me you're not."

Porter looks down at his knife and scowls. As if it's betrayed him by acting alone and unwisely. He lowers the weapon to his side and wills the steel back into his voice. "I'm no fool so far as I know. I surely did hear what you were inquiring about from Eliza herself and from my boys who were nearest to home when you came calling. So it's to be

rails this time, is it? Well, so be it. You, sir, can hear it from my own lips: I know nothing of your rails and as sure as the sun rises on this blessed island, I don't want to know nothing about them neither. In future, you'll be talking to me direct about that sort of thing and not dragging everyone in your path into the conversation."

Strong, confident and marginally threatening. Porter is pleased with himself and not in the least bit surprised when Amer responds with an attempt to stare him down. Porter stares back, knowing full well that could be bad for his health, but he couldn't rightly call himself a man if he didn't stand his ground against a tyrant. So he braces for a blow, but after bouncing the hammer in his hand a few times, Amer hurls it at the workbench. It smashes into the barn-board above the bench, then clatters to the floor.

Porter doesn't move. He doesn't dare. Neither does John nor faithful, dutiful Sam. They all stand stiff and silent and breathless. Then Porter grabs a sack of wheat and hoists it up onto his shoulder. He's man enough to put an end to the tension if no one else is. Admittedly, that could mean taking a fist to the gut, but he's primed. He slits open the sack and lets loose a torrent of grain. Stray kernels flicker through the air as John glances up, a question on his face, but he does not ask it and Porter mimes his assurance that everything remains under his control, although he himself is not so sure. He feels reckless. Somehow he's managed to get himself locked in a battle of wills with a man for whom control is as vital as his heartbeat. That isn't good. It may not even be survivable. Christ, how is he going to get himself out this mess?

Maybe he won't have to. Amer rounds on his farmhand, cursing like a cornered raccoon. "For Christ's sake, Sam. Why are you still here? Grab some tools and head down to the government road. Laban's down there mending the gate some ingrate dismantled in the middle of the night. Not got the strength nor the wherewithal to get the job done properly by himself. You need to help him set the damage right while I work on getting our rails back. They can't have gone far."

Relief floods Porter's spine. This isn't over, not by a long shot, but he's survived the first crisis and hopefully he'll survive the next. Because there will be a next as sure as there's trout in the river.

Sam bounds out of the barn while Amer watches him go. Then he turns to Porter, his jaw locked. Porter braces for what comes next, and what comes next is a question. "Now just how far did those rails go and in which direction? Say it clear and there'll be no consequences."

Of course there will. There are consequences to everything in life, especially here, Amer makes damn sure of it. Porter wills his voice calm. "That surely does sound like the sort of question only a fool would ask if I'm being perfectly honest. But I'll humour you just this once, sir, by telling you as plain as can be that I've got no earthly clue where your rails might be. My best guess is that Charlie Bryan himself possesses the gumption to undertake such a grievous stunt as you have fallen victim to."

It's a lie, of course. Porter knows exactly where the rails are. They're safe and sound where he hid them in the wee hours before dawn. But Amer doesn't know that, not for sure, or they would be having a very different conversation right now.

Amer is shaking his head. "Not buying it. The Bryan boy is pretty simple. He doesn't sneak around in the dark damaging things in ways that make his enemies guess at who the villain might be. Only a coward would do a thing like that. The Bryan boy is a lot of things, but he's no coward. No, if he wants the gate gone, he burns it to the ground or sledges it into toothpicks. Then he crows about the destruction to everyone within earshot. Haven't heard a single peep from him about this. Not hard to figure why. This is someone else's handiwork. The sooner you confess, the sooner we can get on with making this whole thing right."

On whose terms? For sure they'll be on Amer's and it's equally for sure that Amer and Porter won't see eye to eye on a suitable remedy even if Porter were fool enough to confess, which he isn't. Stealing the rails had seemed like a good idea at the time. It seemed like an excellent way to gain an advantage over Amer, but now Porter is questioning his own intelligence. Did he really think he'd get away with it? Yes, that's exactly what he thought.

Porter jumps the sack forward on his shoulder, his mind groping for a dodge. "I'll be confessing nothing, sir, as you well know, and although

I'd be loath to advise you not to fixate on something you're clearly going to fixate on anyway, I find myself wondering if it's yet occurred to you to ask yourself why I myself would destroy a perfectly good gate that was clearly meant to keep Bryan's cattle from your stream. It's surely no threat to me. If there's one thing we need around here, I should think it is more fences, not less. I'm guessing you see it the same."

As bluffs go, this one is pretty weak. It's easy enough for Amer to counter, only instead he shrugs. "Not worth my time to guess. But I know it was you."

Is that the best he's got? Porter would have to be defective to jump at such pitiful bait. Surely the better choice is to go down swinging. "Well, sir, as I've told my sons too many times over the years to rightly count, believing something isn't enough to make it so. If a man can't prove a thing, he surely shouldn't be speaking like he can. I myself would've thought you of all people would agree. Since that's clearly not the case, I feel I must remind you on behalf of all who remain silent that the missing gate cut across the government road and I don't recall the magistrate granting you yourself the liberty to block that thoroughfare, unless I missed a proclamation on the matter."

He had not. That fence is in clear breach of the law and Amer can't be allowed to get away with it. It's one law for all residents, not one law for the higher-ups and a second law for the minions. Not that Amer is a higher-up – and Porter surely isn't a minion – but that's not the point. The point is Porter was right to take down those rails and he wasn't the only one thinking of doing it either. He was just the one who acted.

Amer hoists a sledgehammer. "Was the only way to prevent Bryan's cattle from drinking from my creek. Not subsidizing his operation with my water, not after all he's done to provoke me. If you were in my place, you'd have done the same."

Porter blinks at that one. How is he not in Amer's place? "Bryan's cattle have been on my land plenty enough by anyone's reckoning. I'd even go so far as to say they've surely been on all our land more than they've been on his own. That being as it may, you, sir, don't have the right to fence off a road that's clearly meant for the use of us all. Does it

really sit straight in your mind that I or anyone else around here should grovel for your permission to travel down a public road?"

Porter already knows the answer to his question. Amer not only thinks it, he finds ways to coerce every man in Tehkummah into his debt so they feel obliged to ask his permission to walk along a public road or cut down a tree. That's how he operates. Like a natural-born villain.

Amer guffaws. He tosses the sledgehammer towards the barn door and returns to the workbench for an axe, inspecting the integrity of its blade by slamming it into a block of wood. "No lock on it. Easy enough to open by any creature with hands. That would appear to include you."

Dunderhead. "You can't rightly think that's my point, sir. I'll say this once just so we're clear as can be: You yourself don't own the government road and you yourself are not at liberty to put a gate across it, so far as I know. If you think to put up another one it's fair to say that it too will surely go missing. You best heed me on that."

A smile creeps across Amer's lips and Porter immediately regrets what he's said. He has given away his own game by pushing things a sliver too far and doesn't Amer know it. He grabs a maul and a couple of wedges, shaking them at Porter. "So you admit to the removal of the first?"

Not on your life. "No, sir, I admit to nothing, so don't go making yourself look a fool by thinking I do, you hear me?"

Amer's smile grows wider, exposing what's left of his crooked yellow teeth. "So then you won't mind if I search your land for the missing rails. Not likely to find something that isn't there."

That's a farce. "If you were in possession of your fair portion of brains, you would surely know that you'll be searching no thing of mine, sir. I've heard it said by some that you yourself were once the law in Owen Sound and I'm willing to grant that's the honest truth of the matter, but you're no such thing here so far as I'm aware. No, sir, if you yourself are so sure I pinched those rails – if you're absolutely convinced – then make your case to someone who's a true lawman on this island. It should be easy enough to find such a man as that. I surely did see Boyd heading up to Bryan's place not more than an hour past. If you see fit to

hurry, you should have no trouble catching him up on the trail back to
The Slash."

Amer looks puzzled. Pulling a flask from his pocket, he strolls over
to the barn door. "What's Boyd doing up there, I wonder?"

That's clogging his brain. Porter should've mentioned Boyd sooner
and saved himself a whole bunch of bother. "Well, sir, he's your own
man, or so everyone says, so surely you should be showing some ever-
loving sense by asking him yourself why he was where he was instead of
asking the likes of me. In the meantime, heed my warning: Don't you go
anywhere near my wife again without my stated permission or there'll
surely be buckets of blood with your name on them."

That was admittedly a stupid thing to say. It's the verbal equivalent
of spitting in Amer's face, but it felt good to say it until Amer started
contemplating him like a problem in need of solving. The brute takes a
swig from his flask. "Meaning?"

Isn't it obvious? "You know full well what I mean. There are no earth-
ly circumstances under which you could truthfully mistake my Eliza for
that Bryan woman, so don't you go provoking me further by pretending
there could possibly be."

Amer nods slowly. "Not sure why you're thinking I'd confuse the two
women. They look nothing alike."

As if any of this is about looks. "I should think you'd be a far sight
smarter than to attempt playing dumb with me on this matter. There
are surely plenty of men around here who'd like to see you dead, and I'm
warning you, sir, you don't want to be adding my name to the bottom
of a very long list."

"Is that a fact?"

"Fact enough."

Amer nods slowly. "You going to tell me who's on the list or do I have
to guess?"

Like he even needs to. "Since you ask, I hear Charlie Bryan's got him-
self a pistol and has been practising murder at the northerly end of his
land. The maples have surely got the worst of it, so far as I know, but
what I find most interesting, sir, is his willingness to waste a raft of lead

on defenceless trees when, as you yourself well know, his family has precious little to call their own."

Amer says nothing, but he doesn't look surprised. Porter is disappointed. He would've liked to see his neighbour choke a little or sputter or gasp. Maybe this will do it: "I should think that if you yourself wanted to stop people whispering gossip about you and Eleanor Bryan, paying Charlie's fine for thumping your son wasn't the best plan you could've come up with. It's got people seeing scandal in your direction and there's nothing that makes words flow freer than that, as you must well know."

Amer gives a lazy shrug. "Had nothing to do with Mrs. Bryan. Her boy beat Laban. I brought charges against him for the doing of it, as was my right. Had I known at the time that the cause of the fight was my horses straying into Bryan's fields, I would've settled the matter without the law. But Laban can sometimes be slow to admit the truth. No end to the trouble that causes."

That's a dirty lie. It had something to do with Eleanor, Porter can feel it, and Amer's denial only serves to fuel Porter's desire to find out what. "That's not what people are saying, as you yourself can surely imagine. No, sir, it's all around the bush that you've got some loyalty to Eleanor Bryan that the rest of us know squat about. You may be able to hide a lot of things, but you surely can't hide that."

Amer takes another swig, then waves his flask dismissively. "Wrong track entirely."

Not likely. Porter cuts off the flow of grain. "May I remind you, sir, that I myself have a clear view of Bryan's homestead from my land? I see every soul that comes and goes there and you spending all that time alone with a woman who isn't your wife causes the kind of talk that's not easily stopped. You surely don't want that talk getting back to Bryan and you even more surely don't want it getting back to Charlie, assuming it hasn't already, and I'll here now guess that it may have."

That gets Amer's attention. His goat too. Amer roars. "Villain! What lies have you been spreading this time?"

Porter mimics Amer's lazy shrug. "Well, sir, since you ask, I've not said nothing to no one, although I surely can't help but wonder why

Charlie is suddenly carrying a pistol when just this past spring he had to return the shotgun he borrowed from Sloan. It makes no earthly sense that the boy can't afford a long gun to put food on the table, but somehow he can afford a pistol. There must surely be a reason and you speaking private to his mother could be it."

Porter scores a direct hit with that one, just as he knew he would.

Amer's face hardens. "You don't know the half of what you're talking about."

That's true, Porter doesn't, but he senses he's getting close. "That's my point exactly. I surely don't know half of what I'm talking about but if I were to know the truth of all this – and I mean the whole truth, not the paltry fragment you've offered up so far – I'd surely be able to set people straight and stop those wagging tongues once and for all."

Amer curses under his breath. "So I'm to believe you'd do that for me?"

Porter is simultaneously shaking his head and suppressing a smirk. "No, sir, you're to believe I'd do it to make sure no further harm comes to Mrs. Bryan, as I should think an intelligent man such as yourself would've already guessed."

A series of complex emotions plays across Amer's face. "Thought you and Bryan were on friendly terms. Makes what you're saying now seem like a betrayal."

Like anyone could be friends with a man like Bryan. "Bryan's all right when he's sober, but I've seen him drunk enough to know that when whiskey loosens his fists, they land on whatever target is closest and no one is closer to Bryan himself than his wife. That's fact enough."

"And yet you stand aside as if nothing's amiss."

It's not his place to do a damn thing about Bryan's behaviour, nor is it Amer's. The difference is, Porter knows that. He slings the last empty sack over his shoulder and joins his son in pigtailing the tops of the full sacks of flour. "Lifting a finger in that direction would be a fool's errand, as surely you know or at least you ought to. There isn't a man around these here parts who couldn't rightly tell you, sir, that Bryan only drinks when things are going poorly, which surely makes him no different than most other men on this island. The truth of the matter is the man himself just

needs a few good crops under his belt and then the drinking will surely stop and the situation will improve. There's not a doubt in my mind, sir, that Eleanor just needs to keep out of harm's way until then."

Porter isn't sure why he's justifying himself to this man and is about to say as much when Amer thrusts a verbal blade. "No such thing as a good crop here. Surely you've learned that much. Only a fool would make the mistake of thinking this island is farmable. You don't strike me as a fool."

Porter arches his brow and points to the sacks of grain. "This island is farmable."

"Some of it. The swampy bits, I'll give you that. Enough to keep a family fed if a man puts the whole of his spine into it. But this island doesn't have what it takes to grow crops on a commercial scale. You've got to diversify if you want to survive up here. Bryan doesn't understand that, but I'm thinking maybe you do."

Is that a compliment? The look on Amer's face suggests it might be, so then why does Porter feel like he's catching the back of Amer's hand? "Well, sir, I believe what I understand is that you yourself surely don't belong on this island."

Amer looks gut-punched, but quickly gathers his wits. "And where do I belong?"

"Back where you came from, I should think."

An eight-year-old couldn't have said it better. Porter cusses himself for sounding like a child, but he's right. Amer doesn't belong here. Porter does and so do his sons, and their sons, all the way down the line. Amer has no line. He just has Laban, and what a disappointment that boy would be to any father.

"You feel strongly about that?"

Porter stands tall. "Yes, sir, I feel strongly about everything I say. Maybe just this once you should try to see the truth as it stands. Do you really think people around here don't know that you've been buying up north lots so that you can illegally lumber when you're supposed to be farming? Because they surely do even if not one of them feels at liberty to tell you as much to your face."

Amer takes one last swig from his flask, then returns it to his pocket. He strolls over to his workbench as if time is a commodity he'll never run short on. "What does it matter what people know? Not buying anything the law doesn't allow for."

"That's not strictly speaking true and we both of us know it. A rumour has been going around that you, sir, continue to sit on Owen Sound's town council, and don't bother to deny the truth of it. That one fact is sure to cause you a problem since a man has to be a permanent resident of the Manitoulin in order to gain a patent on any land here. I'd think the land agent might be keen to know that you have yourself a conflict and there are many around here who have a good mind to tell him."

Amer plucks something off his workbench and sticks it in his pocket. Porter can't see what it is, but he's guessing it's sharp. It's best he keep his guard up and his wits alive.

Amer pivots. "Not all stories are true."

Porter cuts some twine, his knife held firm. "And not all stories are lies neither. I myself am willing to bet that Bryan himself is right now telling Boyd all about the logs you've been illegally selling to Lyon. I can't see him holding back with a weapon as sharp as that and I'm thinking you can't neither."

Amer snorts. "You bloody hypocrite. You're doing the same as me."

Porter is surprised by the accusation. He thought he'd been clever in covering his tracks. "You don't know that."

"Got Lyon's word on it. Guessing the man knows his business."

Porter watches his son wrestle a sack of flour out to the waiting cart. He considers not replying, but Amer would surely take that as an admission of guilt. He might as well concede. "Well, sir, Lyon shouldn't be telling you my business. I'm surely going to have to have a serious word with that man about what he shouldn't be saying and who he shouldn't be saying it to. There's a whole raft of trouble that can come to a man who speaks what shouldn't be spoken."

Amer shrugs and heads over to the door. "Probably figured I already knew, seeing as how we're so close."

Close? Amer must be referring to the proximity of their homesteads and not to some non-existent friendship. He heaves a sack of flour up onto his shoulder. "Close isn't the word I'd ever use to describe you and myself, since you bring the matter up. No, sir, there's a world of difference between you and me and God surely knows it, even if you don't."

Porter heads out to the cart and somersaults the sack onto the pile his son has built in the back of the cart. Amer calls from the door. "You're selling timber against the law, same as me. You may find comfort in telling yourself you have a higher motive, but when you get right down to it, we're not so different."

They most definitely are. Porter may be illegally selling lumber, but that's the sum of it and he wouldn't be doing that if the law were in any way fair. Amer, on the other hand, has more schemes going than the devil himself. Land speculation, illegal timbering, money lending, usury. It's shameful, all of it, and that's only the stuff Porter has caught wind of. There's surely worse that hasn't yet hit his ears. "If I were you, sir, I'd spend more of my time worrying about what Bryan is saying to that lawman and less of it on whatever deals I may or may not be cooking up with Lyon. It's plain to all and sundry that Bryan is out for your blood. There isn't a man in Tehkummah who doesn't know it, not even you."

Porter helps his son lift the last two sacks into the cart and secures the load, hoping that Amer will silently drift back into the barn now that Porter's mind is clearly occupied elsewhere. No such luck.

"For all his blustering and badgering, Bryan is nothing more than a snivelling failure. Let him waste his time with the law if that's what gets him going. He'll be off this island soon enough. Just you wait and see."

Porter tightens a rope. He considers letting that last comment slide, but his curiosity gets the better of him. He tries to sound casual. "What do you know about it?"

Amer grinds his heel into the ground, satisfaction lighting his face. "Time's running out for the old man to pay off his debt. Almost doesn't matter how well his crops do this year. Unless he's growing gold, he'll be landless by fall with his future as uncertain as it was when he got here. Won't be a problem for any of us after that."

So Bryan hasn't been keeping up with the instalments on his land. There's no great shock there. Many men around here have fallen behind and the authorities have so far looked the other way. Has something changed? Porter wants to ask, but no, that'd only prolong this conversation, so he climbs into the cart next to his son and snaps the reins. The horses jolt forward. Porter waves over his shoulder, not daring to turn around to see what expression his abrupt departure is leaving on Amer's face. He doesn't want to know. He has other things on his mind. Things that have nothing to do with that insufferable tyrant.

SOME WILD THING

Charlie Bryan storms towards the mill at Michael's Bay. He makes this trip far too often for his own liking and always to fetch shorts for his momma's baking. What a waste. If they were anything but poor, he'd be on his way to get real flour right now and not by the sack. No, he'd be returning home with an entire wagonload, saving himself a whole lot of time and bother. He could have free time to do as he pleases without always having a tool in his hand or purpose in his stride.

Strike that. If they were anything but poor, they'd have a millstone in their barn like that good-for-nothing Amer. Now there's a dream. As it stands right now, his family doesn't even have the barn to put one in. So Charlie's rushing to the only mill within walking distance so he can collect a 100-pound sack of the husks that remain when wheat is ground into flour. What the locals call shorts. What Charlie calls other people's leavings. Wretched stuff. The baking that comes of it is rank. Like someone pressed sawdust into a pan and heated it until it hardened into a brick. Bread, his momma calls it. That's a laugh. All crust, no innards. You could build walls with the stuff with no fear of eventual decay. He'd be better off eating the slop that gets fed to the pigs.

Suggest it and he'll get the strap for sure. Not for disrespecting his momma's baking, mind you. How could anyone respect her baking or anything else about that wretched woman? Always snivelling. Letting his

poppa beat her and worse: letting him beat her children. So weak. So detestable. Has a duty to protect her children, but does she do it? No, she hides in the forest like a wounded moose instead. Every damned time.

No, the strap won't be for any insult to his momma. It'll be for having the gall to imply the old man isn't adequately providing for his family. Which he isn't. Never has. Never will. An anchor pulling down his family and anyone else stupid enough to get too close to him. So his momma says. Daily. And she's right. Cruel fate for Charlie to have such peasant for a poppa. The cruellest.

So Charlie must succeed where his poppa constantly fails. And he must do more than that. He must save his kid brother from the worst of the poverty and the violence and the desolation. It's a duty he feels deep in his bones as he hunts and fishes and bloodies his hands ploughing impossible ground.

Charlie tries hard not to remember that while he and his poppa were working the logging camp this past winter, his momma and kid brother were forced to mash hawberries into birch syrup to stave off starvation. That's his poppa's doing. No two ways about it. When Charlie has a family of his own, he'll make sure there's always enough food on the table for ten grown men, a solid roof over his head, and so many clothes he can make a bonfire of them weekly if he so desires. Can't call yourself a man if you can't do all that. Not in Charlie's book. Not in anyone's.

Charlie looks behind him as if fearful his thoughts may be the subject of a malicious eavesdropping. Silly. Superstitious. There's no one behind him, not even his own shadow. He can let his mind wander to the cedar boughs. The rotting log. The suggestion of blue above the trees. He's travelled this path so many times that everything he sees has become a landmark to help him judge his distance and pace, which today is a little faster than usual. That's good. He'll have time to drop a line in Blue Jay Creek and maybe pull out some fish. Or stop by the general store and pretend for a few minutes he has money to spend on calico for his momma or, better yet, a new blade for the plough instead of repairing for the umpteenth time the one his poppa broke on a rock not four days past. Old man can't even plough a field right.

Charlie huffs out his rage. Three times. Like a locomotive picking up steam. Still miles left to travel. Easy miles. Not like later when he'll have a 100-pound sack pushing down on each shoulder. Those will be hard miles. It'll be the sack that weighs him down at first, but soon it will be his back, then his legs. Makes him mad to think about it. Furious. Should be the old man making this journey. It's his lifetime of failure that makes it necessary. Failed as a farmer in Ireland. Then came to this country and failed again, this time in Erin. Then he dragged them all up to this godforsaken island just so he could fail yet again in the back end of nowhere. And always someone or something else gets the blame. The cursed English. The even more cursed potatoes. The midges. The land speculators. The debt collectors. The government. The neighbours. The ancestors. The fates.

No blame left for the old man himself. Not once has it ever been his fault. At least not the way he tells it. Charlie often wonders if his poppa will ever come to realize that the only common thread from one end of his life to the other is the old man himself. Likely not. The whole point of the whiskey, so far as Charlie can tell, is to poison all possibility of that sort of revelation straight out of the old man's mind. It certainly poisons all possibility of salvation.

A horse whinnies.

Charlie dulls his footfall, silently chastising himself for getting so caught up in his poppa's failings he forgot to keep an ear out for the stealth approach of enemies. He feels for his knife. Then grasps it. Hard. Best be prepared to defend himself against strangers and neighbours alike. You never know, after all, who your fate will come from. If he's learned nothing else from all the dime novels he's read, he's surely learned that. Others may sneer at his choice of reading material. They may get all snooty and suggest he read the sort of books that will improve his mind. What those naysayers don't understand is that he gains valuable insights from reading a few lines from those adventure stories between pulling stumps and fetching water and choking down unchewable bread. How else is he supposed to learn how to tame a charging bear or escape a murderous posse or creep up on an unsuspecting stranger, which is what he's doing now?

Charlie approaches the clearing not twenty paces ahead of him, his knife ready to stab. Slash. Gut. That's when he sees Annie, daughter of that worthless ruffian Amer. As Charlie watches, she bends down to admire a cluster of wildflowers lurking several feet from the path. Her horse is roped to a sapling, content to feed on long, patchy grass while his mistress busies herself inspecting every flower she sets eyes on.

Annie has been at this a while. Charlie can tell by the twists of green and yellow and pink circling her head like a halo. He could stab her if he wanted to. Slit her throat from ear to ear. Watch the blood spurt into the sky, then bury her body in a shallow pit set back amongst the bushes. Or maybe not so shallow. Depends on his mood. Whichever he chooses, Amer would never know what happened to his daughter. It would be well worth the hassle just to see the look on the tyrant's face.

Charlie smiles as he steps into the clearing, trying to look friendly. He scours the periphery for any signs of a chaperone stationed just out of view. It'd be just like Amer to set a trap, then pounce on any man who strays too close to his precious daughter. He guards that girl like she's a hothouse flower at perpetual risk of frost. And Charlie is ice. He scans the shadows, listening for the softest of sounds, but no one else appears to be around. He could grab her by the neck. Stick a knife between her ribs. Pry them open. Now. Before anyone happens upon them. It would be easy. Like a passage he read in a story two books past. The one he traded away to one of the boys down at the mill for the novel he has in his sack now. Dog-eared. Stained. Read so many times the pages have come loose. His prized possession until he trades it for a new one. But not until he gets to the mill.

Charlie clears his throat. Annie looks up, not changing the position of her body. Her face betrays no surprise and definitely no fear. How odd. A girl out here alone in the bush setting eyes on a man who is the avowed enemy of her poppa. She should at the very least flinch. If this was an adventure story, she'd most definitely scream.

Instead Annie smiles and raises her hand to offer Charlie a hunk of bannock. Charlie shakes his head even though the only provision in his

sack is a half loaf of brick-bread. He waves his blade at Annie. "Should you really be out here alone?"

Annie looks puzzled. "That's a fine way to greet a girl you barely know, but to answer your question, there's no law against it so far as I'm aware. Besides, I'm not nearly as alone as you seem to think I am. I've got Crispin with me."

Annie points at her horse with the bannock. Charlie contemplates the beast as he tucks his knife into his waistband. Surely the silly girl understands he's inquiring about a human companion. Fat lot of good a horse will do her if Charlie decides to strike. Or a wolf. Maybe someone should tell her this. "Not usual for a girl to be travelling unaccompanied through the bush. All manner of things could go wrong and you'd have no one to help you."

"I thank you kindly for the consideration, but I assure you that I need no one to help me." Annie slips the bannock into the large pocket in the front of her apron and picks her way over to Crispin. The horse snorts and nods when Annie rests her hand on his back. Then she starts twisting flowers into his mane.

Charlie stares boldly. He doesn't know what to make of this girl. She's not daft so far as he's aware. Some have even described her as clever. Mrs. Sloan said something to that effect just the other day. And yet here she is picking flowers with no one but a horse for a companion. And she appears to be doing it for the fun of it. He's not used to such blatant frivolity. Pleasure is something you hide. Or deny. His entire life he's watched his momma and sisters scrubbing and chopping and churning. He can't ever remember one of them doing a thing simply for the fun of it. It makes him uneasy to see it now. Like watching a boulder balancing on the edge of a precipice. No way to get comfortable. "Your parents know where you are?"

Annie's laugh is almost infectious. "Well, now, let me think on that a moment. I seem to recall it was Mother who ordered me to fetch the post from up Boyer's place just past breakfast. She saw no reason to arm me or send some beastly man to guard me from all the troubles you see in your mind. Besides, forgive me, but I can't help noticing that you're

speaking to me as if I'm a child. I'm no more of a child than Crispin here. I'll have you know I turn fifteen next week."

And yet her skirt stops at her calves and her feet are bare. Surely those are the hallmarks of childhood. Although Annie may think of herself as a grown woman, safe to say no one will agree with her until her hem brushes the ground and her hands turn to women's work. If those things ever happen. Her lack of wariness towards lone men in open fields is cause enough to believe adulthood may not be her fate.

Charlie should lend Annie one of his books so that she can read for herself about the fate of young girls who wander in forests all alone. He raises his arm and points northeast. "Boyer's farm is a good five miles thataway. And I see no post nor any sack for you to carry it in. Makes me wonder if what you're telling me is strictly true."

Annie shrugs. "I see no reason why I would lie to you. I doubt you're one of my father's spies or I assure you I would've come up with a better tale than the flimsy one I just spouted. Some wild thing about a highwayman coming up behind me, guns drawn, leaving me no choice but to flee through the bush until I found myself in this field where I've been ever since, protected by the golden rays of the sun."

Charlie cocks a brow. "Highwayman? You can't be serious. No such creature around here. Never has been. Wrong country. Wrong century. Wrong everything. You got that from a book, didn't you?"

Charlie is half-hopeful this could be true even though he knows in his heart that Annie's reading material is most likely restricted to a better class of book than the ones he typically fills his mind with.

Annie adjusts her wildflower halo. "Well, sir, I see you're not the sort to let a thing go until it sits straight in your mind, so let's just say my horse wandered well off course. I would've nudged him back in the direction we were supposed to be travelling, but I figured he was on the trail of something sweet and I was curious to discover what it could be."

Charlie thinks on this for a moment. He's not sure how to react. This girl and her fanciful behaviour is confusing. Offensive even. If nothing else, it's a luxury he can't afford. His poppa knows the distance to the mill and back. He'll demand explanations if Charlie is more than

an hour beyond when his return is expected and they'd better be good ones. A strap hangs by the door for those times when his excuses are adjudged, rightly or wrongly, to fall short of the truth.

Charlie clenches his teeth. Then he clenches his fists. What a creature Annie Amer is. She toys with nature. With her elders. With the rules. Sent to fetch something as crucial as the weekly post and she shirks the responsibility so she can frolic in a field with no apparent fear she'll suffer consequences. Does she not know that her momma lives for those letters? All mommas do. Annie shouldn't have to be told this. And Charlie definitely shouldn't have to be the one to tell her. "Best not to blame your horse for your own wilful ways."

Annie pats Crispin's neck and sighs. "I dare say there's a long list of things it's best for me not to do. It's reviewed with me regularly and I have to confess that not all of the things on it make sense. For instance, why can you be out here travelling alone through the bush without anyone so much as suggesting you need a chaperone and yet there's an assumption some horrible fate will befall me unless I have one? Most of the things that could happen to me could happen to you and yet no one seems bothered one whit by that."

Charlie hears a snap. It's faint, but it's definitely there. What would Seth Jones, hero of the dime novel he read six books previous, have done in a situation like this? Just one thing. Charlie's hand finds his knife. He grips it as he scans the surrounding trees, hoping to locate the source of the unexpected sound. It could be benign. Then again, it could be the first sign of an attack. One he'll be ready for.

Charlie continues to scan the trees as he points to Annie's feet. "It's the way of things. Where are your shoes?"

Annie doesn't look down. "Would it surprise you too terribly much if I tell you they're back at home? I saw no need for shoes when riding a horse bareback. I should've thought that much would have been as obvious as the freckle on my chin."

To whom? And why would someone whose family can afford the finest tack be riding around the woods with no saddle or harness? Just a feeble rope looped around the horse's neck that would hardly

be sufficient should Crispin decide to buck or bolt or worse. This girl makes no sense.

Charlie turns. He catches a look of amusement creeping across Annie's face. Her lips part. Words will fall out if he lets them. Little-girl fantasies. But Charlie won't let that happen. He holds up a finger to silence her. And she obeys like a hound or a gunwale-stunned fish. Charlie bends down and scoops up a rock, testing its weight. Its shape. Its general throwability. Annie follows his sightline. The intended target is strutting around in the tall grass at the edge of the clearing. Whether or not she sees it is of no concern to Charlie. His only concern is that she not speak or move until he's finished, otherwise he'll have to redirect the rock at her.

Charlie steels his mind. He does the opposite with his wrist. He has one shot to get this right. He bounces the rock in his hand exactly four times, then draws back his elbow, whipping the missile at the solitary partridge. His aim is bang on. It usually is. The bird drops as Charlie yanks the knife from his waistband, more than willing to slit its throat should it turn out to be stunned and not fully dead. It's happened before. But not today. Today Charlie grabs the limp bird by the neck and slings it over his shoulder.

Annie looks between the bird and Charlie's face several times. "Excuse me for saying this, but you look decidedly different."

Charlie lowers his knife. "Than what? You see me near every day. Person can change only so much from one hour to the next."

"From when I saw you late winter."

Late winter. Annie is referring to the sugaring bee when the bush families gathered to bleed hundreds of maples and birches of their sap. Seemingly endless buckets of the sweet liquid had been dumped into huge vats suspended from chains over open fires. Charlie had stumbled across the group in the woods behind Sloan's place just as the long, slow process of boiling down the sap had been getting underway. Everyone had been full of cheer. They were gossiping and laughing and taking turns stirring the pot, occasionally slopping steaming liquid into the snow, ostensibly to test for doneness, but really to give the frolicking children a sugary treat.

Charlie had kept his distance. He'd been on his way to Manitowaning, where he'd been sent to fetch supplies for the logging camp, but his loneliness had led him to take a detour through the woods near his family's homestead. He'd been thrilled by the festive atmosphere, but he'd also been so fatigued from the long, brutal days of labour he could do no more than prop himself against a tree. Even so, it was an enjoyable thing to witness. Not often has he heard mirth overtaking a bunch of people more inclined to misery.

Charlie glances at Annie. She's staring at him, an inquisitive look playing across her features. He considers striking out. Catching her off guard. Knocking the question clear off her face. But even he has to admit the pleasantness of the memory. "What impressed you more? My steadfastness in holding up that tree or the grace with which I almost fell over when Mrs. Sloan grabbed my hand and dragged me amongst all you dancing ninnies?"

Annie whoops with delight. "Every last bit of it. The whole thing was a whirl. I can still see you in my mind, staggering and stumbling as if trying to catch your balance on a storm-struck ship."

Charlie feels the blood rush to his face. Damnable girl. That's not how he wants to be remembered. "Glad I amused you."

If Annie notices Charlie's embarrassment, she doesn't let on. Instead she twirls around like a top on a dangerous tilt. "Oh, you very much did. It was the only time I can ever remember seeing you smile. I wasn't sure you knew how. That reminds me, are you coming to the next one?"

Annie continues to spin. Charlie steps back so as not to impede her whirlwind. Only briefly does he consider sticking out his foot. "I'll likely be in camp again this next winter. Was a fluke I happened to swing by that day. Even if I'm sent on another errand, it's not like to be timed so well as to bring me home during a sugaring."

Annie stops spinning, her arms held out like the wings of a gull on a gusty day. "No, you silly goose, I mean the stumping bee next week. There are new neighbours out Mr. Boyd's way. I don't rightly remember their name – Smith, Smithers, something like that – but the bush families are heading over to The Slash a week Tuesday to help the poor

souls pull the first mess of stumps. I was absolutely certain you'd be in-vited owing to your muscles and your oxen and your youth. If that isn't the case, I'm inviting you now."

This is the first Charlie is hearing of any bee and he can guess why. Bigotry. Villainy. Favouritism. No end to the sinful traits flourishing in these woods. "Been on this island four years now and somehow it's never our turn to be stumped. Seems everyone is in line ahead of us, including those who came later."

Annie ponders this. "I'm sure I don't know anything about that. What I do know is that Mother has asked her busybody friends to send their bach-elor sons up from Owen Sound. It seems a calamity is upon us. Namely, there aren't any quality suitors on this island and Mother is having a devil of a time trying to find me a match. I'm not supposed to know that, of course. I only discovered the plot by sneaking a peak at one of her letters."

Should've struck her with the rock when he had the chance. But he'd hesitated. And for what? Charlie is rapidly coming to the conclusion this girl needs the reins her horse doesn't have. If he'd ever even thought of reading one of his momma's letters, he'd be whipped until his bones saw light. "I'm guessing that I wouldn't be welcome even if I had the nerve to show my face. Sure thing I'm one of the low-quality suitors your momma is complaining about."

Charlie winces. He shouldn't have worded it like that. Implies inter-est when what he feels is contempt. Resentment. Futility.

Annie doesn't appear to notice. Her attention is now directed at a bee-tle crawling through the grass. She stretches down to pick it up. "That's the most nonsensical thing I ever did hear. Everyone's welcome, especially you. I need you to protect me from Mother's designs. Lord knows she'll be ordering me to behave like an angel. I'd rather not. I don't have anything in common with those mainland boys and yet sure as sunshine, Mother will marry me off to the first one with a fortune if Father lets her. It's not conceivable to her that I would already have a suitor in mind."

What suitor? And where did she find him? Surely not while flitting through fields like a nectar-drunk butterfly. There aren't any suitors out here. Not even low-quality ones.

The beetle crawls out of Annie's palm and onto the back of her hand. She raises it in front of her lips and blows. The beetle sits there unmoving for several seconds. Then it takes flight.

Charlie is perplexed, but not by the beetle. No, he's perplexed by this girl who is asking him to play a role not even his sisters have ever asked of him. He's not sure he wants to be Annie's protector. In fact, he's fairly certain he doesn't. It isn't the sort of thing that would go by unremarked. Not by her poppa. Not by his. Not by anyone's. On the plus side, it'd make Amer so incensed he'd likely burst an artery. Can't say that would be a bad thing. "What about Laban?"

"What about him?"

"Isn't it usually the older brother who performs the role you're asking of me?"

Annie's snort startles Charlie. "That's a fool thing to say. Laban may be older than me, but that's the sum of it. Beyond a doubt, he's as ineffective as a blunt knife at protecting me from Mother or anyone else."

Of course he is. Didn't need to be told that. The simpleton didn't hardly defend himself when Charlie beat him for setting his horses loose in his family's oats where they ate more than their fill before Charlie came upon them. Then Laban strolled over and demanded the return of the four-legged thieves as if it was a given they should even be returned at all after what they'd done. The gall. Chased him back to his own side of the fence. Knocked him to the ground. Would've finished the fool off if Amer hadn't swooped in just as Charlie's fist was coming down on the boy's windpipe for the third time. A boy who can't defend himself shouldn't be allowed to exist. Not out here. "But I'm guessing your brother will be at the stumping bee and you can't possibly be blind to the fact that we've had trouble in the past."

Or to the fact that her poppa had called in the law to handle a matter that had already been handled, at least so far as Charlie was concerned.

Annie rolls her eyes. "There isn't a single soul on this stretch of island who doesn't know all about that, but just so long as you're not fool enough to bring along that revolver of yours, things are likely to run

smoothly. Believe me, Father isn't about to make a fuss in public that can't be pinned on someone else."

Charlie knows this to be true. But that's not what concerns him at the moment. "How do you know about the gun?"

Annie picks up a smooth white stone. She turns it over in her hand and runs her fingers along the vein of pink zigzagging through it. "How wouldn't I? If you wanted to keep its existence a secret, you probably shouldn't have done your poaching on our land."

"You saw that?"

Annie rubs the stone over her cheeks and forehead, the expression on her face inscrutable. "I surely did, but that's not what should concern you. What should concern you is that Mr. Porter also saw you and so did Mr. Boyd and Mr. Sloan and possibly others that I'm not yet aware of."

Charlie is troubled by this. He thought he'd been stealth. A great warrior on the hunt. The only person he knew to have seen him with the gun was Boyd and that was the result of sloppiness he wasn't likely to repeat. Now he's discovering that he's been as visible as a lighthouse on a moonless night. Assuming, of course, that what Annie is saying is true. "How do you know all those people saw the gun?"

Annie is silent. Charlie glimpses a hardness in her eyes that he hasn't noticed before. It leaks into her voice. "People don't think I hear things, but I hear practically everything that's said within the walls of my parents' house. So tell me, are you planning on shooting my father? If so, in the head or in the heart?"

Charlie's breath stammers out. "Not sure your poppa would approve of your question."

"I'm absolutely certain that's true, but you really should let me worry about my father. All you need worry about is your answer."

Charlie need not worry about that. "Traded the gun this past Saturday for a fiddle and some brass knobs to dull the oxen's horns."

Annie turns the white stone end over end. "Well now, that's a curious turn of events. Do you still have that fiddle?"

Charlie nods.

"And do you play it fair?"

Charlie shakes his head. "Play it rough. But I've only had it a few days so the music is bound to get better."

Or so he hopes. As it stands, Charlie can't get the individual strings to sound as if they belong on the same instrument. He fingers them and saws at them, but they insist on sounding like a badly shot animal clawing its way towards death.

Annie frowns. "That's a crying shame. I thought for a second there that we maybe had a reason to be alone in the same room together. I guess we'll have to conduct our secret rendezvous in the bush."

What secret rendezvous? Charlie doesn't recall agreeing to any such thing. A sharp crack spins him around. Doc Francis emerges from the trees, muttering and gesturing as he carries on an animated conversation with an invisible companion. At first, Doc Francis appears unaware he has company. Then his awareness emerges. He gives them a brisk nod. Annie steps in front of him. "Well hello, Dr. Francis. It's always a pleasure to see you, but why, may I ask, are you wearing such a long face?"

Her question makes it longer. "There is illness at Mr. Boyer's homestead, so if you had any plans to avail yourself of his hospitality, I suggest you change them. It will be a couple of weeks, maybe even three, before it will be safe for visitors to attend the family."

His words come out louder than necessary. Wilder. Annie mule-kicks the ground. "In case you do not know it, sir, the Boyer homestead is where the post is held. Mother needs her letters as prompt as can be or the sky will surely fall and crush us all."

Doc Francis bats away Annie's complaint. Literally. If her complaint had been a ball, it would've sailed over the trees. "The post will have to wait. There is diphtheria in one of Mr. Boyer's children and the others will surely soon fall ill. I cannot stress enough that you don't want to come in contact with that homestead or any of its occupants until the sickness has passed." Doc Francis mutters something under his breath. Something apparently meant for his invisible companion. Then he nods and turns back to Annie. "I cannot change the facts to suit your mood, Miss Amer. You are old enough to know that."

The doctor motions for Annie to move out of his way, then steps forward. Charlie leaps off the path. No choice really. By the doctor's own admission he has come in contact with both Boyer's homestead and its occupants and now he's standing before them like an omen. This infuriates the younger man. "You're the doctor for the Indians up at Manitowaning. The Boyers aren't Indians, so far as I know."

Doc Francis claps eyes on Charlie. Then he claps his hands. "I am the doctor for anyone who needs one. There is no difference between white and red when it comes to diphtheria. You will do well to remember that."

"Government know you think like that?"

The doctor spits, then chokes, then clears his throat. "Does the government know I think like what? That sickness in settlers burns through Indians like wildfire? That stopping it before it spreads beyond a single homestead is to everyone's advantage? I believe they do, although they enjoy the luxury of forgetting it when it suits them."

Charlie looks back along the trail he's already traversed and then forward along the trail he has yet to follow. He wants to get away from this man. This omen in human form. "And this diphtheria. You got the cure for that or you just guessing?"

It's a legitimate question. At least in Charlie's mind. But clearly not in Doc Francis's. He takes a step towards Charlie. Charlie takes a step back. The distance between them doesn't change. "Do we have a problem I do not yet know about, young man?"

Charlie looks away. "Not that I'm aware of."

Doc Francis gives a brisk nod. Then he strikes the air. "I am truly glad to hear it. Now I have an axe wound to attend to before the sun moves low so I will be on my way, if it is all the same to you."

Doc Francis tips his hat to Annie. Annie curtsies. Charlie can't help but wonder if she does so in reverence or jest. Her face gives nothing away.

Charlie flushes and turns to the retreating doctor. "Don't tell anyone you saw us together."

Doc Francis waves over his shoulder. "I never do."

He never does. What does that mean? Since when has Charlie ever been alone with Annie Amer? Never, that's when. Crazy old bonesetter.

Charlie turns, then topples as Annie kicks his feet out from under him. She jumps on Charlie's chest and pins him to the grass. Charlie's temper flares like bellowed flames. "Why are you sitting on me, you silly girl? I'm not a horse."

Annie thunks her finger against his forehead. "And I, sir, am not a defenceless child. You should try remembering that the next time you think to turn your back on me. If you ask me, this is the worst possible way to kick off a romance."

Annie springs off Charlie and brushes her skirt flat. Then she heads over to Crispin, unropes him from the sapling, and swings herself up onto his back. Charlie has yet to react. He can't think of a reaction. It's like his brain has been hit by a tornado in the form of a girl and is in desperate need of a good shake. God help him. Or her. It's not clear which.

Charlie picks himself up off the ground and locates his partridge. He swings the dead bird, once again, over his shoulder. "Can I assume we're done here?"

This is a sincere question. Charlie doesn't want to start down the path to the mill only to have Amer's daughter trample him in a spontaneous show of strength. Or insanity. Or wilfulness. Or whatever else her jumping on him was supposed to signify. Annie, however, appears to be more interested in plucking the flowers from her horse's mane than in committing another spontaneous act of athleticism. "Done as dinner, thank you for asking. I've got berries to pick this afternoon and I'll catch the devil if Mother thinks Ellen did most of the work."

Which Ellen likely will. Probably already has. Still, Charlie can't help but wonder what 'catching hell' looks like in the Amer household. No dessert? Performing two piano concertos instead of one? Surely not a strap across the back or a head into a wall. That much is obvious by the way Annie is calmly urging Crispin along the path, her dirty feet dangling free and her flower halo visible in her wild, tangled hair. No hesitation. Not even a hint of concern. No, nothing terrible is going to

happen to this girl. It's as if that's been ordained. By the same God who has so thoroughly cursed Charlie.

Speaking of cursed, Charlie turns. Then he runs. Even if he sprints the entire way to the mill and back, he'll still likely catch a whipping when he arrives home. Possibly it'll be to punish him for his tardiness. More likely it'll be for the gun Boyd is no doubt just now discussing with his poppa. That blasted weapon. More trouble than it was worth. More trouble than a gold nugget is worth, which reminds Charlie of the book he's about to trade away. He slows his pace and sticks his hand into his sack. Why bother running when the end result is just going to be another whipping?

4

ALWAYS WAR, NEVER PEACE

Anne Amer looks towards the approaching hoof beats and sees her daughter returning on the bare back of the horse her father gave her for her thirteenth birthday. Annie's safe return should make her mother feel calm, content, elated even, but instead she suppresses a scream. Anne sent Annie to fetch the weekly post as soon as the breakfast dishes were washed and stacked, yet only now is her daughter sauntering back home, her hair a tangle that will take Ellen hours to fight her way through. And Anne sees no sign of the post. Lord, not this again.

Anne presses her hand to her forehead, which aches to an alarming degree. She slips her hand into the pocket of her apron and draws out a small glass bottle from which she takes a generous swig. The warmth spreads through her body, softening her joints and soothing her spirit. All will be well. The pain will recede and soon so will the urge to beat her daughter senseless.

Anne upends her basket, dumping weeds onto the compost pile, then heads for the house, pausing by the garden gate to breathe in the lilacs. Did she remember to tell Ellen to sugar some blossoms for the cookies tomorrow? Maybe not, but she most certainly did tell the hired girl to tie the Virgin's Bower to the trellis and that clearly hasn't been done. Anne will have to repeat her instructions, lowering her

tone and adding menace to her voice. If you want a job done right, it's best to sound like you mean it.

Anne sways. She's certain she's going to pass out or vomit or both, but no, she steadies herself, then steps up into the summer kitchen and flicks her eyes around the room. The oak table hosts dozens of jars of freshly preserved berries. She steps forward and touches the closest one. It's still warm – will be for hours – but Anne keeps her fingers where they are to remind herself that none of this has been done by magic. No, it's been done by Ellen, who's currently grunting and heaving as she scrubs the surface of the stove with sand. "Ellen."

Ellen jumps and spins, her gritty hands pressed to her heart. "Mrs. Amer, thank goodness! Thought for a second you was the ghost from down the swamp come to claim me."

Ellen and her superstitions. One day maybe a ghost really will float in here and won't she be surprised then? "It's lucky for both of us that isn't the case. Did I mention the pastor will be dropping by tomorrow for tea?"

Ellen looks concerned. "Not so's I remember, ma'am. Will it be the good china then?"

Of course it will be the good china. Does the silly girl think Anne will be serving Pastor John from the trough like a pig? "Yes, Ellen, that would be appropriate. I think we should also serve the same lilac sugar cookies that you made for the social this past week. I'm assuming it won't be too terribly much trouble to make another batch."

Ellen shakes her head with an irrational vigour that Anne chooses to ignore. "Also, I think we should serve the tea I brought in special from Toronto two Aprils past. You know the one I mean. It's in the blue tin on the top shelf behind the biscuits. Does that sound like something we can do?"

Ellen gives a dim nod. Then she brightens. "Still some cordial in the pantry, ma'am. Preacher the sort who likes a tipple?"

Anne frowns. "Heavens, we best assume not. It would be nice to have finally found a holy man who can stay upright through an entire sermon."

Thump. Thump. Thump. Both women turn towards the back of the kitchen where George's farmhand, Sam, is stacking freshly split wood. He glances up, notices the women staring, and gives them a quick nod. Then he heads around back to fetch more firewood.

Sam. A foundling if ever there was one. He came to the island with them from Owen Sound. The poor boy is from one of those families with too many children to count, all of them expendable. Her husband took the boy on when he let Oswald go for reasons that were never fully explained. Not that they needed to be. It wasn't Anne's place to question her husband's decision. Besides, Sam is a better fit than Oswald ever was. He's a hard worker and loyal as a hound. She has no doubt he's the rudder her son needs to make something useful of himself.

Speaking of which, Anne had seen Laban and Sam mending the gate down by the government road earlier today. It'd gotten damaged by some foolery she doesn't know the truth of. George told her he didn't know the truth of it either, but her husband often tells her things like that regardless of whether they're strictly speaking true. Whether it's to protect her or appease her, Anne does not know. She feels for her bottle. It's there, thank goodness.

If Sam is back, Laban should be too. Anne pivots and heads for the door, but stops short when Annie tromps through it with insolence on her face. "Annie, darling, it's time for you to practise your melodies."

Annie pushes past her. "Oh, Mother, I'm absolutely certain you meant to say it's time for berries."

Anne slaps the doorframe and lowers her voice to a rumble. "I'm afraid that chore has already been done, dear. If you allow your eyes to adjust to the light, then maybe you'll see the truth of what I'm saying."

Annie makes a big show of inspecting the jars neatly lining the table-top, then huffs. "Well now, doesn't that beat all? I'm absolutely certain there's nothing I love more than slaving over a hot stove on an even hotter summer's day. I dare say the Lord in all his cruelty has seen fit to thwart me."

Anne grabs her daughter's arm and yanks her close, trying hard not to notice the weeds dangling from Annie's unkempt hair. "I'm so sorry

you're disappointed, my darling, but let's not drag the Lord into things that are clearly the devil's doing. Where's the post?"

Annie wrenches free and plucks what's left of the bannock from her apron pocket. She tosses it to Ellen, who has to lunge to catch it one-handed and with a curse on her lips. Annie looks disappointed until she remembers her mother's question. "Well, Mother, as it so happens, Mr. Boyer's got the diphtheria up at his place. Dr. Francis informed me not two hours past that the fetching of the post will have to wait until the situation over there improves. He's absolutely certain it will be two weeks or more before that happens. If you see fit to rush it, I dare say we'll all catch our deaths. That's the God's honest truth of the matter."

So that's what the excuse is to be. Anne knew there would be one. Maybe it would be elaborate and maybe it would be lazy, but it would definitely be loaded up and ready to fire. Why? Because Annie had no intention of fulfilling her mother's instructions when she rode out of here this morning. Anne knew that the moment she spotted her daughter's shoes abandoned beneath her bed. The stockings she couldn't locate, but it'd been easy enough to guess, correctly, they too hadn't made it onto her daughter's body. Wilful child! Not hardly fit for society.

Anne drops her voice to its lowest register and tries to sound menacing, knowing even as she does this that what works on Ellen often does not work on her daughter. "I'm sorry to hear that, dear. But seeing as how that's the case, I would've expected you home hours ago. Where could you possibly have been all this time? You better not have been mooning over that Bryan boy again because in a million years that won't ever happen."

"I hate to disappoint you, Mother, but I was mooning over no one. Sadly, my tardiness is due to my having been kidnapped."

Anne considers slapping her daughter. At the last second she chooses restraint, but only by the grace of God. "My poor child. Were you kidnapped by anyone in particular?"

"Would you believe it was by an entire passel of bears?"

"Okay, Annie, that's more than enough. The melodeon is waiting for you in the drawing room. I expect to hear music by the time I draw my

third breath and it's going to continue until I say otherwise. Am I making myself clear?"

"Yes, Mother." Annie storms through the summer kitchen on her way to the parlour and Anne immediately regrets not smacking the back of her daughter's head. It's too late now, so she spins and punches open the door, then thumps down the steps, pausing to listen for the melodeon. She hears it all right. Her daughter has launched into an elaborate version of "Three Blind Mice." That's not what she's supposed to be practising and there's nothing her mother can do about it without altering her plans, which she's loath to do.

Anne makes a mental note to upbraid her daughter as soon as she gets back. She rounds the corner of the house, hoping to find her son bucking up logs alongside Sam. Instead she discovers her husband slamming a maul into the end of a log, then kicking the split pieces off to the side. Anne steels herself for a fight. She and George had rough words this morning owing to her husband bringing back candy from Manitowaning for their insolent beast of a daughter. If he continues to spoil that child with undeserved treats, she'll end up a spinster for sure. There's no worse fate than that, or at least none that Anne knows of. She tries to sound cheery. "Hello, my love. I thought you were gone for the afternoon."

George lowers the maul. "Day unfolded in unexpected ways."

"Good, I hope."

George weighs his answer. "Not good nor bad. I'll be taking Sam up to the woodlot tomorrow. Lyon's boys are coming first thing next week for all the pine we can down. Cedar too. Southern market's heating up. The more we cut, the more we sell, the faster I secure the patents on all our lots."

Anne is distracted by a milky X imprinted on the front of her husband's shirt. It's from the business end of a butter churn. It has to be. But whose? And why? She doubts George will tell her the truth so she doesn't bother to ask. "Please promise me you'll be careful, my love. The bush families will take up arms if they catch wind of what you're up to."

"Why would they?"

"Catch wind of what you're up to or take up arms?"

"Either."

George isn't that naïve. "Well, dear. I can tell by the things the neighbour women half-say that their husbands are wise to you doing business on the soft side of the law and a certain kind of person resorts to violence when they feel they have been wronged. Wouldn't you agree?"

Anne scans the property for her son as George hauls another log from the pile. "They're guessing. Gossiping like old women because they don't have the foresight to do things the way they need doing. Not my fault they can't see the only thing of value on this godforsaken island is its timber."

Anne returns her eyes to her husband. Sam is less than half his age and yet George is having no trouble keeping pace with him. No one can ever say her husband lacks fortitude. Compassion, on the other hand, is another matter. "You know I would never question a conclusion you've so thoughtfully drawn, my love, but I can't help wondering if it has yet occurred to you that maybe you had access to information they didn't?"

This isn't an idle question. Anne had seen the surveyor's documents spread across the kitchen table when George was plotting their escape from Owen Sound. Whether he purchased them with money or favour she does not know. What she does know is that only those in an official capacity were supposed to have access to those documents and she doubts being a councillor in a neighbouring district granted her husband any such privilege. No, a deal had been struck, the details of which had not been shared with her.

George grunts. "That's a fault?"

"It's not about fault, dear."

George once again drops the maul to his side. "Became a constable for all the right reasons. Sydenham was a cesspool back then. Drunkenness. Brawling. Killings. Helped clean the place up. Glad to do it, but I took risks others were content to avoid. Deadly risks. Was owed more than I was paid. Others saw it the same. Made sure I got my due. Not for you to question how I'm compensated for my years of hard service."

Sydenham. George calls Owen Sound that sometimes. It's still a backwards village in his mind, a place for a man to make his mark, then flee when his deeds threaten to bring harsh consequences. Anne raises her fingers to her temple. She isn't stupid. Her husband had been saying for decades that if Owen Sound was ever going to prosper, it needed to find more efficient ways of accessing the larger markets to the south and the only way George felt that could be done was via a railway line connecting Owen Sound to Toronto. The logic had caught, the tracks had been laid, and the profits were expected to start rolling in and then, abruptly, they headed for the bush. There's more to all this than Anne knows. She can guess at the edges of it, but the heart continues to elude her.

Anne waves to Laban, who's just now loping in from the back pasture, his faithful dog Twist nipping at his heels. George turns to see who's siphoned off his wife's attention. When Laban spots his parents, he averts his eyes. George calls out. "Field them horses?"

Laban nods. His father scans the horizon. "Any sign of the Bryan men skulking around back there?"

Laban addresses his response to his feet. "No, Father, not back there. I did see Charlie out on the settlement road arguing with one of the Porter boys just past first light, but I've not seen him since. I saw the old man take off around noon or so on foot and he looked to be headed for Sloan's."

George looks grim. "Never good when we don't have eyes on those two. Listen for the report of a firearm. Always be prepared to fight. Hear me? They'll come at us from behind if we let them. Best to make sure that doesn't happen."

Anne lets out a heavy sigh. She's heard these instructions too many times to ever forget them and she knows her son has heard them more than her. Always be on the lookout. It's not nature that will kill you, it's the neighbours. Anne feels rage rising in her blood. Why does it always have to be this way? Never peace, always war. The only thing that ever changes is the name of the enemy.

Her husband's mind continues to churn. "What was Charlie fighting with the Porter boy about?"

Laban leaves off affectioning the dog, but continues to stare at its fur. "I couldn't quite catch it. It sounded like a cart ended up in the creek, but I'm not sure whose cart or which part of the creek. Charlie seemed pretty steamed about it though and the Porter boy was having none of it. I thought there were going to be fists, but tempers played out quick enough."

George takes in what his son has said and so does Anne. She senses Laban isn't telling the tale straight, but she's unsure in which direction the lie falls. Charlie Bryan being steamed makes sense since that boy has never been calm a day in his life. The Porter boy standing up to a teenager twice his size also makes sense owing to those children being tougher than hogs. It must be the subject of the argument that hides the lie. Anne will get the truth from her son later. Better yet, she'll send Annie to get it. Her daughter may be as defiant as a bullet-stung wolf, but she has a way of working things out of her brother that her mother can only envy.

For now, Anne would like the subject dropped. "As fascinating as this story is, I, for one, have not seen a cart anywhere near the creek and I'm guessing neither of you have either, so what do you say we refrain from telling tales that spring from conversations half heard?"

Laban shrugs. George, on the other hand, turns to his wife with reprimand in his eyes. Anne takes this opportunity to change the subject to one her husband will like even less. "By the way, dear, did I mention that Pastor John will be visiting us tomorrow afternoon? It will do both of your souls good to sit with us a few hours and hear the Lord's message."

Her words strike like lightning. Both Laban and George look set to protest, but Anne raises her hand. "Don't neither of you heathens speak. Not once have I asked you to attend services since we arrived in the bush nor have I protested when you've done your chores on Sundays against the Lord's command, but this you'll do for me and I won't hear a word against it."

George kicks at a log. Anne knows what he's thinking, but she also knows he won't defy her on matters of the Lord for fear she'll start bringing him into every conversation.

George gives Anne a brisk nod. "Me and Sam will set out at dawn. Aim to be back while the sun is still high."

"No, dear. I'm afraid you're going to do better than aim. You're going to give me your solemn word."

George stares at the horizon for longer than is comfortable, then draws a cross over his heart that eerily matches the chalky one imprinted on his belly. The truce is too much for her son to bear. "You always take Sam to the north lots. Why never me?"

Anne winces. Laban's insolence is as mistimed as it is uncharacteristic. The boy isn't prone to outbursts. Normally, he is quieter than a church mouse. In all his twenty-one years, he's never talked back, not like this, and certainly not on this subject, so why is he doing it now? His words can only have one possible effect and that's to spur George into pointing out what a disappointment his son is, which he does without hesitation. "Because Sam is capable of doing ten times the work you can in half the time. That translates into greater profits. When you can hold pace with Sam, you can be the one I take to the north lots. Not before. Don't make me say it twice."

Laban looks gut-punched. Anne shoots her husband a look and, to his credit, George abides it. He smooths his tone. "Besides, I need you to finish replacing the rails our ingrate neighbours made off with. Was convinced it had to be that devil Porter. Now I'm thinking the Bryan boy did it so he could steal water out from under my nose. Probably borrowed the Porter boy's chore cart to do it. Fair bet he's doing the thieving at night while we slumber."

George raises the maul over his shoulder and brings it down heavily on a waiting log, sending shattered wood in all directions. For her part, Anne blinks at her husband. She's certain he's weaving together strands that belong to different blankets. Charlie Bryan could've been fighting with the Porter boy over just about any cart for just about any reason and still had energy enough to pick a dozen more fights with a dozen more people on a dozen more subjects. Fighting is like breathing to that boy. Besides, Twist would surely have barked up a storm if Charlie Bryan or anyone else had gone near the creek and night after night she's heard nothing but crickets.

George grunts. "Hard to reckon why that Bryan boy is so dead set against me."

Anne can't quite believe her husband just said that and yet she hasn't swilled enough medicine to have hallucinated it. Her husband knows full well why Charlie Bryan would want to steal from him or worse. It's fair to say the whole island knows why. George had the boy charged for his intemperate behaviour towards Laban. Her husband was justified, of course. Charlie should never have laid a finger on her son and George had no choice but to act as any father would. Charlie Bryan was just lucky that George did him the kindness of paying the resulting fine. He didn't have to do that. He could've let those wretched Bryans sink further into debt, but Anne had pleaded with her husband to intercede and he'd grudgingly agreed, knowing full well in advance that he'd get no thanks for the doing of it. But thanks wasn't the reason she'd asked her husband to calm the situation. Eleanor's continued good health was.

Anne's thoughts are interrupted by Laban's snort. "I have no trouble reckoning it at all. It's a long list and at the top of it is you cheating Charlie out of the money you owe him on account of leasing his back pasture."

George drops the maul and raises his voice. "And you believe that to be fact, do you? Got news for you: was Charlie who named the price. Didn't bargain him down, which was my right. Gave him every cent he asked for, so if he's not happy with what he got, it's naught to do with me."

But Laban isn't backing down. "He says you agreed to a price, then paid him less when the term came due. He says you take him for a fool."

Good heavens, where is this insolence coming from? For her sake, Anne hopes this isn't rebellion suddenly taking root in her son and yet for Laban's sake, she's hoping that it is because otherwise she's going to have to assume her son has been possessed by the devil and no good can come from that.

George takes a step towards his son, his voice louder than Anne would prefer. "Were you there?"

Laban's gulp is perfectly timed with the shaking of his head. "No, Father." That's a positive sign that Laban's newfound rebelliousness may be waning with a single booming challenge.

Her husband appears to agree. "Then you have no idea what I did or did not agree to. Should've gotten the deal on paper. Knew that good-for-nothing Bryan boy would find a way to twist this whole thing to his advantage."

Now there's an assertion only the devil himself would believe. Anne signals to her son to drop the matter, but Laban either ignores her or doesn't catch her meaning. "It's hardly to his advantage if he has less money in his pocket than he was expecting. It seems to me the advantage is all yours."

If Laban keeps this up, his mother will be forced to see him in a whole new light and so will his father, who is presently looking more than a little aggrieved. "Very much to his advantage to spread gossip that will set the bush families against me."

A series of emotions play across Laban's face. He's losing his nerve, his mother hears it in his voice and sees it in the way he addresses his next accusation to his fidgeting feet. "That would be more believable if he were the only one telling tales of you altering deals once they've been agreed. But he isn't. It's gotten so as no one who has a choice is willing to do business with you."

Cold amusement spreads across George's face. "Then it's a good thing most of them have no choice, isn't it?"

Laban flushes red. His resolve is falling like a hammer from a roof, but at least he tried. There's hope for him yet. Anne just prays her husband will let his newfound insolence slide, choosing to see it as a rare folly in a boy who normally does as he's told, but she might as well have been praying for snow in August.

George leans back until his spine cracks. Then he leans sideways. "You seem to know a lot about what the Bryan boy thinks. Since when are you two on friendly terms? Seem to recall him busting you up so bad not even you could forget it."

Laban is a beet. "It has nothing to do with friendship nor the opposite. It has to do with whether Charlie has cause and it sounds like he does."

George turns away from his son, not because the argument has reached its conclusion, but because the time has arrived for him to help Sam load the split wood onto the wagon. "Cause? Boys like that always think they have cause. His father is a failure and his boy is following in his footsteps. Don't kid yourself. There'll always be strife between the Bryans and us because there'll always be anger directed at those of us who succeed by those who fail. Best you learn that now."

Anne gestures Laban towards the cart to make amends. Her son looks set to resist but then relents, reluctantly joining in the labour while George continues to simmer. "Charlie is going to end up with nothing soon enough so you best be prepared for more violence. Men who are going down to defeat inevitably lash out at their superiors. Charlie is no better than the rest. That beating he laid on you was just the start."

Laban looks pained. "You don't know that. Not for certain."

George chucks an armful of wood on the wagon. "I know he has a revolver. Never had one of those before. And I know he didn't get it to shoot squirrels out of trees. Unless, of course, he considers me to be a squirrel."

Charlie Bryan probably considers him something far worse than that. Possibly a tornado or an infection or a wolverine, but it doesn't matter. With this one revelation, George has won his son over. Anne can see it in Laban's face. She aches to say something to win the boy back, but she doesn't know what, and besides, it's too late for her to stop what she inadvertently started by coming out here. She should've never left the kitchen, which George is now storming towards while calling over his shoulder to his son. "Come inside with me. I want to show you my old revolver. You'll take it with you when you head out to the fields from now on. No arguments."

Laban jogs to catch up with his father. When you get down to it, he's as obedient as a lap dog and always has been. He may have been atypically inspired to speak harsh words this day, but he'd never seriously challenge his father. He doesn't have it in him and Anne has never been

able to decide if that's a good thing or a bad one. She won't be deciding it now.

Anne draws the bottle from her apron and takes a swig as she mulls George's revelation about Charlie and the revolver and the threat to her husband's life. Maybe it's true. Then again, maybe it isn't. Anne has heard no proof either way. She takes another swig. If George was truly in mortal danger, he would surely have said something to her before now, Anne is certain of that much. Just as she's certain that when she returns to the house she'll discover her wayward daughter has left off practising. She sighs. Forget the revolver. It's that insolent nightmare of a girl who'll be the death of them all unless Anne can find some way to rein her in.

WHISKEY IN A JAR

Eleanor Bryan daubs the sweat from her brow for the third time in less than ten minutes and raises her eyes to the Lord, who she is certain is floating in the sky somewhere above the tattered, tilting roof. It would be a mistake to think she's giving serious contemplation to affecting a conversation with the Man Upstairs on a day when it's this blessedly hot and there exists in the world such a thing as a summer kitchen. Anne Amer has one and Eliza Porter and even that dreadful McPhail woman the next concession over. Not one of them knows the hardship of a wood stove belching heat within the confines of such a wretchedly small cabin on what is as yet the hottest day of year.

Bill says Eleanor should consider it a blessing she has any stove at all when the fates themselves could have demanded she cook over a fire pit in the yard, but Eleanor would bet the stars her drunkard of a husband would think none too highly of those same fates were he the one who daily had the honour of feeling like an overcooked roast. And that's if we're telling the God's honest truth about things.

Eleanor groans into the back of her hand and takes a good look around her person, knowing as she does this that she's going to see only such a sight as she's seen a thousand times before, namely cabin walls that never have been properly chinked and whose logs are haphazard, mismatched and splintering. Bill didn't so much as remove

the bark before stacking the butchered trees one atop the other, the consequence of which is that her daily chores include peeling disintegrating bark from the smooth wood underneath and fearing with each tug that this day will be the one when those same said logs collapse in a heap on top of her.

Eleanor would not be speaking false if she were to announce to the world that down to a man no one ever mistook her husband for a carpenter or an engineer or even a gentleman. And let's don't get started on his abilities as a farmer. There isn't time enough for her to countenance her grievances on that score.

Eleanor sets about settling her rambling mind, for it is surely threatening to gallop forth like the most spooked of horses as her frustrations flare. 'Tis its nature when things go sideways, but it must be stopped cold in its tracks, something she sets out to accomplish by turning her mind to her youngest, Arthur, who is presently devoting the entirety of his strength and diligence to the task of grinding endless handfuls of oats in the very coffee mill his momma inherited from her own dear momma in the months before striking out from the mainland.

Eleanor can't help but wonder why her son is undertaking his task with a dull inefficiency that threatens to find dawn upon them before he is through. "Arthur, my sweet boy, if I told you once, I told you a hundred times that shifting the sack of oats to the other side of your person will enable your cranking with your right hand and feeding the hopper with your left. In such a way as that we'll amass enough flour to make more than a piddly loaf during the weekly baking."

Eleanor peers into the crock although, truth be told, she in no way needs to do this to confirm the flour thus far ground is such a measly disappointment that it would not tempt even the most starving of mice. It pains her something awful to acknowledge that every last speck of that aforementioned flour has issued from oats the boy's poppa grew with rude tools such as would be discarded by anyone with a proper choice. Oh, how she wishes her son was just now grinding wheat and not these maggoty oats that not even the oxen would eat if any other option made itself known.

Eleanor eyes the sack of shorts Charlie slumped in the corner no more than a half hour past to her joy and surprise. She knows not what spirit possessed him to perform such a kindness and he told her not its inspiration. Not that this is a wonder. It's surely not the boy's way to speak unless provoked and then he speaks only the harshest of words. So be it. His momma long since stopped expecting words of hello or thanks from that cheerless boy. This solemn day he granted her not so much as that as he plucked the dipping bucket from beside the water barrel and beat a most direct path out the cabin's one and only door. His momma can only guess his intent is to fetch some quantity of water for her domestic travails although nothing so much as that was said.

Eleanor sheds her mind of Charlie as best she can, for an episode of fainting is upon her owing to the heat or the lack of water or the racing of her mind, some such thing as that. She cannot yet discard the possibility that the impending swoon is the product of endless disappointments that would have inspired her own sweet momma to label her a failure had that saintly woman been alive to witness the botchery her daughter has made of her life. It's a testament to the Lord's mercy that the ground did swallow up that industrious woman long before Eleanor became such a mockery to all that is good and holy.

Eleanor can only wonder at her mind's refusal to take the bridle. Can it not see there's a mountain of work in need of doing and not a single soul present to do it but she, owing to her girls having been previously dispatched by Bill? Their eldest, Carrie, was married off quick as could be upon their arrival on this island. It was a dreadful business, but they could no more afford to feed that dear girl than to burn money in a ditch. Their youngest, darling Annie, though not yet fully a woman, is already off to live with their second child, Hattie, up in Green Bay, surrounded by a veritable army of Skippens. Good people if ever there were any, and kind as kittens to her precious girls. And though it had to be so, Eleanor wishes each and every second of each and every day that she'd been granted leave to press those cherished girls to her bosom until they were proper adults.

Eleanor daubs the ocean of sweat leaking from her brow and surveys all that is yet to be done through her labours and those of her slow-cranking son. If they have any hope to succeed in finishing their tasks before the clock strikes a new day, a good story must surely be told lest boredom arrive to slay them both. "Sweet boy, do you remember a time long past when our lives were firmly rooted well south of here on that farm in Erin?"

Arthur shakes his head. "No, Mama. I remember no place but here."

Eleanor takes to chopping radishes and onions and random herbs as she waits for her son to reconsider his answer as she knows he surely must. "But sometimes, if I try really hard, I think I can remember green."

Ah yes, green. Erin certainly was that, what with the mossy forests and the crystal-clear waters rushing forth along narrow creek beds. The trail to the church was an eternal favourite owing to it's being lined with dark, cracked boulders that rose higher than she could raise her hand and which remained mercifully cool to the touch on even the hottest of summer days.

Erin has been firing Eleanor's mind these many days, yanking her thoughts back again and again to that verdant paradise, which shines ever so bright now that it resides such an impossible distance away. "I know exactly what you mean about the green, my sweet boy. I sometimes try to call Iowa to mind and find often my inner vision is met with the richest of golden yellows. I've come to believe that's how the mind recalls a place when you leave it too young for the memories to fully stick."

Eleanor teases this thought around her mind as her hands cube the stale bread that Charlie saw fit to lug around in his natty sack for the best part of a week before announcing its rejection. It's no matter to her since stale bread mixes with seasonings just as well as fresh and when rendered into stuffing, Charlie has proven time and again that he can no more recognize his rejects than grow whiskers on his chin.

Eleanor smiles as she presses the stuffing into the cavity of the fresh-gutted pheasant Charlie had seen fit to fling onto the rickety table upon his brief and unexpected return. He did surely wear a glow such

as befits a knight who has lately beheaded a slow-witted unicorn. There is a doubt nowhere in Eleanor's mind that her son's high self-regard is down to those wretched dime novels the boy peppers his mind with despite her counsel that the only book that ever needs reading is the Holy Bible.

That being said, Eleanor would be perpetrating a falsehood if she did not now confess that it is most welcome to have more mains for the evening meal than the trout Arthur pulled from the river this morning past when he ought to have been plucking weeds from the garden.

Eleanor leans forward and tugs a thread free from the edge of the oat sack with the one hand while sliding a needle from her waistband with the other. She labours to sew the bird's skin-flap shut using the looping stitch passed on to her by her own dear momma. "I would be speaking false if I failed to admit that at times I remember more than just yellow. I think it is the little things that my mind dawdles over, such as how the long prairie grass felt brushing against my little-girl legs or how much more of the sky filled my eyes on the wide-open plains than it does here on this bunched-up wastrel of an island. All that vast blueness during the day burst open at night to display the broadest sweep of heaven you ever did see and every inch of it filled with glorious stars."

Eleanor rises and plunks the pheasant into the waiting pan that she slings into the oven with a certainty earned through practice. She returns now to the table, where the trout needs hacking, then plopping into the pot of water that's been on the boil for longer than she would normally consider wise.

Arthur halts his labour and a frown muddies his darling face. "I don't remember nearly so much as you."

"Of course you don't, my sweet. I was senior to you when I left Iowa with my momma and poppa. You were not but five when we dragged you from Erin on that rollicking lumber hooker that seemed dead-set on drowning us in waves, the likes of which I dread to ever experience again. Those few years of age were to my advantage, gifting me with more memories than your mind could ever have thought to hold at your modest age. But if I'm telling the God's honest truth of the matter, I'll

admit that I do not have as many memories as I would've liked, given a proper choice. Keep grinding."

Eleanor brushes the dastardly heat from her arms before dipping her hand into a basket and extracting a pea pod that she pinches just so. Its spine pops open, putting a dozen plump peas on display for her thumb to eject. She flicks the empty pod into the bucket sitting heavily at her feet, surprised, as always, how effortless a chore becomes when you undertake it tens of thousands of times.

Arthur appears most concerned. "Why did your parents ever leave the States? It's so much more exciting there than it is here."

Eleanor grabs another pod and fails to stifle the most unmotherly of laughs. "What do you know of it, my sweet? Only what that brother of yours tells you, I wager, and what Charlie knows of it has its basis in tales told by boasters who themselves don't know the half of it. Mind my words, those books Charlie devours speak falsehoods that will likely as not be the ruin of him."

Eleanor prays to the Highest Power that Arthur finds in her admonition the warning she intends. She has now several times caught the boy rifling through the weary pages of books Charlie has himself read so many times it would be no true challenge for him to recite entire passages from memory. It's a mortal shame he cannot do the same with verses from the Bible.

Arthur, bless his soul, has tried as only a schoolboy can to sound out the words in Charlie's books. It's as if they have near the same value to the lad as the lessons foisted on him in that sorry schoolhouse that rendered useless some perfectly serviceable farmland within this year past. Eleanor stands sure that memorizing his sums won't lend the dear boy half so much good as learning to plough a straight row or to properly stook sheaves. Maybe that future land baron Andrew Porter feels dreadfully important consigning his children to a place such as that, but Eleanor sees more sense in a boy learning the ways of the farm. Charlie, for all his faults, never took to schooling as such and was as relieved as she when moving to the island meant he was bothered by lessons no more.

Mercy, there's her mind galloping forth again. Eleanor glances down at Arthur, who looks well and truly like he's been slapped by his momma's rough words. His head hangs low and his labour continues in the quiet way that tells his momma he's afraid to say one word further for fear of reprimand.

Eleanor looks to the door next to which the strap hangs on a nail as an unnecessary reminder of what does happen when the rules are not given their due respect. Arthur has been subjected to that strap a mess of times, as have all the boys, and, to a soul, it was rarely obvious which rule fell short of being observed. The last use of the strap was to set Charlie straight on account of his beating on that useless Amer boy. The beating was not itself the problem. Anyone who sets loose their livestock in a neighbour's field deserves to be on the wrong end of a beating, if not worse. No, it was the fact that the boy was indiscreet in the doing of it that caused his poppa to yank down the strap and beat Charlie hollow.

Eleanor just now rejects that memory in favour of a more palatable one. "My dear parents fled Iowa because options there were few. Times then were harder than your young mind can hardly imagine. Crops failed too many times to count and even in those stray years when the wheat was bountiful, not a living soul could afford its purchase so it was left in the fields to rot. Then my poppa learned of land available in the Canadas for all those willing to labour and that was a powerful carrot. On our trek north we passed many Easterners heading to the place we just left and beyond, some claiming to be journeying forth to California. I could not help feeling sorrow for them due to me knowing there was naught waiting for them there but hardship. Telling them so would have been a fool's errand, mind you. You never can tell people dark truths when they've got their minds set to dreaming. I've often wondered how many of those poor souls made it. Not many, I should think. These many years since I've heard tales of suffering the likes of which only the devil himself could've designed. So when that brother of yours tries to fill your head with stories of grand adventure, don't you go putting no stock in. Lots of people acted on tales such as those and many of them are no longer with us."

Eleanor hears bluster coming from the far side of the cabin's walls and pulls herself stiff. Creaks fall to clanks before the door swings open and slaps the wall hard, bouncing back. Eleanor laments, not for the first time, having no way out of this cabin save for the door through which peril enters. She wishes she had to hand an axe or a gun or even a rabid dog, but she has not one of those useful things. She does, however, by God's mercy, have a knife and boiling water and a temper that would put a raging creek to shame.

There's no need for any of it owing to it not being her husband's arrival home from Sloan's she's hearing but rather Charlie finding his way back from the creek with a bucket in each of his hands. The boy slogs over to the water barrel and dumps his load of water before making haste for the waiting cart where he grabs hold of two more buckets. Back and forth he trudges until the barrel is full and his momma's soul finds the notes to Hallelujah.

Charlie gestures at the meagre stack of wood awaiting service at the foot of the stove. "Behind on my chores thanks to those good-for-nothing villains down at the mill. Won't have nearly the time to chop more wood before nightfall, Momma, but I'm thinking you won't be needing it neither. Will get to it in the morning before stumping unless Poppa says different."

Eleanor nods. It's so dreadfully hot in the cabin she'd bet the devil her finest apron she could find success cooking the whole of the evening meal without benefit of the stove. With God as her witness, she knows better than to ever say such filth within earshot of another human. If Bill heard such words as those springing from her lips, he'd hand her stove to the first beggar to pass, then blame her for the loss. But Bill isn't gracing her presence just now, Charlie is, and he looks exhausted by labours that were once his to share with his elder brothers until first Bill, Jr. found his purpose in Sandfield, followed soon after by Abel, who earns his keep as a farmhand up in Bidwell. That leaves Charlie to shoulder burdens once spread amongst the three. "Did the boys down at the mill think to give you any trouble?"

Charlie shrugs. "Boys down at the mill always give me trouble, but I straightened them out pretty good."

Eleanor doesn't like hearing words such as that. "May I ask what needed straightening?"

"Seemed to think our credit had run dry. Showed me ledgers. I showed them fists. Matter settled in my favour."

Eleanor had the sense of it being something like that. "This something your poppa's going to be hearing about from Boyd then?"

Amusement flutters across Charlie's face. "My guess is not one of them wants it known they took a beating from the likes of me."

"That being as it may, those boys aren't the ones who concern me most."

Charlie's expression takes a serious turn. "Lyon won't do nothing against his own interests, Momma. And it's in his interest to sweep his refuse into bags for us to eat so that when he needs his roads built this winter, we got no choice but to labour."

Eleanor sighs. Although she may fear that book reading will bring nothing but misery to her son, she must truthfully admit that Charlie has a firmer grasp on the way of things than many around here.

Her son dekes outside, returning with a raisin pie that's been losing heat on a rock by the door. He thumps it on the table before turning his feet towards the waiting cart. His momma stops him cold. "Any chance of you doing me the kindness of slopping the hogs on your way past their pen?"

Charlie eyes the bucket his momma is tapping with her foot. She's been using it to collect bones, vegetable scrapings, fish skin, and pheasant guts and the bucket is just now dancing with any army of flies. Charlie barks like a wounded dog. "Don't do no woman's work, Momma. Not now. Not ever. Insult for you to even ask."

Oh, really. Eleanor's fists find her ample hips. "And yet I've harvested a far sight more rocks from these here fields than you and your poppa combined. I've chopped more than my fair share of firewood, too, if we're saying the truth. And don't you even get me started on all the times I hauled water from the creek when the harvest saw you both run short on time. My memory even goes so far as to remind me that I worked the plough when the both of you again fell behind this spring

past. Since when, I ask you, my high and mighty son, are those things woman's work?"

Charlie looks at his momma square. "Since they needed to be. But it don't work the other way around. Since when do you not know that?"

Since never. "Maybe that's the way of things in this household since your brothers absconded, but that's not how it's always been, so don't you go making like it is. And I'll see you further informed that it's not the way of things in other households neither. I've fixed eyes on Laban out slopping pigs plenty and not once have I heard tales of his whining for the doing of it."

Charlie's smile is sly. "At that servant's request, not his momma's."

Eleanor is awash with confusion. "Now just what are those wily words supposed to mean?"

Charlie's smile is now a smirk. "Laban's got an eye for that chubby little island girl who does all his momma's chores. Always making a fool of himself over her. She asks, he does. The pig slopping is proof enough of that."

Eleanor doubts that what Charlie is saying is factual, owing largely to her inability to imagine Laban or anyone else thinking fancy thoughts about a rough girl like Ellen. She's not the sort to attract a man's interest, not even one as daft as Laban Amer. The poor girl is likely to end up matched to some ne'er-do-well cousin or maybe a preacher or, more likely, to no one at all. That's how Eleanor's got it figured and she doubts Charlie has any deeper insight into the matter, seeing as how he has not yet worked out that silly little Amer Miss has designs on him. That's plain enough to the eyes. If there were any sense in that little girl's head, she'd swish her skirt in some other boy's direction. But then, look who her momma is.

Eleanor returns to shucking. "I didn't ask you for your thoughts on the matter. I asked only for a little consideration, which your momma surely has the right to."

"And you got it, Momma. Said I'd help you with the firewood first thing tomorrow and I will. But not with the women's work. That's for you." Charlie's eyes land on his little brother. "And him. No reason I can see why Art can't add pig slopping to his list of chores."

Eleanor has had enough of Charlie this hot afternoon and takes to demonstrating it by whipping a pea pod at his fool head. It lands like a dead mantis on the dirt floor between them. She and Charlie together stare at the pod until Eleanor finds the wherewithal to break the trance. "Arthur is grinding oats for tomorrow's bread as you would surely see if you took the time to suss things out before opening your ignorant trap."

"And he's doing a fine job of it. Just as he did a fine job scything brush earlier today." Charlie pauses, then continues on in a noticeably darker tone. "Won't be doing any of those things much longer. This time next year, Art will be out in the fields with us doing the work of men. Best you don't go believing otherwise, Momma."

The nerve of that boy thinking he can address his momma like he's her better. If that heathen were to live a hundred lifetimes, he'll never be that, not with his temper. The mere thought of Arthur spending his days at the mercy of her miscreant son and her drunkard of a husband sends a chill clear down Eleanor's spine. She can allow no such calamity to transpire. This boy she'll save. She's already taken steps to ensure that happens and daily thanks the Lord that so far she's been able to keep those steps secret from the tormentor she married and the one she birthed, who is just now tapping on his younger brother's shoulder. "What do you say tomorrow you come out to the fields with me and we'll see who can build the biggest rock pile. I'm betting it's you, but there's only one way we can find out for sure."

Arthur looks up excitedly, as is the child's nature, but his mood soon dulls when he catches sight of the fury in his momma's eyes. His sweet gaze drops to the floor and his head gives a solemn shake. Charlie ruffles the boy's hair. "C'mon, cowboy. You can't do women's work forever. Poppa will see to that if I don't."

"Poppa will see to what?"

There's an audible uptake of air as Eleanor, Arthur, and Charlie all turn to face Bill, who is breaching the doorway looking for all the world like an enraged bull. That he's been drinking is beyond dispute, owing to the red of his eyes and the rage pulsing through each one of his aging muscles. To Eleanor's mind, the only question worth a cent is whether

the drunkard has swilled enough whiskey to pass out or merely enough to go on a vile tirade. Eleanor prays to the Lord it's the former since she relishes not the thought of spending yet another night hiding her person in the bush while her whiskey-infused husband goes off on one of his bitter tirades, the subject of which will doubtlessly be the famine and the English and the travesties that brought him to this country, this island, and this low point in his life, as if there's a soul left on this island who could possibly believe that at some point in the dark distant past Bill's life had ever had a high point.

It's Charlie who bursts forth with an answer. "You'll see to it that the last of the corn gets in the ground by the end of the week, Poppa. On track for it. If the skies stay clear, we'll have no trouble getting it done."

Bill sways like a tree that's been cut most of the way through and although Eleanor is sure he will eventually topple, it's a fair guess he hasn't reached that point just yet. "Shouldn't think it'll take that long. Move."

Bill shoves Arthur off the crate the sweet boy has been kneeling upon to help his momma with the flour. Setting it rough against the wall, Bill sits down hard and sends his eyes around the room in search of something to land on. Whatever that unfortunate object should be, Bill will surely use it as a weapon against one or all of them.

"Don't know why any son of mine would think he had a talent for a thing like that."

So it's the fiddle propped against the far wall that's to be the drunkard's target. So be it. Beats Charlie taking another crack at playing "Whiskey in the Jar," such as he did on the evening since past. Now to be fair, Eleanor has never once heard a version of that song that set her mind to joy, so her son's attempt, such as it was, was no more offensive to her than most. Still, it baffles her soul to ponder what in God's name possessed Charlie to bring a musical instrument into a cabin so cramped as this. They're not a musical family so far as she's aware. They are not even a happy one.

"Not aspiring to talent, Poppa. Just thought a little music in the evenings might be more enjoyable than listening to the crickets chirp."

Bill snorts. "Not the way you play it."

Charlie snorts back. "Can't play like the ancestors without hitting a few wrong notes first."

"Not heard you hit one right yet. Still got that gun?"

Charlie stalls. He clears his throat. "You know I don't."

"Boyd seems to think you do."

Charlie wears the appearance of concern, then anger, then upon his dear momma's soul, defiance. "How can I have the gun if that's what I traded away to get the fiddle, Poppa? You see bags of money lying around here? Got the knobs for the oxen like you asked, then bargained hard for the fiddle to be included in the deal. Told you as much already. Is the gun what Boyd came to see you about?"

That's not a question Eleanor would have counselled the boy to ask, so she can hardly claim surprise when Bill pulls his spine straight, bringing the appearance of pain to his face but also a deeply wrought rage. "Don't you even think of raising your voice to me, boy. What Boyd came to see me about is no concern of yours. I'm not even sure I can say for certain why he turned up. You know that Gaelic bastard doesn't never speak a word straight. All I really know is whatever Boyd's reason for coming, it's most assuredly for the benefit of Amer."

"And did Boyd get what Amer wanted him to?"

Bill suppresses a belch. "Does he ever?"

Yes, all of the time and in all manner of things. Charlie knows this, as does Eleanor, but neither sees advantage in saying as much to Bill, not while his eyes continue to harass the fiddle in such as way as to suggest it has somehow insulted him. Eleanor is taken with the notion that at any moment he'll snatch it from its resting place and smash it against the wall or the floor or Charlie's powerful back. Instead the miscreant finds a new target. "Get that money Amer owes you?"

Charlie's face darkens and his voice calls to mind thunder. "If I did I'd have said so, Poppa. No concern of yours one way or the other. It's mine to get and I'll get it. That's fact enough. If that scoundrel thinks he can cheat me of the two dollars he still owes me on the lease of the back pasture, he's wrong. Law's with me on that."

Bill laughs in the manner of someone who has just now been told a fairy tale so absurd not even a child would be taken in by it. "But is Boyd? Seems to me he *is* the law out this way and if Amer has a claim on him, well, then Amer can do whatsoever he pleases. Not once have I seen Boyd decide a thing against him, not even when everybody agrees Amer is at fault. Not thinking that day will ever arrive. So listen carefully: If you're owed money by a man like Amer, you got to find a way of getting it that he can't use against you later."

Charlie's eyes fix themselves on the strap hanging by the door and he wears not the look of fear that had taken hold of sweet Arthur's face. No, Charlie's face shines with a contempt that his momma takes to mean he's lately grown to realize that such a weapon as that would fit his own hand near as well as it fits his poppa's. Lord help them all if he ever gets up the nerve to make good on this realization.

"Said I'd get it, Poppa, and I will."

Eleanor prays to the Lord that Charlie has wisdom enough to halt right there, but sure as mice scamper in the pasture, the fool boy goes and proves his brain is made of folly. "Amer says the money isn't owing due to his paying my fine for beating his worthless son. But the one has nothing to do with the other. Wants to pay my fine, so be it. His fault there ever was one. But the price for the field is the price for the field. Wanted credit for the fine, should've said so up front and I would've considered it before naming my price. But he didn't. And he can't rightly change a deal once it's been set."

Charlie is likely speaking God's truth, but any suggestion, no matter how small, that Amer may be getting the upper hand on their family will provoke just one response from Bill. "Amer thinks he owns the rules. Like they're a horse or a plough or a woman. More than happy to teach him what's what, but you've got to be straight with me. Did Amer pay you what's owed on that field without you passing it on to me? Makes a difference to how I go at him."

Lord, let it rest there. But no, Charlie has contempt on his mind and it lends an edge to his voice that his momma adjudges unwise. "That what this is about, Poppa? You think I bought the fiddle with

the field money and kept the gun without saying a word about it? For what purpose?"

Eleanor can most assuredly think of one. She eyes the hunting knife she's lately been using to cut and chop and slice. She would not be speaking true if she said that here now marks the first time the thought of plunging it into her husband's chest has ever touched her mind. Charlie has surely thought likewise. She can't imagine his having that gun on his person and never once letting his mind contemplate the using of it against his very own poppa.

Even so, her drunkard of a husband retains control, at least for the present. "Not about purpose. About knowing if the gun is still here and the only reason that could be is because the money that was owing has been paid. So say the truth before this goes any further."

"Money's still owing. Gun is gone. I know the difference between the truth and a lie."

Charlie brings to mind a pot on the boil. His momma senses the need to bring forth some action to disperse the heat or all will surely be lost. So she turns, abruptly, intending to effect the necessary change when she discovers the blood-red eyes of her miscreant husband trained on her person with a look such as causes her soul to clench. Never does she want to be the object of that man's attention when the whiskey flows freely in his veins.

Eleanor gathers up the peas in her apron and sets a course for the wood stove, which, as the Lord so dictates, takes her away from Bill. It's a start, but then Charlie goes and speaks, causing his momma to fear her spell of inaction has surely cost them the day. "Amer and Boyd and all the rest of them may think having no money makes me lower than them, but I'll own the patent on this land one day. They'll have no choice but to face me as their equal then. Not one of them will think of cheating me when that day comes."

Eleanor is dismayed that any son of hers could possibly think that which Charlie has just now voiced. It's his nature, she supposes, to believe such things as that, but it's the most dreadful of follies for this boy to entertain the notion that his destiny will be anything more than a labourer

in someone else's fields, assuming it's so much as that. His temper has given all, save his eldest brother, an aversion to taking him on and even his own flesh and blood hesitates, saying maybe the year to come or the one after that, by which time this homestead will surely be in the hands of another and the four who remain will be a far sight worse than destitute.

Eleanor again finds herself at the stove though she cannot now remember why. Her mind is agitated in the worst possible way. The truth is, she can't stand so much as the thought of this wretched place. Never – not once in her life – have the pangs of isolation pursued her as mercilessly as they do on this island chock full of interminable forests and impassable roads and godless neighbours. In all her years, Eleanor has never known the like of it and she wishes she knew not the like of it now. At least in Erin her family was near and every fortnight brought about a church social at which she could gossip and sing and tell silly jokes. There was even a general store brimming with goods the likes of which she could ill afford to possess but sometimes, when her spirit was at its ebb, the proprietor would gift her a sweet on account of all the good she was doing for the community.

What does she have to bring her joy here? Not a thing worth counting. No, what she has here is a dress made from flour sacks, one pot for all her cooking, forks carved from wood and cups fashioned from tin cans, a leaky roof, a dirt floor, a worthless drunkard for a husband, an ungrateful brute for a son, and a dear boy she's trying desperately to save from the corruption of his poppa.

Eleanor casts her eyes on Arthur, who is just now picking at the oat sack that appears as frazzled as his precious nerves. To see the sweet boy as clearly as need be, his momma must raise her hand against the sun that is just now streaming through the poorly chinked walls.

This is all too much.

Eleanor once again turns from the stove with purpose and once again she finds herself caught in Bill's glare, only this time his feet are beneath him and his fingers are balled into fists. She braces for the blow that is surely to come. "Been hearing tales about Amer sneaking over here when I'm not around. What do you have to say about that?"

That was surely not the blow she was expecting. Eleanor reclaims her wits. "I'm not rightly sure what foolishness is agitating your mind, husband, but it's rare for you to be elsewhere, so far as I'm aware. If you were as frequently absent as your words just now suggest, the chores that daily render me exhausted would surely be lessened by far."

"Don't be daft, woman. Plenty of times I'm not here. Spent just this afternoon over at Sloan's. Spent most of last winter in the logging camps. Same was true the winter before. You recall things differently?"

Always this. "I recall them same as you, but unlike you I recall separately that George Amer takes to Owen Sound for the winters, so any thought you have of his setting foot on this homestead while your person is elsewhere is most assuredly false. You know I'm speaking true, for any man who spends his winters not on this island is surely not to be found in our own home."

Bill's face brightens, as is its nature when his mind fills with thoughts of the most grievous kind. Arthur stops fiddling with the oat sack and, in his quiet way, fits his body under the table where his staggering poppa can not easily get at him.

"Who said anything about Amer being in our home? Didn't say nothing like that. Only suggested he'd been on our land. It's your own guilty mind that's blurted out that nugget of truth. You might as well say the rest."

But Eleanor sees sense in not saying a blessed thing while a chance still exists for her to save Arthur from the drunkard before her now. "I've got nothing to say when you have evil on your mind and I've got no guilty conscience on account of my not having done anything that would be the cause of it. Let's remind ourselves that I'm not the one breaking commandments like they have no value in God's eyes."

Eleanor can no longer countenance her husband. She steps urgently towards the door with the hope of saving her bones from a thrashing by hiding amongst the trees until her brute of a husband either sobers up or passes out, she'll not burden herself with a preference as to which.

But Bill is not to be denied.

He lunges forward, catching Eleanor by the arm. She makes the sincerest of efforts to pull away but, drunk though the heathen most assuredly is, her husband remains possessed of a cast-iron grip. "Don't speak wise to me, woman. Whole neighbourhood knows what goes on around here when my back is turned. Think people don't see Amer creeping over here? They see sure enough. And once they've had a good laugh, the truth finds its way to me."

Charlie now shows himself for the miscreant he is by blocking his momma from the door and, by extension, the bush that lies beyond. She can but wonder at the foolishness of a boy who fancies himself the hero of his own adventure story and yet moves against his momma to win the favour of his poppa. A boy who doesn't protect his momma against harm in all its forms is a boy who'll spend an eternity burning in hell. Eleanor taught Charlie as much. She taught all her sons as much and they'd all learned the lesson save for this one here.

Charlie, however, is not her main problem. "Exactly who around here do you imagine can see who comes and goes from our door, husband? We live in the bush, in case you need reminding. The only ones with the kind of view you're suggesting is Porter himself and when have you ever taken what he says on its face?"

"Since he started speaking true."

Eleanor cannot but narrow her eyes. "Since he started saying what you wanted to hear, that is. You ignorant fool. You're always looking for a way to justify your own brutish behaviour and now you're trying to convince you and me both that you've just now finally got one. Well, have it your way. Let us together hope that throttling me will finally make a man out of you."

Bill grabs Eleanor by the neck. She tears at his fingers but there's naught she can do. Blackness starts filling her eyes and her body tingles, then numbs. By the time Bill shouts over his shoulder to his youngest, his voice seems as distant as a foghorn on some far away shore. "What do you say, boy? You ever known Mr. Amer to be alone in this house with your momma?"

Arthur freezes like a deer in the path of a hunting wolf and looks desperately to his momma before shaking his tiny head. Bill takes the sweet boy's hesitation as proof he knows more than he's saying which, admittedly, he does. "Thought as much."

Bill shoves Eleanor backwards. She collides with Charlie, who deflects her into the wall. As Eleanor drops to her knees, Bill yanks her back up all the while barking orders to Charlie. "Move the oxen to the back pasture and hobble them. Don't need them wandering over to Sloan's place tonight. Gets hard to claim their waywardness is an accident when it happens near every evening."

Charlie neither speaks nor hesitates. He yanks open the door and rushes out into the late afternoon sun, looking back not once. Damn the fool. If he thinks chopping wood for his momma tomorrow will set right the treachery of this day, he's got another thing coming. But not until tomorrow.

Bill reaches for the strap, while Eleanor frantically flicks her eyes around the room in search of Arthur. The sweet boy is under the table yet, demonstrating the sense the Good Lord gave him by brandishing a crate as a shield against his festering poppa. Eleanor prays it will be enough. It's the only thing she can reasonably do now that Bill has started to swing.

6

NO TRUER TRUTH

George nods slowly. "Again."

Laban plunges the cleaning rod down the gun's barrel, then measures out the black powder with shaking hands. He pours the powder into the barrel, taps the revolver against his palm, then tamps down the ball and affixes the cap. George is impressed. Proud even. The boy's hands may have been shaking like an aspen in a windstorm, but he got the job done and George has to admit he couldn't have loaded the gun any faster. Not that he tells Laban this. Praise leads to weakness and his son is already disturbingly prone in that direction. Unlike his daughter.

George turns towards Annie, who's staring down her sheet music. He doesn't blame her. His daughter is far too spirited a girl to be lolling about at a melodeon. Hand her an axe or a hammer or even a sharp stick and she'll be entertained for hours. But a melodeon? George doesn't know what his wife is thinking. Does Annie really strike Anne as debutante material? Girl's got gifts beyond sipping tea and plaiting her hair. That much is obvious to anyone not caught up in what the neighbours think.

Alas, he'll catch hellfire if he interferes with Anne's attempts to mould their daughter into a marriageable young woman. So George snatches the gun from his son's fumbling hands and places it in the upper drawer of the sideboard alongside his truncheon and handcuffs,

all relics from his days as a constable in Owen Sound. He half-turns. "Fetch the butter up from down the creek. Make it quick. The evening meal isn't long for the table."

"Yes, Father." Laban looks relieved as he slinks towards the front door. It's a short trip down to the creek where Ellen stores crocks of food to keep them from spoiling on these hot summer days. That's where the butter is. Fresh. Cool. Bursting with flavour. George's mouth waters just thinking about it. He needs a distraction.

George turns to his wife. She's perched at her writing desk, rereading last week's correspondence. Stubbornly. Pointedly. As if the illness up at Boyer's is somehow his fault. Classic. At least she's found something in her letters to make her grin. "What's amusing you so?"

Anne looks up and sighs. "Emma Harrison is relating her adventures up at Indian Falls this May past. She says so much water was rushing over the cliff she was hard of hearing for two full days afterwards. Can you believe a thing like that?"

Can anyone? "No."

Anne purses her lips. "Well, dear, if she says it's so, it most likely is. There is no reason for her to waste ink on a lie when there's plenty of other adventures she could be telling me about."

George can think of several, all of them dull. He strides over to the sofa and begins unlacing his boots. "Don't you think it's odd that we've been up at those falls plenty of times and there isn't a single occasion when the water was so loud we couldn't later hear the other?"

George yanks off his left boot and inspects it. A bit of crease near the big toe and a scuff behind the heel. That's to be expected. Overall these new boots are standing up well to the work-filled days. George won't have to bust that shopkeeper upside the head after all. Or have someone do it for him. That's good news. And confirmatory. Buy quality goods and they last you a lifetime. There's a few around here who could stand to learn that lesson.

Anne puts down her letter. "My word, you're cynical. You asked what gave me a smile and I told you. There's nothing for you to comment on. A woman's words to another woman don't require a man's insights. I

dare say you wouldn't want me adding my two cents to the nonsense you men say to one another."

Got that right. George wrenches off his right boot, inspects it and, finding nothing to complain about, sets it down next to its companion. He steels his resolve. As annoying as Emma Harrison can be, George has to admit she does have her uses. "Mrs. Harrison have anything to say that might interest me?"

Anne understands what he's getting at. Owen Sound has never been short on gossip, and much of what continues to swirl through parlours pertains to kickbacks and counterfeiting and the abrupt arrival of the government men. As if what goes on in Owen Sound is any worse than what goes on in any other town. When you get right down to it, what had George done that was so wrong? Took a few dollars to look the other way when money was being minted against the government's interests. Not like he was the one doing the minting. Not even like he knew for certain who was. Received good money not to know those things. Money he made damn sure came from the official mint in Ottawa.

"Has Mrs. Harrison ever said anything that interests you, dear?"

George leans back and shrugs. "Not so's I recall, but there's a first time for everything."

Ellen trudges in from the kitchen with a serving dish of fried potatoes in one hand and a basket of freshly sliced bread in the other. She places both in the centre of the table alongside the steamed spinach and caramelized onions that are already there. Anne waits until Ellen exits to continue.

"Well, my love, maybe this will be of interest you." His wife squints as if the passage she's about to read is written in tinier script than the rest of the letter. "Mrs. Harrison says right here that Mr. Little has written something in the *Advertiser* about that land assessor – what was his name? – Mr. Black or was it Brown? Anyway, seems he's been accused of showing around official papers that should've been kept confidential."

Several sheets of music cascade to the floor. Annie initially pretends they've fallen by accident, but quickly drops the facade when George

stamps his foot. She hastily sweeps up the fallen sheets and returns to the melodeon.

An irritated George turns back to his wife. "I'd have thought Mrs. Harrison would mention the assessor's name in her letter. I'm a bit surprised she didn't."

Assuming she noted anything even remotely relating to the assessor. George has his doubts. He could demand to see the missive so that he can verify what his wife is telling him, but that would spark a war and he's not in the mood for doing battle with his wife this late in the day. Instead he notes this is the second time today his wife has challenged him on the same matter. "You're in a funny mood today."

Anne drops the letter to her lap. "No funnier than most, my love."

"Something the matter I should know about?"

"You mean aside from the local women not accepting me into their affections?"

Walked straight into that one. "Just takes time."

Ellen is back and this time she's carrying a plate of hot meat and the crock of butter he'd sent Laban to fetch. George looks to the kitchen door, but no, Laban isn't following. Where in God's name is that dawdling boy? Nothing complicated about walking to the creek and back. Even a simpleton could do it and Laban is slightly above that. Or maybe he isn't. Did George really need to specify that Laban return to his father's presence along with the crock? Had he sent Annie on the same errand, she'd have bounced back here in minutes and she's six years the younger of the two.

Ellen's signal cuts short George's internal rant. He allows his wife to herd him into the dining room along with their daughter. Not that this lessens Anne's griping. "How much time? It's been nearly three years during which I've invited them for tea every chance I get. I've also hosted quilting bees and socials and for every one I supply more food than the entire island could possibly eat and none of it makes a stitch of difference." Anne gives the table a sound rap. "I even brought a fresh-baked pie to Eleanor Bryan the other day and you know what that wretched woman said to me?"

How could he possibly? George shakes his head as he pulls out his wife's chair and beckons her to sit.

"She said, 'Best not pass your servant's baking off as your own.' She wouldn't look at the pie let alone accept it. Instead she sent me on my way with some comment about Annie being more trouble than most mothers could bear. Can you believe that?"

Yes. George has no difficulty whatsoever believing that his daughter could bring a mother to tears. Seen it many times himself. And, if she's being truthful, his wife would have to admit she has no difficulty believing the same. George tucks his wife's chair under her as she artfully arranges her skirt around her hips. "Best just let her be."

Laban stumbles into the room. George considers caning him right here and now over his tardiness and the insolence it implies. But he quickly decides that his wife's mood is trouble enough for one meal. He'll punish Laban later. When his wife is out of earshot. And eyeshot. And mouth-shot. Lord only knows when that will be.

George motions Laban to his customary seat across from Annie and heads for his own place at the head of the table.

Anne's frustration continues to swell. "It's excellent advice, my love, but you know I can't do that. Have you seen what Mrs. Bryan wears? She only has the one dress and it's fashioned from flour sacks, of all things, or at least it once was. Now it's made mostly of patches and mends. I brought her some of my old clothes not three weeks past and she behaved as if it was beneath her to accept them. How does that make sense?"

How does it not? "Some women have pride."

Anne slaps the table. "We all have pride."

It would be pointless for George to argue. He settles in opposite his wife, trying not to notice she hasn't stopped fiddling with her rings since sitting down. "And her hair is so wild I'd be surprised if she even owns a hairbrush. I think she just spits on her fingers and combs them through the tangles. I've heard some women do that, I just never thought I'd meet one of them."

No one moves or speaks or breathes. They're all thinking the same thing but no, Anne hasn't even come close to running out of steam.

"That's not even the worst of it. When I brought Eleanor my clothes, I glimpsed a multitude of bruises around her neck and wrists that looked very much like a man's fingers. They'll be her husband's, unless I miss my guess, or possibly Charlie's. They're each as bad as the other. Tell me you asked her about those, my love."

"You know I did."

"And she said they were caused by her labours, right? There's no chance. We all do more or less the same chores and yet she's the only one who ever wears black and blue and green on nearly every visible part of her body. It's a travesty. That woman will be dead before long if no one does anything to stop what's going on over there. Mark my words."

George would rather not. He's growing weary of this conversation. Actually, he was weary of it the first time they'd had it more than two years past and it hasn't picked up any shine in the dozens of repeats since. Seriously, what does Anne want him to say that he hasn't already said? "Done my best. Can't force a woman to accept help who doesn't want it."

Like hell he can't. But he won't. Not this time. Not when the stakes are so low. And certainly not when Annie and Laban are fidgeting. With their fingers. Their cutlery. Their clothes. He'll have to stick them in cages if dinner isn't served soon.

But Anne is ignoring her children. Actively. Stubbornly. She leans towards her husband and volleys a whisper. "Still, my love, you've got to try."

"Not right now I don't." And he means it. George doesn't need all this aggravation at the dinner table. He wants to relax his mind and organize his thoughts. If he doesn't, tomorrow's trip to the north lots will be a complete waste. All it takes is a forgotten tool or a mistimed deed. "I've tried. You know that to be true. I've offered her shelter on many occasions. I even offered to book her passage back to Erin so that she can be with her kin. But Eleanor has made it clear those things would only cause her more peril. I even went so far as to pay Charlie's fine, as you yourself insisted, so as not to cause that family financial hardship in addition to the public shaming the boy so rightly deserved. I get no more for my efforts than you do. And I've risked far too much trying to help a woman who clearly doesn't want my help, at least not as much as

you want it for her. If Bryan ever finds out what I've been up to, there's sure to be blood. Is that what you want?"

Sometimes he thinks it is. And yet, truth be told, George would have paid Charlie's fine without his wife's insistence owing to Laban not being forthright about the horses having trespassed into Bryan's pasture. That was Laban's doing and the boy rightly deserved a beating for the carelessness that led to the breach, even his father must concede that.

George glares at his son, then he glares at Anne, who interlaces her fingers and gestures for him and the children to do the same. Finally, They bow their heads. "What I know, my love, is that Eleanor Bryan is growing old before her time. My word, I've never seen a woman look so ancient unless she's been on this planet eighty or ninety years and I know for a fact she's only a few months older than me. It's such a waste. You can tell from her bones she used to be beautiful."

George sits silently while his wife spends grace praying for Eleanor's eternal soul. Exhaustively. And exhaustingly. When she's finished, he changes the subject to one he hopes will inspire glee. "Which one of you remembers skating on that ice rink the winter before we left Owen Sound?"

His daughter brightens. "I remember it well, Father. I dare say we borrowed blades from the Johnsons down by the hollow and when Laban stepped onto the ice, he didn't even get his second foot down before falling backwards. When the silly goose tried to get up, he fell again. He spent the whole day falling."

Laban passes the potatoes to his mother and accepts the basket of bread from his father. He's glowering. "That's what you remember? Because what I remember is that those blades were rusty and wouldn't tie onto my boots properly. You got the good blades, which is why you stood and I fell. There's nothing more to it than that."

Anne sees wisdom in throwing water on this argument. "Well, my darlings, I'm quite sure we can all agree that one of the best decisions we ever made was to buy those blades off Mr. Johnson before we left the mainland. They came in handy for sliding across these lakes in the dead of winter. I dare say it would've added twice the time to our journeys if we had to shuffle across the ice in our boots."

Anne accepts the bread from her son and passes the bowl of steamed spinach to her daughter. "Which one of you remembers the earthquake?"

This time it's Laban who brightens. "Me. I remember how the walls swayed and that doll – the one with the china face – it slid sideways off the shelf."

Laban is referring to the doll Anne has been dragging around since she was a young girl and not to any that had been given to Annie. China faces or not, not one of those had lasted a month. George looks hard at his whirlwind of a daughter. She won't be outdone by her brother. "I could see circles wobbling in my milk and I remember thinking that something in my bowl was suddenly alive, so I stuck my fingers clear down to the bottom to see if I could grab hold of it. Mother got so mad!"

Anne smiles slyly at George. "Yes, Mother did."

Laban eyes his plate and mumbles. "Then Father left Owen Sound without us."

Anne, George, and Annie all stare at him. It's his mother who speaks. "Laban, darling, those two things aren't related. If you think back you'll realize that they didn't even happen in the same year."

Laban mumbles a little louder, his eyes never leaving his plate. "But he did leave."

"Only to come here, darling. There wouldn't have been a home for us to live in if your father hadn't boarded here with a total stranger in order to get the roof up and the walls on."

Not necessarily in that order, George thinks, as he shoves the bowl of caramelized onions into his son's hands and waves his wife into silence. She can defend him when he's dead. Until then, he'll do it himself. "Wasn't the hardship it could've been. Sloan not only took me in as a boarder, he helped build this place for reasonable wages. Good man. Honest. Hardworking. Fell behind in his own labours to make sure I'd be able to bring you all here before that first snowfall." George pauses and smirks. "Can you imagine how things would've turned out

had I roomed with Porter instead? You'd all still be squatting in Owen Sound and this house would be nothing more than a dream."

Or a nightmare. But everyone laughs, his wife the hardest. "That is so true, my love. With all those children running around, it would've been chaos. How many of the little ones are there, anyway? Eight? Nine? Good heavens, there are so many I can't keep track of their names so I just call them all John, even the girls."

More laughter erupts. Only George is grim. He slathers butter onto a thick slice of bread. Gloom always follows any mention of that ingrate Porter. Even when he's the one who mentions him. The man needs to be removed from the planet once and for all. The sooner the better. Should've done it today in the barn. No good can come of letting a man like that think he can match his betters. "The father can't even sign his own name. Got to use an X. Shameful. Won't never be anything more than a labourer without knowing his own name when he sees it written on a piece of paper. No end to the misery that'll cause him in the long run."

Anne sees fit to protest. "May I remind you that Mr. Porter owns his own land, my love? I believe that makes him a landowner, not a labourer. It's an important distinction that's best not forgotten."

George fists his cutlery. Anne is all fire today. He'll take her to task for it later when the children aren't around. Or the servant. He takes a generous bite of buttered bread. Then another. Out of the corner of his eye he spies Ellen hovering by the sideboard. Ostensibly she's arranging a plate of biscuits and two berry pies, but her silence combined with her molasses-like slowness alerts him to the possibility she may be eavesdropping. He raps the butt of his knife on the table. "Tell me, Ellen, you been hearing any noises at night?"

Ellen turns to her master, wariness straining her features. "What sort of noises, sir?"

"Horses, carts, the sound of voices or labour. Anything that might suggest someone or a couple of someones may be stealing water from our creek under the cover of darkness."

Ellen can't hide her relief and, to her credit, doesn't try. She carefully reviews her memories. "No, sir. Nothing like that. Hear the wind sometimes and the crickets and the frogs, but no grunting nor snorting nor cursing nor any other noises such as men make when they do anything more taxing than staring at their own feet."

What an odd way to put it. Not that George was expecting normal from a girl who just last week threw rocks at a star she judged to be winking at her. He tries again. "Not seen anyone moving around in the moonlight? Maybe going to or coming from Bryan's place?"

Ellen shakes her head. "No, sir. Only the ghosts."

George lays down his knife and considers not pursuing his enquiries further. Then he asks a question he knows in advance he'll regret. "Which ghosts would these be?"

Ellen gestures northward. "The ones that live in the bush over yonder, sir. Seen them more times than I can count. They're bright and wavy and when you asked about sounds, I was trying to remember if they make any. I mean, in my head they scream, but I don't think anyone else can hear that."

George reminds himself that Ellen hasn't volunteered any of this. He asked and she'd been duty bound to reply. That makes the folly his. "I see. Well, I'm sorry to hear about the screaming. I hope you won't be hearing it further."

Ellen looks placated. Then she looks alarmed. "No sir, that's not a good thing to hope for at all! Do you not know that ghosts steal the souls of the recently departed? It's only when they capture them that the screaming stops."

Good Lord, what an imagination this girl has. George finishes his bread and pushes back his chair. He's had more than enough of this foolishness. "I'm wondering if there will be tea with dessert. I don't see any laid out."

Ellen looks troubled. "I can see you don't believe me, sir, but I've lived on this island longer than everyone hereabouts and I know more about these ghosts than anyone still living. When they turn up, it means death is near. No truer truth than that."

No truer truth. George considers this as he surveys the table. He's contemplating the platter of meat, but no. Best to leave the remainders for tomorrow's excursion to the north lots. "And there's no chance these ghosts you're speaking of are caused by swamp gas?"

"I believe not, sir. I believe they're caused by the sickness up at Mr. Boyer's."

Sounds reasonable in an Ellen sort of a way. It's Anne who protests. "Ellen, we've had more than enough of this nonsense for one meal. I've told you before, there are no such things as ghosts. God wouldn't allow it. If you'd truly taken Jesus Christ into your heart you'd know that. Now go fetch the tea, then clear the table. In precisely that order."

The thumping of Ellen's boots on the wooden floor underscores her dejection. Anne aims her fork at her husband. "Just so we're clear, my love, this whole thing is your doing."

George is amused by the suggestion. "How do you figure?"

Anne jabs the air with her fork. "It's simple, dear. Somehow you've got it into your head that Charlie Bryan has been stealing water from our creek based on nothing more than some argument Laban only half heard. It's likely that discussion was about something else entirely and yet here you are interrogating a servant. Worse, my love, you're expecting her to give you answers that conform to the conclusions you've drawn in your head. That's no way for a lawman to behave, not even a retired one, if you don't mind me saying."

George rearranges his utensils in an attempt to diffuse his mounting rage. "The best way to discover the proof of a crime is to ask questions of those who might be able to provide it. That's the very definition of how a lawman should behave."

"I understand, my love. And let's say Ellen provides you with the proof you're seeking. What will you do then?"

Isn't it obvious? "Then I'll act."

Anne leans forward, still pointing her fork. "What you mean to say is 'Then the law acts.'"

George shakes his head, which admittedly isn't the best way to placate a woman brandishing cutlery. "I mean what you heard."

Anne retracts her fork, placing it precisely one thumb-width from the edge of her plate. Then she lays her palms flat on the table and spreads her fingers. "George, my love, I revere you almost as highly as I revere God, but I would be remiss if I didn't remind you that you're not the law up here."

Remiss works fine for him. "You're reminding me of nothing I don't know, but they've got a revolver over there and pretending they don't isn't going to change the facts to what you want them to be."

Anne presses down on her hands as if preparing to rise. "It's not about changing the facts, my love. It's about what you're intending to do about them."

Plenty. "This isn't the first time I've faced the threat of violence. I know what needs doing and I know how it needs to be done. You're going to have to trust me on this. My wits haven't failed me yet."

"No, dear, but they have come close."

Laban and Annie have been looking from one parent to the other as they follow each volley of this dispute. Now they're blatantly staring at their mother. As is George. All are wondering the same thing. "When?"

"You know when, my love. What was that murderer's name? The one who plunged into the river by the jailhouse and almost escaped when you were bringing him in for questioning."

That old chestnut. "Hall. His name was William Hall. What a sorry character he was."

Anne lifts her hands from the table and drops them in her lap, apparently having thought better of rising. "He may have been a sorry character, but he had the gumption to go for his gun when you tried to arrest him, my love. If you hadn't secured it at the last possible second, I dare say that would've been the last of you."

George waves off his wife's concern. "His arrest was never in doubt."

Anne's hands are back on the table, only this time when she presses down, she really does rise. "Although I'm sure that's probably true, I must confess it did concern me a little when I learned that at one point Mr. Hall's son held the gun on you while Mrs. Hall secured your wrists

with your own handcuffs. I'm just wondering, my love, where your wits were then?"

It's Laban who answers. "He didn't need them, not with such accomplished *assistants*."

Laban takes particular care with that final word. George turns on his son. "What do you mean by that?"

Laban blanches and looks to his mother. Not seeing a cautionary signal, he continues on in a voice that's just this side of fracturing. "Well, Father, what I mean is, you weren't the only constable in Owen Sound. There were others who could've assisted you. Instead you brought two men who between them never held a badge. There were lots of rumours as to who those men were and why you brought them with you on police business."

George should be putting a stop to Laban's word-flood, but it's rare for the boy to challenge him and he's curious how far his son is going to take this. "Go on."

Laban's voice is thin and tight and small. But oddly persistent. "They say Hall did dirty deeds for the higher-ups in town until one day he demanded money to stay silent about their misdeeds. Soon after that, a man was murdered in one of the boarding houses and the people Hall tried to blackmail accused him of doing it."

Laban has come remarkably close to the truth and that causes George to wonder who talked. Because someone clearly had. To his son no less. And that someone will have to pay for their treachery. "Is there more?"

Laban takes a quick breath. "Yes, Father. When you and your assistants grabbed Hall, word is he knew he wasn't going to make it to the jailhouse alive so he tried to escape. I never did hear the end of that story. Did he make it to court or did some tragedy befall him before that could happen?"

George leans in close to his son. "What do you think?"

Laban gulps. "Think too many people were saying it for there not to be some truth in it, Father."

Too many people. So his son didn't get his information from a single source. Well, doesn't that beat all? George stares hard at his son for

several seconds. Then he throws up his hands. "Not going to argue the point. But I have every intention of eating my dessert in peace. And since I can't very well dismiss Mother, I'm dismissing you. Go fetch the horses. And make sure Bryan's cattle are nowhere near our fields. Take the dog with you. And your sister."

Annie thumps her chair. "But, Father! Why me? I've done nothing to warrant being excused."

George thumps back. "I'm absolutely certain the opposite is true. I just haven't heard about it yet. Consider this your punishment for that. Now go."

Annie looks like she's going to raise a ruckus, but her brother beckons her to follow. On the way out, he turns back to his father, confusion lighting his face. "Excuse me, Father, but since when do we bring in the horses at night?"

"Since tonight. Got a feeling something is brewing over at the Bryan place. Something not in our favour. Want to limit their options for mayhem. Don't ever question me again."

Laban doesn't move from the doorway. So George decides to move him. "Send Ellen in on your way out. I want that tea on the table in the next five minutes or she's going to find herself out on her backside with no letter to recommend her."

George leans back as his son disappears through the doorway. Then he leans forward and bellows at the empty doorway. "Don't even think of heading for those fields without that revolver."

7

THE TREES BACKED THEM UP

Eleanor spits blood into the corner of the room. "You'll have to do a far sight better than that."

No, he won't. Despite her bravado, Eleanor is nearing her breaking point. A few more strikes and the truth will come pouring from her like water from a pump. Bill can almost taste it.

As he tightens the strap around his knuckles, Bill contemplates his wife. What a tragedy she turned out to be. The polar opposite of the angel she'd been in her youth. The moment Bill set eyes on her, he knew she was the woman to cure his sorrows. Strongest feeling he ever felt. Thought it would last a lifetime. Lasted a couple of years. Maybe three. Now she brings his soul to ruin.

Bill slathers birch syrup on a hunk of stale bread and stuffs it into his mouth. Then he licks his fingers. The bitch still hasn't answered his question and he's growing tired of waiting. "Well?"

Eleanor's back is to the wall and her knees are tucked tight against her chest. Her voice is an anvil. "I can hardly say as fact a thing I know not to be so, husband."

Still with that. Is she really going to force him to beat her a third time?

By the looks of it, yes. Eleanor's eyes are fixed on the door. Doesn't take a genius to figure out she's plotting to make a dash for the woods the moment Bill lets his guard down. So guess what he isn't going to

do? "No good will come of you pretending ignorance, woman. You know when Amer is going to show his deceiving face next or you have an idea. Tell me and this whole thing ends now. Keep speaking coy and your bones will break as surely as winter twigs under my boots. Your choice. Make the wrong one and you'll be lucky to see the light of the moon. Art too."

That got her attention. Eleanor flicks her eyes loft-ward. Bill follows the flick and glimpses Art peeking over the edge of the raw boards. It's not like he didn't know the boy was there. Art had scampered from under the table like a frightened squirrel the moment Bill began striking the strap against the wall. Coward. Just like his momma. Well, a few months out in the fields will toughen the boy up. Toughened all the boys up. Gave them the fire they need to survive in this world filled with villains and traitors and English. Was his duty as a father to make sure that happened.

Now it's his duty to make sure other things happen. Bill catches the flash as Eleanor signals to the boy to duck out of view. Just as well. Bill can't deal with them both and his insolent wife is presently the one in greatest need of correcting. He leans down and bellows. "You're really going to make me come at you again, aren't you? You and your wicked ways. Not even the sense to save yourself. Well, so be it. A secret kept is a whipping earned."

Eleanor locks eyes with her husband. "I have not a single secret worth calling by that name, not from you nor anyone else I should think."

Liar. "You can protect yourself or you can protect Amer, but you can't protect you both. Neither of us is going anywhere until you speak true. So say it straight and say it now. Can't save you from your wickedness if you hold back."

Eleanor snorts, but says nothing. Damnable woman. Bill grabs the bowl of steaming fish from the table and cradles it in his arm. He raises his eyes to the ceiling. An hour from now, moonlight will flood through the gaps between the planks, striping everything silver and black. The colours of doom. Christ. What's become of his life? "Was lies that brought me here."

Bill presses fish into his mouth and looks down at his sad excuse for a wife. A thick ribbon of blood streams down her forearm. And she's snarling like a cornered weasel. "That's not down to me, husband."

"Did I say it was?"

Bill crams more fish into his mouth, chewing and speaking and swallowing more or less simultaneously. "They promised me work if I got on that ship in Londonderry. Knew it was a lie. Had the feel of it. But I could see no other way to get away from that vile stench. And I needed to get away from it. So many bodies rotting in ditches and fields and roads. Couldn't walk a mile without tripping on another. Putrefaction was everywhere. Couldn't escape it without leaving Ireland behind."

And that was like leaving his soul behind. Bill tries to cough the thought away. Eleanor, for her part, tilts her head like a confused dog. "This again? How many times have I heard this same sad story? I would surely not be speaking false if I were to say it's been a thousand or even ten thousand times. Nor would I be risking damnation if I were to hazard that it's every blessed time whiskey hits your sinner's tongue. Such a man you are, always moaning about the past like somehow the famine and the corpses and the despicable English were about you now. I recall not a time when you blamed the sky for your troubles, but I'm as sure as the Lord is merciful that's yet to come."

Harpy. It's clear she's not getting what he's saying. Never has. But then how could she? She would've had to have witnessed the horror firsthand to know what he's talking about. Even then it'd be hard for her to understand what he himself could not. That God had turned on the Irish. Struck them in the one place not even the English had dared. Broke them. Crushed them. Not a single prayer answered. "Every potato we pulled from the ground was the finest any of us had ever seen. We were proud as kings. But then those potatoes – the ones that were going to feed us and clothe us and pay our rent – turned black on the ground like nuggets of rotting coal. Couldn't believe our eyes. Or our fate."

"Ah, yes, the potatoes. I nearly did forget the high place those dastardly vegetables have attained in your drunkard's tale. We grow them year after year, mind you, and eat them more regular than most everything

other than fish, not to mention selling the excess to whatsoever neighbours will have them. You don't never moan about the blessed potatoes when they're lining your stomach or your pocket. 'Tis the drink that makes you speak ill of them now."

Bill picks at a fish bone lodged between his teeth. What kind of woman listens to such misery and doesn't offer a soothing word? The sort his momma warned him against. Should've known from the outset Eleanor's beauty was a trap, but he'd made the mistake of thinking this woman was an angel. A lie his eyes told his brain. And look where it's led him. Exactly where it leads all men. To ruin. Might as well say it bold. "Was lies that brought me to this island."

Eleanor digs her fingers into the dirt floor like some feral beast preparing to thrust itself into the air. Once again she spits, this time in Bill's direction. "It was no such thing as that."

Her voice is a club. It knocks Bill sideways, but only for a moment. He hurls the now empty fish bowl at Eleanor's spiteful head, missing to the left. The bowl thuds to the dirt floor where they both stare at it as if expecting it to move on its own. It's Bill who breaks the spell. "Was a lie all right. Biggest one ever told."

Eleanor digs her fingers even deeper into the dirt. "By who? Speak the miscreant's name or say no more on the matter."

"The government, that's who."

Eleanor looks relieved. Clearly she'd been expecting him to land the accusation on her. And, to be truthful, that's what Bill had been planning to do. Only then his thoughts had swerved like a stream rounding a boulder. And his mouth had gone with them. "We'd still be farming that parcel in Erin had it not been for that infestation wiping out our crops. Couldn't barely earn enough to keep up the lease on the land let alone afford the basics. Said it was a midge that caused all that devastation. A midge, can you believe it? Sounds like a low-bred woman." Bill wipes his palms his shirt and smiles to himself. "Acted like one, too."

Eleanor doesn't acknowledge her husband's joke. Not a half-hearted chuckle. Not a raised eyebrow. Not a suppressed grin. Nothing. Instead she looks bored. Like she's heard this all before. Like she's lived this all

before. Like she's not in the mood to be living it again now. Well, that's too damned bad. "Then the government promised cheap land on this here island. Looked like the break we needed. Felt like it, too. The advertisement clearly said 'farmable' like it was proven fact. Was no such thing. Filthy lie. And the trees went along with it. I ask you, since when do maples not mean good ground?"

Eleanor releases the floor. "So you're saying the trees lied to you, husband?"

Damnable woman. "No, woman, I'm saying the government lied and the trees backed them up."

Eleanor snorts.

To think he'd once thought her an angel. Is this a sound an angel makes? No, and neither are the next sounds that emanate from this definitely non-angel's mouth.

"That's more ridiculous than most things you say, if the truth is being told. I myself have been on this planet near to fifty years and not once has a tree ever said a single word to me. Should that ever happen, I pray that the Good Lord grant me the wherewithal to head into the bush and trouble my family no further."

Bill punches the tabletop, but Eleanor forges ahead. "Poppa did often say that whiskey and a low mind were the most dangerous of combinations. There's no better proof of that dear man's wisdom than the nonsense that's just now spewing forth from your lips, but since you've started in with the spewing of it, tell me, my wise and whiskied husband, what did those talking trees say that could possibly have led you so far astray?"

"Not a goddamned thing and you know it. They lied by growing in poor soil when they only ever grow in good soil damn near everywhere else in this godforsaken country."

Eleanor spits on each of her fingers in turn. "The trees can hardly be to blame if you read their meaning wrong."

"You saying the blame is mine?"

Bill watches Eleanor spit-clean the dirt from her fingers. There's a thud up above and Eleanor's gaze shifts briefly to the loft, then back to

her husband. "I'm saying not a single farmer worked this land ahead of you, so it was down to you to determine through your labours if the ground beneath you could be passably worked, husband. If that speculator had been prone to falsehoods, he would've demanded a far greater sum to compensate for his devious portrayal and then where would we now be? Up north of the island in bush so thick it'd take a day to clear an inch, that's where."

Eleanor, as always, is missing the point. The only real question is, is she missing it on purpose or is she missing it because she's not capable of getting it? Whichever it is, she isn't cutting him an inch of slack.

Eleanor leaves off cleaning her fingers. "If the truth is being told, husband, this here today is typical of you. First you hit the bottle and then you get to feeling sorry for yourself. Granted, this is the first time you've ever blamed trees for your own fool decisions, but it's nice to know that fate and God and the English don't occupy the entirety of your thoughts. The only lies in any of this are the ones you tell yourself daily as if a billion lies could somehow ever equal the God's honest truth."

Eleanor has a way of placing daggers in her words and aiming them at arteries. Still, it's Bill's choice whether he allows himself to bleed. "And exactly which lies would those be, woman?"

"The ones where you tell yourself each and every day you're not a failure at the only thing you ever set about doing. You must surely admit that's a pretty big one."

And that's a pretty familiar accusation. There was a time when it would've gotten him riled. More than riled. It would've sent him over the moon. But not now. Now Bill deflects her words like bats in the night. Just Eleanor being Eleanor. Which reminds him. Bill turns towards the smoky stove. "Fair guess the potatoes are ash by now."

Eleanor tears a strip of fabric from the hem of her apron and uses it to bind the wound on her arm. "A wise man would've considered that before starting in on me."

Bill should haul Eleanor to her feet. Make her clean up her mess while berating her for the waste. But there's little point. She wouldn't accept the rebuke. Nor would she take steps to set things right while he

remains in the room. So he stomps over to the stove and slaps the pot sideways. It hits the floor with a satisfying sputter. Bill clucks his tongue as he turns back to Eleanor, only to catch sight of her inching towards freedom. No bloody way. He snatches the crate from where it lies abandoned under the table and plunks it against the door. He'll sit here like a sentry if he has to.

Eleanor backs away. As she should. She's not the one in charge here. Best she remember that. Bill lifts his foot and peels off a disintegrating sock. He hurls it at Eleanor. "Darn this." He switches feet and yanks off the other. This he also chucks at his wife. "Both by tomorrow."

Eleanor doesn't bother deflecting the poorly aimed missiles. Not when she can let loose another dagger. "If I had but a needle I would do it right now. Alas, the last one I had flew from my apron when you were swinging that strap. There is little hope of locating it, for a needle in the dirt is no easier to find than one lodged firmly in a haystack. Charlie will have to fetch another the next time he ventures forth to Michael's Bay. If the Lord is truly our Saviour, the mill boys will take some mouldy oats in exchange for it. That, husband, may be the only way we can afford such a luxury as that."

Bill slaps the tops of his knees. Does this woman never quit? "Plough needs a new blade and you're talking to me about trading grain for a needle? Would that be one kernel or two?"

Bill hears the hysteria in his voice. The things this woman says. Incredible. It's like arguing with poultry. "You need a needle, woman, you borrow one from a neighbour."

Eleanor guffaws. "From which neighbour do you propose? Eliza Porter seems a proper candidate, I suppose, if you don't mind it getting around the neighbourhood that you can't so much afford the price of a needle. Or what about Anne Amer? I shouldn't imagine that a high-status woman such as that would ever deny a request for charity, although I could be wrong in my thinking. Maybe I should confirm the truth of it with her husband the next time he stops in."

Bill launches himself at Eleanor, the strap raised high above his shoulder. This bitch has tested him for the last time. And she knows

it. Eleanor scrambles for the ladder and starts hauling herself up to the loft. She doesn't make it. The strap comes down full force on the back of Eleanor's legs, causing her calves to spurt blood and her feet to slip from the rungs. She dangles from the ladder as Bill gathers the back of her dress in his fist. It rips when he tries to pull her off so he grabs her skirt instead. It remains intact. That clinches it. Eleanor won't be getting away from him. Not this time. This time he'll finish what she started.

Only then the cabin door bursts open, sending the crate flying towards the far wall. Charlie rushes in, his eyes darting every which way. When he spots his poppa, he blurts the reason for his explosive return. "Poppa, Amer's horses are in our back field."

Bill stops in his tracks. He absorbs what his son has said, then lowers the strap. "How many?"

Charlie's eyes continue to flick around the room. "Just the two, Poppa. But it's the best two. The ones he brought down from Little Current this past month and paraded along the government road like they were made of gold."

Bill releases Eleanor's skirt and steps towards his son. The answer to the next question is critical. "In the leased field or the other?"

"The other."

Just as he was hoping. Bill nods slowly. It's not often he gets the upper hand on Amer, but he surely has it now and he'd be a lunatic not to press his advantage. He tightens his fingers into fists. "Then the villain is stealing our grain by way of his horses' stomachs and we have the right to claim those thieving animals as our own."

It's clear Charlie has been thinking the very same thing. He points his thumb over his shoulder. "Do you want me to fetch the horses? I could hide them in the bush or maybe lead them down to Boyer's for safekeeping until this thing with Amer plays out."

Bill is shaking his head. "Got the sickness at Boyer's place. Best not to lead anything that way until someone catches sight of Boyer's kin either out on the road or stuffed in a box."

Charlie's eyes snap to the loft. It doesn't take much for Bill to guess that Art is once again peeking over the edge. A signal passes between

the two boys that Bill doesn't know the meaning of. He could demand an explanation, but no. There's no time for distractions. Not when a battle is about to begin. "No question of you fetching the horses. The law allows for it. But let me think through the particulars so we can stay in control of this thing for as long as possible. Know already that Amer will go for the law just like he did the last time his horses were in our fields. No, we must act against him before he acts against us. Let him be the one assessed a fine."

Bill presses his fingers to his temples. There'll surely be consequences to any action they take beyond leaving those horses be. Big ones. At least Charlie had the rare good sense to seek counsel before snatching the unexpectedly snatchable horses. Any other day he would've grabbed them, only admitting to what he'd done after hellfire started raining down.

Bill fixes his eyes on his son. "What do you think Amer will do when he discovers his precious horses are no longer in the field where he left them?"

Charlie cocks his head. "We already know what he'll do, Poppa. You said as much yourself, he'll storm over here blustering about how he's going to set the law on us, like Boyd is a dog that barks at his command."

Charlie stops and reconsiders. Excitement lights his face. "Hell, I'll be surprised if we don't see him sneaking across the field in the dead of night to steal back his horses while we sleep. Moon will be bright enough for it. Won't need no lantern."

Bill stomps over to the table and rips a chunk of crust from the raisin pie. He stuffs it in his mouth and chews slowly. The boy is correct. That's exactly what's going to happen. And that's what they're going to have to prepare for. "Sure you don't have that pistol?"

Charlie's face hardens. "Doesn't matter how many times you ask me that, Poppa, the answer's always going to come back the same."

Bill digs out another stretch of crust. He rams the rancid pastry into his mouth, then lowers his sticky hand to the handle of the hunting knife Eleanor had been using to prepare dinner. "Then we'll have to do this the hard way. Fetch them horses quick as you can and rope them to the corral fence. They'll be easy to spot there." Bill nods to emphasize his

words. "We'll need more than our fists. Axe, clubs, knife. Maybe even chains. I'll gather what I can while you snatch the horses. Time Amer learned a thing or two about bush justice. When we're through with him, he won't be in any shape to call in the law."

Charlie's face is as bright as a moonbeam. Excitement ripples through the air. Only then a voice flattens it like a pancake on the floor. "Leave them horses where they are, you ignorant fool. It's time you learned to recognize that while your poppa may have a head for destruction, he has no such thing for strategy."

Eleanor. That does it. Bill marches over to Charlie and jerks open the door, shoving the boy through it before Eleanor's treachery has a chance to sink in. "Horses. Now. Meet me by the corral as soon as you can get there."

Bill slams the door and turns back to his wife. "Too late by far, woman. If you wanted to protect Amer from a gruesome fate, you should've answered me straight when you had the chance. Instead you took the beating. Your choice. And now, no thanks to you, I have the answer I was seeking. This whole despicable affair is going to be settled tonight in our favour, so you best find a way of living with it."

But Eleanor isn't going down to defeat. Not without putting up a fight. "I've lived with worse, for I've lived with you these many years. There's nothing on God's green earth that could possibly be worse than that, as the Lord surely knows. But might I remind you, dear husband, that if you commit violence in the act of stealing a neighbour's horses, the law will surely put you in jail so long the few teeth you have left will rot inside your mouth."

Bill uses his sleeve to wipe remnants of pie from his face. "Don't need you to do my thinking for me. Never have. And I got no fear of the law. The way I've got it figured, the only authority Boyd has when it comes to my land is that which I give him. And I'm not about to give him any. Why would I? That no-good scoundrel has a selective way of applying the very laws he's meant to uphold. A thing is either right or it isn't. A man can either tell the difference or he can't. Boyd can't. Given him enough chances to prove the opposite."

Eleanor is nodding, although it's clear from the expression on her face that it isn't because she's agreeing with him. "So now Boyd is the problem, is he? I seem to reckon him not pursuing you over that fire that burnt clear through Amer's back field. That was never an accident, as any idiot could rightly see, husband, and yet your person is not now in jail. Nor, by some mercy, were you fined. Boyd's selective application of the law has been more friend to you than enemy and not just on that occasion, neither. Would you like me to run through the list?"

Bill grabs the hunting knife and stabs it into the table. He's got no time for this. "Not much of a list when matched against Amer's misdeeds."

"This would be the same George Amer who saw fit to pay Charlie's fine on account of our boy being in the right for beating his worthless son."

"Fool woman. That's not why the ingrate paid it. Paid it so he could hold it over us when it came to make good on the lease for our field. Charlie told you as much not but an hour past. Did you not listen?" Bill shakes his head and mutters. "No end to that man's sins. Made a fortune from illegal lumbering and now it seems he's going to get away with it. At least that's what Boyd says. Claims the law's been changed to Amer's advantage. Could be lying, but I think not." Bill yanks the knife out of the table and flicks his thumb across its blade. "You may have your list. No doubt it's a long one. But nothing I've done comes close to matching Amer's misdeeds. And Boyd has looked the other way too many times for me to believe he isn't profiting from each and every one of them."

Bill watches as all this register on Eleanor's face. Then he watches as it unregisters.

"Enough with your nonsense. Boyd is not what you say he is, husband, nor is he doing what you claim he's doing. Those are wicked fantasies brought forth by a wicked mind. It's not Boyd's job to make law, as you well know, only to enforce it when it needs enforcing and most of the time it needs no such thing. It's the government who says what's legal and what's not. It's them you best be pursuing for changing a law against your interests, if we're telling the Lord's truth."

"And who around here is in tight with the government?"

Eleanor blinks up at her husband. "Lyon?"

Okay, yes. That's true. Lyon is known to make the government dance on the end of his string, but Eleanor knows full well that isn't the answer he's looking for. Let's try this again. "Lyon doesn't currently sit on a town council in a city not so far from here. Nor does he claim to be on speaking terms with the Governor General, unlike some I could name. Want to guess who does?"

Eleanor looks weary. "What you want me to say is George Amer."

Will wonders never cease? "That's right, Amer. No way the law changed on its own. It changed because Amer made whatever deal he had to for that to happen. And don't kid yourself. Amer may have done the deed, but Boyd found a way to profit from it."

Bill reaches up and yanks a coil of rope from its nail on the wall. It takes Eleanor a moment to realize what he intends to do with it. When she does, she grabs the ladder. "No."

Yes. Eleanor won't be getting away. Not this time. Bill binds her to the loft ladder. She wants to go anywhere, she'll have to take it with her.

Eleanor struggles against her fate for a good minute before going limp. Fortunately, Bill has learned from past battles that when Eleanor doesn't fight back it's because she's settled on a plan. Bill doesn't know what it is, but he can guess it has something to do with warning Amer of the tragedy that's about to befall him. She can try. But her bindings are tight and by the time she works her way free – or races across the fields with a ladder strapped to her back – it'll be too late. The deed will be done and there'll be nothing she can do to undo it.

8

AN UNSOUND PHILOSOPHY

Laban slouches into the kitchen as weary and aggravated and defeated as a boy can be. He tries not to notice the devilish grin lighting Ellen's face or the butter crock she's pushing towards him. He tries not to notice anything at all, but Ellen wouldn't be Ellen if she didn't pounce. "Butter needs setting back in the creek, young sir. Do me the favour and I'll have a treat waiting for you upon your return."

Laban blinks the house girl into focus, then blinks her back out. The truth is he avoids Ellen whenever possible, owing to her sly grins and girlish giggles, which he finds childish and troubling. She can't possibly think Father would ever sanction a romance. Nor is he interested in one. He would've thought the unsubtle way he plunked the crock on the table not quite an hour past, then sped back outside like a whipped horse, would've clued Ellen in. But Ellen doesn't clue in. She needs to be addressed bluntly and coldly and even then she only seems to half get a person's meaning. It's almost as bewildering as his banishment from the dinner table before dessert had been served. "What sort of treat?"

Ellen snickers and waggles her finger. "Won't be no surprise if I tell."

For pity's sake. "You didn't say anything about it being a surprise or I wouldn't have asked."

Laban's eyes flash around the room. He's hoping to see his sister, but no, all he sees is Ellen, ensconced in her usual chair at the far end of the kitchen table, polishing Father's boots. He's pretty sure that's not what she's supposed to be doing. "Father wants you fetched to the dining table. He says he needs his dessert served along with his tea. He specifically mentioned the tea."

Ellen drops the boot in her lap. She examines Laban's face and fails to find the answer to the question she hasn't yet asked. "What'd you do to get yourself dismissed from the table this time?"

Laban flushes. "I spoke the truth."

Ellen mock-sighs and shifts the boots from her lap to the table. "That'll do it."

She rises and looks set to assault Laban with some unbidden advice when Annie comes crashing into the kitchen. Laban looks past his sister into the winter kitchen, half expecting to see who or what propelled her in his direction. Seeing nothing, he scowls. "Curse it, Annie. What could possibly have taken you so long to get in here? It's not fifty paces from the dining table and yet I've had an entire conversation waiting for your grand entrance."

Annie picks herself up off the floor and dusts her skirt. "Two ants about the size of my middle finger. I was watching to see where they were going in case they were heading to a nest that needs killing."

Laban considers this. "And were they?"

Annie jumps up and spins, landing with a triumphant grin. "I couldn't rightly say, but I was watching one of them so closely I damn near had an epiphany."

Laban winces and again looks past his sister. Seeing no one, he swats the side of his sister's head, knowing she'd get worse from Mother. "Don't say damn."

"Silly goose, they can't possibly hear me."

This is true. Annie has to raise her voice just to be heard above the sizzles and thumps of the kettle that Ellen has finally, belatedly, set on the stove. "That's not the point. You shouldn't be thinking a word like that, let alone saying it."

Annie drags a chair over to the buffet and stands on it as she reaches for the top shelf, then hands down a pair of china cups. "What about the concept? Can I think about that?"

Laban takes the cups and sets them down gently on the table, then reaches up for the saucers. "God will strike you down if you do."

Annie's fists are on her hips. "I'm absolutely certain there are several people in this house who are in line to be struck down long before me."

Laban is trying to decide whether his sister is in possession of some dark knowledge that's somehow failed to find his ears. Probably, but now isn't the time to be engaging in little-girl games. Laban reaches back and makes sure Father's revolver is firmly secured to his waistband. "I'm not going to waste a thought guessing what that means."

As he gestures for his sister to climb down from the chair, he remembers the ants. "What kind of epiphany did you almost have that caused you to come flying in here like a spooked bird?"

Annie jumps to the ground and immediately sets to work placing the cups on the saucers and the saucers on a serving tray. "Well, brother, I looked too closely at one of the ants and realized it had a personality."

Laban pivots and heads for the door, grabbing the butter crock from the table as he passes. "The best thing about you talking is the relief that comes when you stop."

Laban kicks open the door. At the sound of his master's voice, Twist pops up from his favourite patch of grass, barking and bouncing and wagging his tail so energetically Laban wouldn't be surprised to see it detach. He kneels down to calm the excited dog. He can't have him racing around like a tornado when they approach the horses or he'll spend half the night trying to coax them out of the bush.

"Do you really think this will float?"

Laban half-turns. Annie has followed him outside and is standing in the hollow Laban has laboriously chipped out of a basswood log in an effort to craft his own boat. He shifts the butter crock away from Twist's curious tongue. "It'll float when I'm done and not before, so don't you even think of dragging it down to the creek."

Annie snorts. "Like I could."

Despite the snort, the look on his sister's face suggests the thought had crossed her mind. Annie leaps from the boat and tries to lift one end. "Besides, I'm absolutely certain I'll need Crispin if I'm to drag it any farther than the garden and I'm banished from leaving the yard until the sun sets on the British Empire, or so says Mother."

And Laban can imagine Mother saying it, too, but the only way to enforce such a punishment would be for someone to act as Annie's jailer and no one in their right mind would volunteer for the frustration of that. "Two days of your yammering and Father will say different. There's not one of us who doesn't know that. Even the horse knows it and his brain is the size of an apple."

If that. Laban rises and approaches the half-finished vessel. He runs his fingers over what will one day be the gunwale. Working at his present pace, it'll be winter before the boat is finished. "There's no concern about this boat floating so long as I can chip out enough wood without poking a hole through the bottom or sides. That remains to be seen." Laban nods to himself. "A lot of things remain to be seen."

Annie looks hard at her brother, then shrugs and skips towards the back fields. Laban considers shouting for her to hold up, but then decides it's best to let her go. There's not much trouble she can get into in the short time it'll take him to jog down to the creek and stash the crock, which he does. Then he sprints for the back fields, Twist barking and jumping all around him.

When Laban gets to the winter wheat, he slows. There's not much point in catching up to Annie. He knows where she's heading and he knows she'll tire herself out soon enough. It happens every time and every time Laban carries her back home. Tonight will be the only exception he can think of and that's because tonight he'll be able to flop her on the back of one of the horses. This option isn't usually available to him, since on every other night, the horses are left to pasture in the back field, making Laban's only real task to ensure that none of Bryan's cattle have crossed to their side of the property line. Rarely does Laban spot any bovine intruders and he suspects that's because Charlie knows his routine and waits until Laban has returned home to set loose the oxen.

It'd be just like that fool to believe Laban's father too daft to notice the shortened stalks or the hoof prints or the piles of dung. Or maybe it's just that Charlie doesn't think those things will stand as proof before the law. Who can say?

Surely not Laban. As he continues through the winter wheat, his inner voice nagging and nattering, mosquitoes start swarming in force. He waves away as many as he can and smacks dead the ones that don't heed the warning, but it's futile. The only way to get away from the evening mosquitoes is to hide under water or rub mud into his skin, neither of which are practical during his evening rounds.

Laban spots the top of his sister's head bouncing ahead of him as she crests the rise. If he doubles his pace, he'll catch up to her in a few minutes or possibly even less than that, now that his sister has come to an abrupt stop.

"What's up?"

No answer. Laban calls out a second time and again receives no response. He reaches back and checks for the revolver. It's not until he's pulled within a few steps of Annie that she announces what has brought her to a halt. "There's no one here."

Laban crests the hill and looks out over the back pasture. The sun is low and the sky is streaked orange and pink and yellow, but he can still see the entirety of the field. And he can see that Annie's right. The horses are nowhere to be seen. There's nothing in front of them but a sea of stump-infested hay that eventually gives way to the tangle of untamed bush.

No, no, no, no, no. This can't be happening again. Laban scans the tree line, hoping the horses have, for some blessed reason, wandered into the bush of their own accord, but no. He doesn't see any sign of them. However, he does hear a sound. It's faint and it's distant, but it's definitely there.

Annie spins to face her brother, snapping her hand out to the left. Twist immediately charges off, thinking Annie has thrown an invisible stick. Laban raises his finger to his lips, cautioning his sister not to say another word. Together they listen and together they hear the unmistakable sound of hoofbeats in Bryan's back field.

Laban hangs his head. He can feel the revolver pressing into his back. He doesn't need to check for it. He never really needed to do that. He raises his eyes to heaven and says a silent prayer. Then he addresses his sister. "Go home, quick as you can, and take Twist with you."

Annie says and does nothing. She just looks at her brother with a quizzical expression and, after a few seconds, finds her words. "Laban, please. You know you can't go over there. The Bryans hate us worse than God hates the devil. Remember what happened last time."

How could he ever forget? It was months before his ribs healed to the point where he could breathe with ease and still, to this day, he cannot swallow so much as his own spit without grimacing. But neither of those things erases the fact that the horses must be retrieved from the Bryans' land and he's the one who must do the retrieving. "I've got no real choice in the matter, Annie. And you've got no choice but to do as I tell you, so get on home and don't let Father know what you've seen here tonight. I'll have those horses fetched back to our field before anyone knows they went astray."

That sounds good in the saying. The problem comes with the doing. Still, he's not going to stand here arguing about what has to happen next, since it won't change a thing. "Go home now. Don't make me tell you a third time or I'll find a stick and beat the insolence clear out of you."

Laban's words come out gruffer than he intends and he's as surprised as his sister by how much he sounds like Father. This spooks Annie. She bolts towards home without once looking over her shoulder. Laban issues a sharp whistle and signals for Twist to follow. The dog is off like a shot.

As Laban watches his sister and his dog racing through the wheat, he draws a deep breath and prays he'll be able to get those horses back without encountering Charlie or Old Man Bryan. He has his doubts, but his only other option is to return home and explain to Father where the horses are and that they're likely there because he forgot to hobble them. That isn't much of an option. He'll get a whipping for sure, so he's resolved to do as the situation dictates and hope Father doesn't discover what transpired here this evening.

Laban checks the sky. It's as orange as he's ever seen it and the shadows engulfing his feet are the darkest of darks. He moves forward cautiously, listening for any sign he's getting closer to the wayward horses.

With every step, Laban feels dread rising a little bit higher in his throat. He knows full well where the horses are. He knew they were on their way to Bryan's corral the moment he heard their hoofbeats. It didn't take a genius to figure that out, since a horse moving under its own direction sounds very different from one being led. There's no question the horses Laban heard were being led and there are only two people who realistically could be leading them: Charlie or Old Man Bryan. Charlie is Laban's bet. The fielding of the livestock has always been left to him and there's no reason to believe today is any different.

Laban slows as he approaches the Bryan place, dread rising in his throat. He doesn't want to be here, not after what happened last time. His ribs ache just thinking about it. He rubs them, then reaches behind his back and tugs free his shirttail, draping it over the revolver. It's best to keep it out of sight so that it doesn't inadvertently spark a row. It'd be just like Charlie to see provocation where no provocation is meant and Laban doesn't want to be the cause of his own beating. His plan is to locate the horses and lead them away before Charlie realizes he's been there. What makes that possible is the horses, which are roped to the corral fence with Charlie nowhere in sight. Laban just needs to untie them, then lead them back home and all will be well.

Laban approaches the nearest horse and reaches up to pat the nervous animal's neck. With his free hand, he starts working the knot, but it's surprisingly tight and he's unable to pry it apart. He pinches and he rips and while he's doing this, he detects a subtle shift. His eyes snap front and centre.

Charlie steps from the shadows. He has a club in his fist and menace in his stride. Fear shoots up Laban's spine as he looks for the rumoured revolver. He doesn't see it, but that might only be because Charlie, like Laban, sees wisdom in keeping it concealed until the last possible second.

Laban swallows hard. "I'm just getting what's mine to get."

Charlie inches closer, gripping and re-gripping the club. "Not how I see it."

Laban wills the panic from his voice. "I'm not interested in how you see it."

A sly smile crosses Charlie's lips. "Not sure I care what interests you. Now get."

Laban can't do that. Surely Charlie understands this to be true. They both know Father too well to believe that when informed that the Bryans have captured his horses, George Amer will do no more than shrug and walk away. There won't be any shrugging and there certainly won't be any walking away. And when the law is finally called in, it'll be because someone is lying dead on the ground and, likely as not, that someone will be Charlie.

Charlie strikes the club against his own thigh. "You deaf or just stupid?"

Deep breath. "I'm thinking I need more choices than that."

Charlie tightens his grip on the club. "Life isn't about choices. It's about who's done what to you and what you're going to do about it in return."

Laban has no doubt Charlie believes this. If there's one thing he can truthfully say about Charlie, it's that he's always sincere in his belief that insults should be met with violence. "That philosophy doesn't seem sound. You might want to think on it some more and maybe read a better class of book. Those adventure stories you've been devouring are making you see the world in a way it can't ever be."

"I'll not be taking advice from the likes of you."

Charlie grabs hold of the top fence rail and rattles it, which also rattles Laban. He backs up, just a step, and immediately wishes he hadn't. Charlie is emboldened by what he rightly perceives is his opponent's weakness. "The way it looks to me is these horses have been in my fields, eating my oats. What I can't figure is why any horse would be in my fields, eating my oats, unless that horse rightly belongs to me. So I take it as obvious these horses are mine."

Talk about convoluted. If they were all to operate under that logic, Bryan's oxen would collectively be owned by every family within five miles. That thought clearly hasn't occurred to Charlie and likely won't. "How long did it take you to work out that lie?"

Charlie raises his club and slams it down on the fence. The horses bluster and yank back their necks, but somehow the fence holds. Laban can't say the same for his knees, which feel like they're slowly dissolving. Not that Charlie notices. "No lie about it. These horses are mine by right of law. Seized them with my own hands in my own field and you not liking it isn't going to hold the least bit of sway with the courts. So run along home and tell your poppa everything I've said here tonight. He got a problem with it, he knows where to find me."

Laban continues to stand his ground despite his weak knees and his trembling hands and his suddenly aching ribs. He can't face Father without these horses and he has to make that clear. "I'm not saying anything to no one. I'm not your errand boy."

"You are tonight."

That sends a chill down Laban's spine. He reaches back and grabs for the revolver, but his shirttail gets in the way. Charlie watches Laban struggle to free the weapon with something akin to amusement lighting his face. "What you got there?"

"A sore back."

Laban is surprised by the quickness of his own lie.

Charlie is surprised by nothing. He grabs the fence rail and hurls himself over it. "Going to be even sorer once I get through with you."

Laban is off like a rabbit, bounding towards the winter wheat. He has a decision to make. If he keeps heading straight, he'll soon have to leap two fences and crash through the creek to get within striking distance of home. If he dekes left, he'll hit the settlement road inside a minute. There he can pick up his pace considerably, but then so can Charlie, and there's no question of Charlie outpacing him. It's a gamble either way, so he mentally tosses a coin, then continues straight for the fields. He'll find out soon enough if that was the right choice. For now, he tries with all his might to block the sounds of Charlie's fast-closing-in

footfall. He spots the first fence too late to jump it and clears the top rail only because he dives over it at the last possible second. Charlie isn't so lucky. There's a thwack, a clatter, then a thud as the Bryan boy collides with the fence, then hits the ground. Laban staggers to his feet and trips forward, listening for any indication his foe is doing the same.

Charlie's voice comes at him through the darkness. "You're the biggest coward I ever laid eyes on."

Laban doesn't reply nor does he slow his stride. Charlie continues to call after him. "Think your poppa would've run just now? Think Sam would've? How about me? Not one of us would've taken the coward's way out because all of us know the trouble that finds us now will keep on finding us until a thing's been settled. Only a coward runs from what's his to face."

Laban reaches back and checks for the revolver. It's still there. This knowledge allows him to haul himself over the final fence with a mitigated sense of failure but, as Laban wades through the creek, he can't help wondering what he's going to say to Father. More importantly, when he is going to say it? Tonight? Tomorrow morning? Can this news really be left until dawn? Probably not.

As Laban scrambles up the opposite bank, he spots a lamp flashing and dimming in the kitchen window as Ellen passes repeatedly in front of it. Laban calms by several degrees. There's something about lamplight that always signals salvation to him. It doesn't matter whose house the lamp is in – his own or another's – when Laban sees lamplight, he can't help but feel safe even on a night like tonight and in circumstances such as these.

Laban swallows hard as he yanks open the kitchen door and finds Ellen greeting him with a plate of biscuits. He waves her off. With Charlie at his back and Father yet to face, he's got no time for pleasurable things.

Laban trips into the parlour and starts towards his parents' bedroom, only to veer away. He paces the full length of the room several times, trying to calm his thoughts enough to organize them into a story that won't diminish him in Father's eyes. What will it be? How's this:

The horses were hobbled. They were in their own field until Charlie came onto their land and led them away.

Laban's story doesn't have to be true. It only has to be plausible and it's plausible that Charlie would do something like that. The only person who can contradict his version of events is Charlie himself and the great George Amer won't take the word of a Bryan over that of his own son. Laban is almost certain of that as he heads for his parents' bedroom and knocks on the door. He hears nothing from within and is about to knock a second time when a grunt gives way to a creak. The door swings open and Father glowers at him in drowsy irritation. "Early day tomorrow. Better have a good reason for rousing me."

Good isn't exactly how Laban would describe it. It's best to just blurt it out. "Charlie Bryan has seized our horses."

Father is instantly awake. "Came onto our land?"

Laban's knees start to buckle and he reaches for the doorframe. "Not that I know of, Father. He says they were on his land, but I've got no proof his words are true."

And so the lie begins. George gives a perfunctory nod. "Knew this would happen. Said as much at the dinner table. A man can tell when a storm is brewing if he watches the skies long enough. Wait here."

As his father disappears behind the closing door, Laban hangs his head for a few seconds, then returns to the parlour. Less than a minute later, Father bursts from the bedroom tucking his nightshirt into his pants. His suspenders dangle at his knees. George spots his son loitering in the middle of the parlour and the look on his face is not one a son should ever see. It's something beyond disappointment. Disgust might be a more accurate description. "Chase you off or threaten you?"

"Both."

"He still standing?"

"Yes, Father."

"Didn't down him where he stood?"

"No, Father. Not on his own property."

"But you had the revolver with you as I instructed?"

"Yes, Father."

"Out with it."

Laban yanks the revolver from his waistband and hands it to Father, who sets it on the sideboard while he turns up the lamp's wick. The sudden brightness in the previously dim room is almost painful. Laban winces as his father turns the revolver over in his hands, inspecting it like a fine piece of jewellery. Then he hands the weapon back to his son and stretches his suspenders up over his shoulders. "Revolver is meant to be used. Best you remember that or you could very well end up in a pine box."

Laban nods, hoping this is the end of the discussion. Father reaches for the lamp. "Where was the old man when all this was taking place?"

Laban hesitates. He'd been too busy with the horses and Charlie and the prospect of another beating to consider whether Old Man Bryan was lurking in the same shadows Charlie burst from. He couldn't have been, for Laban would surely have noticed if that'd been the case. How could he not? "I didn't see him."

"Doesn't mean he wasn't there."

Laban can't dispute that. He can only watch as Father yanks open the sideboard's top drawer and plucks out his truncheon. Then Father heads over to the sofa, where he grabs the boots Ellen has polished and returned. He kicks them onto his feet as he stalks towards the summer kitchen.

As Laban follows, he feels compelled to volunteer a critical detail. "Charlie didn't have a revolver. He just had a mean-looking club and he wasn't afraid to use it."

George pauses at the entrance to the summer kitchen, but doesn't turn. "How do you know?"

Isn't it obvious? "If he had a revolver, he wouldn't have bothered to chase me across the field, not when he could've shot me from a distance and saved himself the effort."

George's back tenses. It's several seconds before he turns. "That how you see it? There was no revolver because Charlie didn't fire a shot?"

Laban shrugs, then nods. Yes, for better or worse, that is how he sees it.

"Then I guess it'll come as a shock when I inform you the reason Charlie didn't fire is because he and his ingrate father are setting a trap and you played right into it."

Laban says nothing. He hadn't considered this but now, as he thinks back through all Charlie said and did, he sees Father could very well be right. Laban slowly nods. His father, on the other hand, is shaking his head. "Charlie wanted you to scamper back here with news of his misdeeds so that I could be lured onto their property, where they'll be waiting in ambush." George points to the revolver dangling from his son's hand. "Shoot when I tell you. Not before, not after. At the exact moment I tell you. Nod so I know you understand."

Laban nods. For the second time tonight, a chill races down his spine. "Is it really a good idea to be walking into a trap?"

Father raises his eyes to the ceiling and mutters, "Not much of a trap if your opponent knows it's been set. Whole point of a trap is the surprise. No surprise, no advantage."

And yet the Bryans will have even less of an advantage if they don't go over there at all. Surely Father has considered this. "Isn't Boyd the one who should be taking care of this?"

Father snorts. "Boyd is powerless in a situation such as this. Only way we can use the law to get our horses back is by heading up to the Sault and filing a complaint. Too expensive by far. No, we have to re-claim our horses ourselves."

Laban glances down at the revolver, then reaches back and fits it into his waistband, wiggling it around until he's certain it's secure. "Charlie seems to think the law is on their side on account of our horses being in his field eating his oats."

"Charlie thinks the law is what he says it is. A boy's got to learn his place in the world sometime and Charlie Bryan has earned the right to learn his tonight. Just fire when I say. Don't waste your time worrying over whether it's right. I'm in a better position to judge than you."

Laban trails his father into the summer kitchen. His feet feel like they're encased in lead and his thoughts are rebelling mightily against the prospect of another encounter with Charlie. He can't possibly do

it. He's fairly certain something inside him will rupture if he's forced to face the wretched Bryan boy again so soon.

Not that Father notices. He grabs the hunting knife that Ellen keeps by the door and sets it on the counter along with the truncheon. Shoving his hand into his pocket, he fishes out a key and holds it in front of the lamp until he's certain Ellen has seen it. Then he sets it on the counter, gathers up his weaponry, and shoulders his way through the door.

Laban turns his gaze on Ellen in the desperate hope that help will come from that direction, but she appears frozen, a half-darned shirt gripped in one hand and a barely perceptible needle in the other. It's a safe guess she won't be lending him a helping hand. It's also safe to guess that the house girl knows what the key is for. Laban makes a mental note to charm the answer out of her later, then bats open the screen door and jogs to within a few paces of his father, who is marching towards the back of the property. This isn't the most direct way to the Bryan place, but even Laban can guess the reason for this circuitous route. The Bryans will be expecting Father to approach from the settlement road so he intends to surprise them by coming at them from the opposite direction. The direction of villains.

Laban doesn't like this one bit. He raises his eyes to the moon, which is a sliver off full. This makes their lantern-less trek across the back fields much easier than it normally would be. Still, Laban finds himself dancing around stumps and rocks as he struggles to keep up with Father. Soon they are closing in on the one place Laban was hoping to never see again.

"There. That's them all right." The horses whinny when they detect their master's stealthy but persistent approach. Father whisper-shouts over his shoulder. "Slower. Stick to the shadows. And soften your step. We could get lucky."

Laban doesn't see how, but he does as he's told. For naught. Bryan explodes from the shadows and plants himself between the Amers and their animals. That isn't a good sign, but it could be worse. Much worse. Laban searches the dark. It takes a good five seconds to locate Charlie skulking in the shadows beyond the corral fence. If there was any doubt

about this being a trap, it's laid to rest first by Charlie's clandestine be-haviour and then by Bill Bryan's caustic greeting. "Your lies have poisoned us all."

He shouts this at Laban's father, who raises a hand in caution. "Not interested in whatever this is. Just come to collect our horses. They seem to have found their way to your corral by means undetermined and it seems only neighbourly that I should take them off your hands before they become a nuisance."

Is he kidding? There is not one person within earshot who doesn't know what's going on here, so why pretend otherwise? Laban is flummoxed. He doesn't know whether to laugh or cry. He reaches back and fits the revolver in his hand, just to be safe. He won't do a damn thing until Father gives the command, but he's sure as hell going to be ready when that command comes, which, judging by the venom in the air, could be at any moment.

Old Man Bryan hammers his club into his thigh with enough force to bruise his own flesh, which strikes Laban as odd, but he's got other things to occupy his mind. Charlie is on the move. He approaches the fence and lays his hand on the top rail, readying to vault it for the second time tonight. Laban prays that won't happen, even if it does seem inevitable. Clearly he and Charlie are both waiting for signals from their fathers, the receipt of which will usher in a more violent phase to this confrontation.

Bryan's snort is returned by a horse. "Nothing undetermined here. You leased land from us for which you still owe money. Seems your horses have taken it upon themselves to volunteer as payment. At least your beasts are honourable."

Laban's father drops to one knee and scoops up a fistful of dirt, which he bounces in his palm as if trying to guess its weight. Laban spots the truncheon firmly gripped in the hand that's hidden behind his back and tenses as his father rises and positions his weight over his back leg. "Even if I did owe you money, these horses far exceed what that debt would be. So the only reasonable action is for me to walk these horses back home and for you to go inside to sleep it off. You reek of the drink."

Bill makes like he's considering doing as Father suggests, but only for a moment. His face hardens and he raises his club high, but before he can bring it down, Father flings dirt sideways into Charlie's face, catching the boy off guard. Charlie howls and buckles to the ground while the old man lunges which, ironically, puts him in the perfect position for Father to slam the truncheon into his skull. Old Man Bryan drops his club as he stumbles sideways, both hands pressed to his head as if dampening a ringing bell.

Father isn't satisfied. He pursues Bryan as wildly and as viciously as a man ever did. The truncheon flashes in the moonlight as it comes down on the old man's wrist, then his back and shoulder and spine. The air is thick with grunts as Bryan tries to shield himself with his arm, but that's just another bone for Father to break.

By now Charlie has managed to paw enough dirt from his eyes to join the fray. He hauls himself over the fence and stumbles to his father's side as Laban tries to will himself invisible in the hopes the Bryan boy won't see him as a target. It works. Charlie's inaugural blow collapses George's shoulder. Several more follow, all of them aimed high and all of them connecting with bone. Thumps and thuds and pops resound with alarming frequency. Laban panics. He cannot fathom how Father can withstand such a ruthless assault. He inches closer, more out of obligation than anything else. He has no intention of intervening. He doesn't want a role in any of this. He wants to run and hide until this lunacy is over, but his knees have gone weak and his thighs are shaking. There's no way he's going anywhere. His body won't permit it. So Laban raises the revolver and swings it between Charlie, who's battling Father, and Old Man Bryan, who's groaning on the ground. He doesn't know which one his target will be. That depends on Father's mood and the timing of the command. Laban's job is to wait, as if that's an easy thing to do in the present circumstances.

And then it happens. George thrusts Charlie backwards and swings for his ribs. This winds the boy. He drops to his knees where he catches a kick to the stomach and another to the head. George backs away, panting. "Down him, Laban."

The command is clear, but Laban doesn't move. Surely the fight is over. Both Bryans are on the ground and both are barely moving. Neither presents a threat, not in any realistic way. That makes Father the victor and the revolver unnecessary, at least to Laban's mind.

Only then Charlie goes and blows it by heaving himself up onto his feet and charging Father like a damaged, drunken bull. Damn that Bryan boy. Why couldn't he have just stayed down and let this fight end with them all still alive? Does he not realize what's at stake? Is he really that stupid or does he believe that he alone in this world is invincible? It'd be just like the fool to think something like that.

Laban points the revolver at the boy's bucking back. God, how he hates Charlie for bringing him to this. Things could've been different. They could've been friends, but who can be friends with someone who's constantly attacking? He deserves a bullet and yet Laban isn't pulling the trigger. He can't. Something inside him won't let him extinguish a life, even one as aggravating as Charlie's. So Laban watches helplessly as Father deflects a seemingly endless series of blows before pulling back his arm and delivering a mighty one of his own. This one connects with Charlie's head. There's a loud pop and a grunt as the Bryan boy hits the ground.

Father is shouting. "For the love of God, Laban. Shoot the boy. Then shoot his ingrate father. Now. Before either one of them can harm me more."

But Laban can't. Not now and not ever. He's the one thing Father has always feared he would be: a coward. It's as plain as the moon in the cloudless sky. Laban lowers the revolver, which causes George to roar and stagger over to his son, wrenching the weapon from his hand. The first shot hits Charlie square in the forehead. Even in the moonlight, Laban can see the dark patch suddenly appear above the boy's nose, the look of infinite surprise, and then the loose-limbed flop. Father swings his arm down to where Bryan is struggling to his knees and fires a second shot. Laban doesn't see where it hits. He only sees the old man sag to the ground as words gush from his mouth in a torrent of gibberish and random expletives. Then nothing.

Father waves away the revolver's acrid smoke. "Get the horses and lead them home. Then stand at the end of the lane until I come to fetch you. There's plenty of work yet to be done. I don't want to waste time wondering where you are."

Father yanks the hunting knife from his boot and hands it to Laban, who stares at it, blinks, then staggers over to the corral fence. He half expects Charlie to make a grab for his ankles as he stumbles past, but that doesn't happen. Nothing does. Laban isn't even sure Charlie's still breathing and he knows better than to check.

Laban steadies himself against the corral fence, watching as Father turns the old man over and pats him down. He's searching for something. Laban assumes it's a revolver, but he doesn't ask. He doesn't want to know. His brain is numb and his fingers are fumbling with the same knot that defeated him only an hour past. It doesn't occur to him to sever it with the knife and, it turns out, he doesn't need to. The knot loosens on its own, as if by magic. Laban stifles a sob. Why now? Why not earlier when it would've averted bloodshed? There's no answer. Not from God and not from his own soul. Laban mulls this as he leads the horses towards the settlement road. When he passes by the Bryan shanty, he hears a creak and turns towards it. The home's one and only door is slightly ajar. Whether that's by accident or design is unclear, but since neither Mrs. Bryan nor Art poses any realistic threat, Laban turns back to his purpose, his mind a swirl of too many conflicting thoughts for one boy to think.

9

STARING INTO THE DARKNESS

Mary Ann nudges her husband's shoulder a second time.

"What?"

"The door."

"What about it?"

"Someone's at it."

Sloan opens his eyes and stares into the darkness. He's listening, but he's also wondering why, in the good name of His Lord and Saviour Jesus Christ, Mary Ann always wakes him during his deepest sleeps. So there's a knock at the door that only she can hear, is there? It was the same complaint last Tuesday and that turned out be the residue of a fast-fading dream. Sloan stops straining. "Must be the wind kicking up. Go back to sleep."

"What wind? There's not been anything stronger than a breeze for weeks now. I dare say the wind has better things to do than knock at our door like a man with worry on his mind."

Sloan again listens and again he hears not a blessed thing. "You're imagining things. Go back to sleep before you wake us both beyond repair."

Sloan barely finishes his gripe when he too hears someone pounding.

"Still think it's the wind?"

He does not. Sloan grabs his shirt and pants from the chair and pulls them on. He stretches the suspenders up over his shoulders and

groggily trips down the stairs. Sloan yanks open the door to find two men silhouetted in the moonlight. He squints.

"Need your help." George Amer. There's no doubt about it. The man barges into the room as if God Himself granted him the right to do so. God Himself did no such thing and just because George used to board in this home doesn't mean he can burst in here in the middle of the night. Sloan would've thought that was clear enough. "You got some business with me that can't wait till morning?"

"If it could've waited, it would've. When was the last time I roused you before dawn?"

Sloan thinks on this, but nothing comes to mind. Still. "Why you doing it now?"

"No choice."

The second man enters and sets to lighting the lantern that hangs by the front door for easy fetching. He should've guessed straight away it would be Laban. Sloan studies the boy's features, concluding he looks like a demon or possibly like he's seen one. Sloan turns back to Amer to find the lamplight brightening his neighbour's face to an alarming degree. Sloan gasps and leans closer, not quite believing what he's seeing. "Dear Lord, Amer. What trouble have you gotten yourself into?"

Amer's palm is pressed to his forehead and there's blood everywhere. His hair, cheeks, and hands are covered and his shirt is so saturated Sloan would have been inclined to believe it started out a deep crimson red if a small stretch by Amer's elbow hadn't remained its original blue. Amer drops his hand, revealing a deep, weeping gash torn clear across his forehead. "Fearful row."

Obviously. Sloan narrows his eyes. "With who?"

"Bryan, of course. Who else?"

Sloan shrugs. It's best not to answer that question since, realistically, it could've been with any one of a dozen men and Sloan wouldn't want to mention anyone Amer hadn't thought of. He draws a deep breath and expels it slowly. "Sweet Jesus, Amer. I warned you about him, didn't I? He's been out to get you from the moment you set foot on this island and that isn't like to change. That kind of hatred runs

deeper than two men. It's about what you represent, not about who you are. You should've finished building those fences as your first priority like I suggested. You've got to place barriers between yourself and a man like that."

Amer returns his hand to his forehead. "You warned me sure enough. You saw what I was up against before I saw it myself. Thought I could handle a man like that. Turns out I couldn't."

That's an odd thing for Amer to say. It's not like him to own a miscalculation. Come to think of it, it's not like him to ask for help, neither, from God nor from man. Sloan wonders just what's brought Amer to his door on this bright, breezeless night. Surely it's not Sloan's ability to stitch a wound. Anne is as skilled at that as anyone. And since Amer doesn't believe in the healing power of prayer, that leaves what? Best just ask. "How bad is it?"

Amer uses the back of a nearby chair to steady himself. "Real bad. Need you to see to the Bryan men quick as you can. They're both hacked up near as bad as me." Amer closes his eyes for a moment. "Maybe worse."

Both. So Charlie was involved in the affray as well. Lord, help us all. "They at your place?"

"Theirs. Left them on the field where they fell. Can you attend them? Now, I mean. Thinking dawn will be too late."

Sloan shakes his head. "No, sir, not alone."

He'll stand firm on that. He may be a God-fearing Christian, but he's no simpleton. There's no way he's going anywhere near Bryan without a posse at his back. The old man came around earlier today and he was mad as a bear. It had something to do with Boyd, although his thoughts were so tangled Sloan couldn't make out what. He probably shouldn't have given him that whiskey though. It was meant to calm him, but it appears to have set loose the devil instead. He can't do no more than pray over it now and hope the pastor doesn't catch wind of his folly or it'll be included in his sermon tomorrow and Sloan will have no choice but to bow his head in shame. Mary Ann will make blessed sure of it.

Amer picks up the chair and slams it down. He's growing impatient with Sloan's failure to comply and isn't shy about letting him know it.

"By all means, rouse the neighbours if that's what it takes to get you down there. Take every man you can find. I want everyone within spitting distance to know what happened at Bryan's place tonight."

Sloan hesitates. It's more likely Amer wants every blessed neighbour to become familiar with his version of what happened at the Bryans' this evening. Sloan knows Amer well enough to know that. He shakes his head. Some things are best left to God and this is one of them, but he pulls his boots on anyway. It's best not to risk offending the Lord with inaction, so he'll do his Christian duty as quick as can be, then get back to his bed.

Sloan heads for the door, his finger pointing firmly at Laban. "Put that blessed lantern out. It's too bright a moon by far to be wasting oil on a walk to a familiar destination."

Sloan makes a beeline for the government road with only the moonlight as his guide. His intention is to rouse Porter and have his neighbour accompany him to Bryan's. There'll be less chance of further bloodshed that way, at least to his way of thinking. If Bryan was a bear before the fracas, he'll surely be a wolverine now. There's nothing like whiskey and defeat to put the devil's thoughts into an already dark mind.

"Hold up there."

Not a hundred paces from his destination, Sloan spots a small figure tripping towards him. It doesn't take much to guess it must be one of the Porter boys and the child is near breathless. "Come quick, Mr. Sloan. Been an awful fight down at the Bryans'. Mrs. Bryan says her men have been murdered. Father won't go there alone. Says the devil himself wouldn't do nothing so foolish as that. Sent me to fetch you to come with him. Says he wants to be alive in the morning and the best way for that to happen is for a bunch of you to set out together."

Sloan can't disagree with that. He grabs the boy by the shoulders and spins him around; then he, Amer, Laban, and the Porter boy collectively stumble towards Porter's homestead. Sloan drops his eyes to the boy. "What's this you're saying about someone being dead? Did Mrs. Bryan say that or is your own imagination running away with you?"

The Porter boy is silent for a moment. When he speaks, it's with the slow stammer of an actively forming thought. "Said something like it.

Wouldn't be surprised for it to be true. Heard the fight myself. So bad it woke the entire house. Watched the last of it from my bedroom window. Couldn't see much, but I surely did hear the yelling and smashing and then the blasts."

And then the blasts. "What blasts?"

But the Porter boy has spotted his father approaching from his homestead and stumbles off to greet him.

Sloan redirects his eyes to Amer and he takes a long look. Something isn't right here. He suspects his former boarder has left a few key details out of his story, or maybe even more than a few. The blasts, for instance. Why is Sloan only hearing of them now? And why is Amer so blessedly mobile? He claims to have been brutally assaulted and yet his movements don't seem in any way impaired. He has no limp nor is he bent over double or grabbing his midsection. There's no wincing, nor groaning, nor shortnesses of breath. He's a fountain of blood, to be sure, but a whole lot of blood can flow from fairly insignificant wounds.

It doesn't take the wisdom of God for Sloan to guess who came out of the battle its victor, but there's something he's not getting. One on one, Amer could easily mark the win against Bryan, but Charlie and the old man together would be a fearsome duo. If one came at Amer from the front and the other from behind, he'd be a man without a chance. No, something definitely isn't right about this whole situation and when he discovers what it is, he's just hoping he won't be caught up in something Jesus himself couldn't handle.

Porter approaches Sloan and gives him a brisk nod before jerking his head towards Bryan's place. "Well, sir, I'll say it plain: I think a grievous thing has surely gone down at the Bryan place tonight and, if I'm being perfectly honest, I would have to say that I believe we should be bracing ourselves for the worst our minds can conjure."

Sloan nods. "Any idea what we're going to find down there?"

It's Amer who answers. "Told you what you're going to find. Two men on the ground, both of them injured. Had no choice but to take them down. If either of you'd been there, you'd have done the same."

Sloan's not so sure about that. Neither, it seems, is Porter, who lifts his eyes to heaven and his voice higher than that. "I should rightly think, sir, that a man always has a choice in these sorts of things."

Amer responds with silence while Porter punches the air between them before storming off. Thank heaven for small mercies. A grim task is surely ahead of them and hot words will only make it harder. Sloan positions himself between his two neighbours as the group picks its way wordlessly through the stumps and the boulders. With every step, Sloan's trepidation grows ever worse, for it's clear the devil reigns over this land tonight. If Bryan is alive, he'll for sure be in one of his drunken rages. That would be challenging enough for God himself to handle, but add Charlie into the mix and all the saints together wouldn't be able to set things right.

On the positive, Charlie's like to be sober, but there's also a powerful negative. That boy's temper is far worse than his father's. Sloan has nearly come to blows with him on several occasions on account of Charlie setting his cattle loose in Sloan's fields. It may have been unchristian of him to consider striking that tiresome boy, but Sloan can only turn his cheek so many times and he prays that on his final day, St. Peter will find it in his heart to forgive him.

Sloan turns to Amer. "The Bryans still alive?"

"So far as I know."

"Porter's boy says otherwise. Are you saying he's wrong?"

"I'm saying he's reporting what the Bryan woman told Porter. Can't believe a woman on a matter such as this. Too emotional by far."

True. Sloan has yet to meet a woman who can tell a story without colouring it with all sorts of unnecessary feelings. Even squirrels do a better job of sticking to the facts. But that doesn't mean she's wrong and Sloan is about to point that out when Amer cuts him off. "If Porter truly believed the Bryan men were dead, he wouldn't have sent his son to fetch you before setting out for their place, now would he? Not realistic to think a grown man would be afraid to approach a homestead because of a woman and her little boy."

Amer has a valid point. Neither he nor Porter was willing to head down to Bryan's alone for fear they might encounter the old man in a

violent mood. But it's what Amer says next that sits awkwardly. "Any doubts about what I'm saying, Laban can confirm the truth of it."

How? Sloan looks past Amer to Laban, who has been as quiet as a shadow since arriving at Sloan's place, so much so that Sloan had forgotten he was with them until Amer's reminder. "So you were there when this whole thing transpired?"

Laban looks set to panic. "Yes, sir."

Sloan thinks on this. "And you took part in the affray?"

Laban looks to his father, who makes a gesture Sloan doesn't know the meaning of. "I did, sir."

Sloan mulls this information. He'd been assuming Amer fetched Laban from home after the row had ended. That assumption had been based largely on Laban not having a blessed mark on him, which raises a serious question. "How is it that you were a part of what must've been a fearsome battle and yet you received no wounds? Did you not help your father repel his attackers?"

Laban starts to stammer out a response, only to be interrupted by his father. "Was nothing the boy could to do. All happened too fast. Went to fetch the horses Bryan stole from my field and the old man clubbed me from behind. No time for Laban to react. Almost didn't react myself."

Sloan looks up to where he imagines heaven to be in that hazy place just beyond the furthest stars. It helps him to place Jesus in his heart when he's pondering things he doesn't want to ponder like why this is the first he's hearing of stolen horses. That's as like to be the cause of the fight as anything else, but why hadn't Amer mentioned this before? "So Bryan clipped you. I can see it. What I'm wondering is where was Charlie when this was happening?"

"Leapt from the shadows and started pounding on me. Had to leave off the old man to pound him back. Was the boy who caused all these wounds, not his useless wastrel of a father." Amer coughs into the back of his hand in what Sloan takes to be a signal to Laban. Amer drops his voice to a devilish growl. "I'm no weakling. Bloodied Charlie just as bad as he bloodied me. Wasn't looking to, but I couldn't take the chance he had that revolver on him. Wasn't in the mood to be shot."

Sloan is trying to keep his focus on Jesus, but Amer is making that a mite hard. "What's this you're saying about a gun?"

Amer throws up his hands in apparent dismay, as if suggesting they've already had this conversation a hundred times when they haven't even had it once. "The one the Bryan boy has been toting around for weeks. Surely you've seen him at the edge of the bush taking shots at pigeons and ducks and God knows what else. Word is he got that revolver to use on me. Couldn't take the chance he was looking to use it tonight."

Whose word is Amer talking about? Surely not the Lord's, since God would never speak such a blatant falsehood and, although Amer most certainly would, his tone suggests he isn't doing it now. Sloan is well and truly puzzled. "Charlie's got no gun. He traded the one he had, not three, four days past."

Amer starts to speak, stops, then starts again. "Suppose Charlie told you that?"

"No, sir. It was Atchison himself who told me he traded Charlie his fiddle for that gun. He was right proud of the deal he'd made and even showed me the gun so that I'd know he was speaking true."

It's Amer's turn to look puzzled and Sloan has no trouble understanding why. "You heard me right, a fiddle. I had Atchison repeat it twice because it sounded so absurd and I was certain I must've heard him wrong. Only I didn't. Charlie no longer has a gun, he has a musical instrument."

"That can't be true."

But it is. Atchison is one of the few God-honest men around here and if he says he traded a fiddle to the Bryan boy, then that's what he did. There's no doubt in Sloan's mind that Atchison would willingly swear on a stack of Bibles without fear of heavenly retribution. Amer's reaction suggests he has no doubt either, although God only knows what Amer would have Atchison swear on. A stack of coins maybe. "The boy had one of my shotguns for a short while, but he didn't have the resources to keep that neither. So far as I'm aware, the Bryans don't possess a single firearm. I'm surprised you don't know that, seeing as how you're usually the one telling me these things."

Amer spits in the direction of Porter's boots and it's not at all clear if it was his intent to hit them. "Heard the Bryan boy still had the revolver and was preparing to use it on me first chance he got. Porter and I were discussing that very thing in my barn just this morning."

Porter gives a terse nod. It must be the God's honest truth then, for if it wasn't, Porter would be crowing over the lie. Still, Sloan isn't satisfied. "Who'd you hear it from?"

"Not at liberty to say."

"It's not really about liberty."

And it isn't. Depending on what they find at Bryan's place, the law may soon be asking Amer the very same question – not to mention the Lord Almighty – and neither will be put off by his claiming a lack of liberty. Surely Amer knows that. "Can you at least say when you heard it?"

"Not two days past."

That's a bit hard to believe. Gossip spreads faster than fire in the bush. Then again, Porter seems to have been under the same impression and there's not a sinner alive who's more up on the latest gossip than him, except maybe the preacher, and he knows better than to pass on such unchristian filth. So it's strange that Sloan is turning out to be the best informed of the trio. "By two days past, the gun had already been traded away, so either your confidant is behind on their gossip or they were setting you up for exactly the sort of battle that took place here tonight. I can't rightly guess which, but I'm thinking you can."

Sloan is weary. When his wife awoke him from his dreams, he was certain she was having one of her nightmares. Now he feels as though he's the one who's been caught in a snare set by the devil himself and he's beginning to fear for his Eternal Soul. He turns on Laban. "And you did what while all this was happening? It seems to me that if there was enough time for Charlie to jump into the fray, there was enough time for you to do the same. Am I to understand you just stood by while two men attacked your father?"

That's certainly what Laban's lack of wounds suggests and nothing about Amer's story indicates otherwise. The way Amer tells it, Sloan could be forgiven for thinking that Laban wasn't even there.

Once again, Amer answers a question directed at someone else. "Did as I told him. Not your business what instructions I give my boy. No reason for him to interfere in a battle between me and those aggressing against me."

Sloan can think of a few. He expects Porter can too and fully expects his neighbour to join him in giving voice to several when Porter surprises him by marching off towards the settlement road without comment, his boy stumbling along beside him and Laban trailing behind the boy. What a devil of a night this is turning out to be.

Amer catches Sloan by the arm. "If Bryan had stolen your horses and then clipped you when you tried to retrieve them, tell me honestly you wouldn't have played it as I did."

"Come on, Amer. You know me well enough to know I would've left it to God to decide."

"That's as bold a lie as I've ever heard."

"You best watch what you accuse a man of. Even me."

Amer drops Sloan's arm like it's a burning coal. He needs Sloan on his side, that's clear to both of them, and Sloan has been tested enough for one night by God and the devil both. There comes a point when one of them will win. God's surely got the advantage, but the devil never runs out of tricks. Sloan picks up his pace, determined to catch up with Porter, who's heading straight for Bryan's mean little shanty. Sloan gestures towards the corral. "Charlie and Bryan were dropped in the field out back. We should probably tend to them first."

Porter's head is shaking. "Well, sir, Mrs. Bryan says she and her youngest dragged the men inside and I don't rightly believe she'd say such a thing if it wasn't the truth, so I think it best we head straight inside and face what needs to be faced."

That sounds like a plan Sloan can agree to. He looks over his shoulder as Porter knocks on the door, then enters without waiting for a reply. Sloan can barely make out Amer and his son continuing along the settlement road to their homestead. It's just as well. Their presence in the home of the two men they've so recently battled would likely complicate things. Besides, Sloan has a feeling Amer's purpose in fetching him

this evening had less to do with a Christian need to help the suffering and more to do with advancing his own diabolical interests.

Sloan follows Porter into the unlit shanty. He can hear Eleanor Bryan sobbing somewhere off to the right. To the left he hears the ghastly rasping of breath being dragged into and forced out of straining lungs. The whole place smells like a slaughterhouse at noon.

Porter aims his voice to the right. "Excuse me, ma'am. Myself and Sloan have come to help you out, such as we are able."

There's no response, so Porter tries again. "I surely mean you no disrespect, Mrs. Bryan, when I say it's far too dark in here for proper seeing. I should think a bit more light would help us to best determine the situation you find yourself in. May I ask, ma'am, do you have a lantern or a candle we can use to take a closer look at your men?"

Eleanor chokes down her tears. "A candle? We've got no blessed money for nothing so fancy as that. If you want to know God's truth, I can afford not the purchase of a needle when one is sorely needed. Should you men wish to see something more than the callousness in your own souls, you'll surely need to set fire to a stick. Finding one is certain to be a challenge. Charlie had plans to fetch in some wood come morning, but I dare say that's not likely to happen now."

Sloan says a silent prayer as the Porter boy dekes outside and returns with a couple of robust sticks. Sloan grabs them and heads for the wood stove, stumbling when his foot comes down on what he judges to be a hand. Sweet Jesus. Sloan crosses himself, then swings open the stove door, holding the sticks in the embers until they catch. He reaches one back to Porter, who holds it out in front him. In the flickering orange, they see the Bryan men stretched out on either side of the stove. Neither man is moving. Sloan would be inclined to say that neither man is breathing, either, except one of them is rasping so loudly the deaf could hear it.

It's Bill Bryan. Sloan crouches next to the old man and holds the torch above his face. Holy Mother of God. Blood is crusted in Bryan's hair and gashes zigzag his scalp. More distressingly, there's a dark puddle beneath his head. Sloan leans in close. "Do you know me, Bill?"

Bryan moves his battered hand to the strip of flour sack tightly wrapped around his throat. He pushes the bloody fabric aside to show Sloan a wound to the left of his windpipe. Sloan holds the torch closer and sees what he takes to be a ball hole. Bryan grabs the front of his shirt and pulls him down, hissing. "If that scoundrel hadn't shot me, I'd have cleaned the field of him."

Sloan stares into the old man's glassy eyes for longer than is healthy, then pats Bryan's chest. "God be with you, my friend."

Because St. Peter surely won't be. Not that Sloan says this last bit. It's not, after all, his place to say it. Instead he shuffles across the hard-packed dirt to where Porter is examining the wounds on Charlie's arms and chest. He signals for Sloan to clap eyes on the boy's forehead and pushes up the sack cloth to reveal a ball hole. Jesus H. Christ, Bryan and Charlie have both been shot.

Sloan again crosses himself, then presses his lips to Charlie's ear. "Do you know me, Charlie?"

There's no reply, so Sloan places his hand on the boy's chest. It's warm – hot even – but it's rising and falling so modestly it takes a few seconds to determine that it's moving at all. He removes his hand and wipes the warm, sticky blood on his shirt as he stares into Charlie's un-blinking eyes. There's no doubt about it, the boy's soul is already gone. "May your soul rest in Eternal Peace."

It's the only thing Sloan can think to say and it's a blessed lie. There won't be any peace where Charlie is going, for the boy is surely not destined for paradise. There are too many knocks against him owing to there not being a commandment too sacred for that boy to challenge or outright break. It imperils Sloan's soul just thinking about the harm this unchristian boy has done or threatened to do or would do if given half the chance. He prays for Charlie anyway. It's the Christian thing to do.

Sloan feels a bump against his arm and opens his eyes. It's the Porter boy, who is just now kneeling down next to Charlie and dipping a rag into a tin. He drips water onto Charlie's lips, causing them to flutter, but that's all they do. "Charlie, wake up. I'll tell the truth about how the cart got damaged. Promise, I will. But you have to wake up."

The hopeless bargaining of children. Sloan can't watch. He gets to his feet and heads for the door, hesitating while he tries to think of something soothing to say to Mrs. Bryan on his way out, but he's not sure what he could possibly say that would bring her comfort at a time such as this. Nothing, would be his guess, so he heads outside and tries once again to call Jesus into his heart. When he turns back, he discovers Porter standing behind him. "Well, sir, what do you think?"

Sloan shakes his head. "Amer said he beat Bill and Charlie. That's clearly the truth, but not once did he say a blessed thing about firing a weapon and yet there's no other way those wounds could've been made. There must've been a gun and Amer or his son must've fired it."

And God let it happen. It's sacrilege to think that, but how can he not? The Lord is Almighty. He is the ultimate Saviour of us all. He alone could've stopped this had He wanted it stopped. It was surely within His power to do so. Instead God let the devil win this round and Sloan must find a way of accepting His will because questioning God's wisdom is the surest way he knows to forfeit his place in heaven.

Porter grinds his boot heel into the ground. "Yes, sir, there surely was a pistol. I myself heard its report not an hour past. I couldn't see any more than a portion of the fisticuffs from my place due to the darkness, but I surely did hear sticks striking sticks and other such things as I wouldn't want to guess at. My boys heard the same as myself and yet the way Amer tells the tale, Bryan surprised him in the lawful act of collecting his horses. I don't see how that could possibly be true if the scoundrel thought to bring a pistol with him. I'm guessing you see it the same." Porter pauses. He kicks the ground so hard Sloan half expects it to crack open and reveal the fires of hell. "Amer surely takes us for fools, sir. There's no better proof than the cock and bull story he told us here tonight. There's no defence so far as I know for gunning a man down on his own property. I'll wager not even Boyd himself will be able save Amer from his own foolish actions."

If Boyd even wants to. Sloan is less sure than many of the neighbours that Boyd is in league with Amer. He's heard the accusation many times, but people often see evil where evil doesn't reside and often miss

it where it does. Yet what disturbs Sloan most at this moment is that
Porter seems more concerned with Amer taking him for a simpleton
than with the fate of the two men lying bleeding in Bryan's shanty. Once
a faithless heathen, never a child of God.

Sloan raises his eyes to heaven and prays for the Lord to take his
anger before he says or does something that will seal his heavenly fate
as surely as Amer has sealed his own. "I believe a crime has been com-
mitted here tonight, Porter. Maybe more than one, but one to be sure."

Sloan needed to say that out loud to hear how the words sound in
the air. They sound harsh and judgemental, but accurate. Jesus, Mary
and Joseph save us all from the darkness in our own souls.

As Porter joins Sloan in staring up at the sky words start flooding
from his lips. "You have no earthly clue how glad I am to hear you say
it, sir. If I were to say the same thing, people around here would surely
think it's just me making up scandals to spread about the bush. But you
and Amer are on good terms so far as I know, owing to his time spent
boarding at your place just three short years ago, and yet you can see
without my bidding that what he told us out on the road can't possibly
be truthful."

Sloan waits. He's expecting Porter to go on a long-winded rant, but
his neighbour goes on a short-winded one instead. "Well, sir, I can't
rightly claim to know how this whole thing got started here tonight.
I'm not sure I believe any horses were ever stolen and that's down to
Amer himself for speaking opposite about the only parts of the brawl I
clapped ears on. I don't think for a second that's because he's confused.
No sir, I think he's telling the tale to his own advantage."

And, God help him, so does Sloan, who draws a heavy breath be-
fore saying what the Lord Himself knows to be true. "The two men in
that shanty may be the only ones who can say for certain what tran-
spired here tonight and that may never happen. Charlie for sure won't
see dawn. The old man maybe, but he's closer to heaven than earth right
now. The next few days will determine if he's like to survive, but my
gut says no. All I know for certain is that God will decide when the
time is ripe."

Sloan runs his eyes over the moonlit landscape. Porter's house is silhouetted against the silvery fields and, a little farther to the east, Sloan can see the roof of his own modest home. He hangs his head. Had he known what was happening here, he wouldn't have slept nearly so soundly and not just because of the noise from the melee. "I pray to Our Lord and Saviour that nothing I said to Bryan earlier today contributed to what transpired here tonight."

Porter cocks his head. "I don't see how that could possibly be, sir. Not once in all the years I've known you have I ever heard tales of you agitating, so far as I can recall."

"I never have, not if I could help it. It's not Christ's way. But Bryan had the right to know his avowed enemy has been entering his home when he's not there to chaperone. It isn't proper for Eleanor Bryan to be alone with Amer behind closed doors. That's the worst kind of a sin and if Bryan had found out later that I'd seen such a thing and kept silent, there's no telling the hellfire that would've come my way."

Both now and in the hereafter. Sloan winces at the thought. If he'd been less of a sinner, he would've foreseen that telling Bryan what he'd seen would result in the tragedy he's witnessed here this night. He sees now that it was the devil's words on his lips. He only wishes he'd seen it then.

Porter breaks into Sloan's thoughts. "No sense beating yourself senseless over things you can't control. The truth can't ever be hidden, not for long, and certainly not for always. Somehow, some way, the treachery you laid eyes on was going to make its way to Bryan's ears. You can't be so foolish, sir, to believe you yourself were the only one who caught sight of Eleanor Bryan's misdeeds. If I'm being perfectly honest, I saw them myself and so did my Eliza. You can't blame yourself for speaking true. God would surely have wanted it no other way."

How would Porter know what God wants? The preacher hasn't ever set foot on Porter's homestead, so far as Sloan knows, and not one of his children can rightly quote scripture. It's blasphemy, all of it, but that's immaterial. Sloan is bound to act in accordance with God's law regardless. "Someone needs to fetch Doc Francis."

Porter nods his agreement. "Yes, sir, and someone needs to fetch the law, as you well know. I believe it's surely best to wait until daybreak for both. There's no sense in sending a man through the bush in darkness to serve a tragedy that's already happened. Enough damage been done here for one night. A few hours' delay won't change a thing. I'm guessing you feel the same."

He's right. Still, Sloan is agitated. He has to do something, so he pivots towards home and starts to run. "Going to fetch Mary Ann. These men need nursing and it doesn't look as though Eleanor is up to it. My wife will have the neighbour women rounded up inside an hour. This is like to be the only day in Eleanor's life she won't be called upon to work herself to the bone."

Sloan has no idea if Porter caught any of what he just said, but he's got more pressing matters on his mind. Namely, he has no clue how he's going to square all this with St. Peter when his days are through. He's just hoping that at some point between now and his final moment, the answer comes to him. If not, he'll be spending eternity reliving each and every one of his sins and that's not an eternity anyone would look forward to.

10

ANNIE BOWS HER HEAD

Annie kneels on the hard wood floor, her eyes inches from the gap between the door and its frame. She's spying on Father, who is presently propped up on the sofa in the next room, his skull swaddled in a modest turban of bandages. She can see him clearly through the gap although, admittedly, not with both eyes at once.

"You've got nerve summoning me here like I'm some lowly field hand. It's best you remember who gave you a leg up when you first came to this island."

For certain it's Mr. Sloan who's speaking. Father sent her to fetch their God-fearing neighbour in the middle of the night when Mr. Sloan hadn't stopped in after assessing the situation at Mr. Bryan's homestead like her father had assumed he would, and there's not a man alive who can claim she didn't do just that. Only when she stumbled across Mr. Sloan, he was in the midst of praying as hard as a man ever did with a Bible clasped in one hand and beads dangling from the other. He said he'd come – and obviously he has – but he further made it plain he would not move a foot from his home until he'd finished saying his peace with God. By her count, it took him six hours to do it and yet all that praying appears to have improved his mood not a stitch.

Father adjusts the pillow beneath his head. "Need your thoughts, not your complaints. Imperative I know if everyone at Bryan's place is like to survive."

Of course not. Annie need not hear Mr. Sloan's reply to know that. She'd been absolutely certain from the moment she discovered the horses missing from the back field that the night would end in bloodshed and, to her everlasting grief, she knew just whose blood was most likely to be shed.

"One ball caught Charlie square in the forehead and the other hit Bryan in the neck. I thought at first the old man had a chance at seeing more life, but now I'm thinking opposite. He's totally insensible. The next time his eyes open he'll be gazing at the angels."

Father looks theatrically glum. "Sorry to hear it. But we need to be clear no shots were fired last night. Any holes you may've seen were made by a knot in the club." Father winces and closes his eyes. "For Christ's sake, Laban. Stop pacing."

Laban, silly goose that he is, abruptly does as he's told as soon as he's told to do it. Annie tilts her head so that she can set eyes on her brother's remarkable ability to squirm. Good old dependable Laban. You can always count on his nerves to frazzle the second things go wrong.

"Cut the games, Amer." The unmistakable irritation in Mr. Sloan's voice draws Annie's eyes back to her father. "I've just come from attending two men who've been downed by balls. It only adds up one way and that way has nothing to do with any knots in any clubs. You can't get that one past me and you certainly won't be getting it past the Lord."

Father makes a show of thrusting himself up onto his elbow, only to collapse back into the stack of pillows with a concussive grunt that crinkles Annie's nose. Mr. Sloan properly ignores the dramatics, turning instead to Laban. "Have you got anything to add to this discussion?"

Laban looks predictably thunderstruck, his eyes flitting between Father, the floor, the ceiling, and the wall. Anything to avoid looking at Mr. Sloan.

"I didn't think so." Mr. Sloan turns back to Father and waves vaguely to the east. "Me and Porter walked the Bryan homestead as soon as the sun rose and found much to suggest that last night's affray may not have played out how you said."

"You didn't find no revolver, so don't bother claiming you did."

Mr. Sloan just now turns the dangerous red of a kettle that's about to explode. He then makes a valiant – though, in Annie's opinion, not entirely successful – attempt to steady his voice. "No, but we did find a bloody truncheon in the grass east of the corral and a knife and an axe and lots of clubs. One even had a clump of grey hair on it. I'm thinking it wasn't yours."

"Your point?"

"My point is that's a whole lot of weapons for four men to have between them when you claim the old man got the jump on you. How surprised could you possibly have been if you thought beforehand to bring a cache of weapons with you?"

Father heaves himself up into a seated position. "Not all those things are mine."

Mr. Sloan appears to be staring hard at the ceiling, although Annie must concede that heaven could be his true target, or possibly God himself. "But some of them are. Don't even try telling me that truncheon belongs to Bryan. The clubs I'll believe, even the axe, but not the gun and not the truncheon. Not even the knife. It's too fine a quality to be something Bryan could afford."

Father melodramatically clamps his head between his hands, leading his daughter to suspect this activity has more to do with skewing favour than attempting to subdue any real pain.

"Just say what's on your mind, Sloan."

"Isn't it obvious? Nothing about this looks like self-defence. I can't help thinking that if that's truly what it was, you would've mentioned the gun."

Father waves dismissively. "Was an oversight, nothing more. Give you my word on that. I'm assuming my word still holds weight with you."

The look on Mr. Sloan's face suggests it might not. "It's only fair to warn you that Porter's gone for the law. There was no real choice. We can't pretend we didn't see what we saw and what we saw leads us to believe the law needs to have its say."

As Annie takes this in, Father stares at the floor. Then he stares at Mr. Sloan. "What did you do with the truncheon?"

Father tries his very best to sound nonchalant when he asks this, but his tone causes Annie to suspect he's trying to suss out a way he can abscond with the weapon before the law arrives. Mr. Sloan appears to pick up on this as well. "I hid it well and it'll remain that way until I place it in the hands of a lawman. Don't go thinking otherwise."

As Mr. Sloan storms out of the room, Father beckons Laban to approach, then digs his fingers into his son's shoulder. "You're to head to the bush at the north end of the lot and stay there until I say otherwise. Make yourself known to no one. I can turn this thing around, but it'll take some time, and until then I need you gone."

Laban yanks his shoulder free. "The north bush? You mean where the hogs and the cattle are kept? Do you really think so little of me that you're going to pasture me in the bush with the animals you intend to slaughter?"

Father snorts. "Maybe it's best you don't put thoughts like that in my head just now."

"Because slaughtering me would solve your problems?"

"It'd sure solve one of them."

The front door swings open with a clattering the likes of which would surely wake the dead. Annie can't see who's entered and at first thinks it must be Mr. Sloan returning to continue the argument. Only then she hears an apologetic half-cough and properly guesses she's witnessing Sam's return from Manitowaning where he'd been sent in darkness to fetch Doc Francis. Annie listens as hard as can be, but does not hear a second set of footsteps.

Father barks. "Doc on his way?"

"Not ten minutes behind me. Had to race all the way back here to stay ahead of him. Man walks faster than the devil."

Does the devil walk fast? Annie has never properly considered the matter until now, but she's not entirely sure why he'd need to since souls would surely come his way if he stood as still as a tree. Doc Francis, on the other hand, is always on the run and for the best of reasons. He's the only doctor on the island, so far as she knows, and there's always some wound that needs binding or illness that needs benefit of herbs or powders or syrups. They've most assuredly got the preacher for such times when the only remedy worth the bother is prayer.

Father lowers his voice as if plotting to conspire. "What exactly did you tell him?"

Annie leans forward. She's terribly curious to hear what Sam has to say and yet only mildly surprised when the fool lowers his voice in the manner of his master even though it's abundantly clear he's not at all grasping why such a thing might be necessary. "Only what you said to tell him, sir. That there's been a fight down at the Bryan place and that you've been banged up real bad."

"Good boy." Father sensibly lies back. "Said nothing of the Bryans?"

Sam raises his shoulders in a shrug. "Don't know nothing of the Bryans, sir. Besides, you said to say no more than your message, so that's what I did. The doc was fixing to set off right after me so I reckon he'll be here before the angle of the sun changes by much."

Annie switches eyes to better see Sam through the gap. Large scuffs plaster his palms and knees, causing Annie to wonder how many times the boy fell along what must've been the roughest of stumbles through the bush for those first few hours. The only light would've come from a lantern and yet somehow Sam had completed the journey in as fast a time as could have been expected of a racehorse.

Annie turns from the gap and rests her back against the wall and listens as Father continues his machinations. "Gather enough provisions for one week plus everything Laban needs to camp out in the bush until this thing settles in our favour. By your count, you've got roughly eight, maybe nine minutes to accomplish all this. I want Laban out the back before Doc Francis sets foot on my porch. Nod if you understand."

The silly goose must've nodded, for he and Laban come rushing past Annie's hiding place on their way to the summer kitchen. Neither fool so much as catches sight of her, which is most assuredly a positive. Alas, their retreat rouses Mother, which is decidedly not a thing that should ever be wished for. "George, dear, exactly how much trouble are you in?"

Mother has been perched on the melodeon bench since shortly after disposing of Father's torn, stained clothes in the wood stove. Her mood had been the darkest of darks then, what with her demanding the revolver and Father refusing to tell her where he'd hidden it. She'd made not the slightest of peeps since then.

Father grumbles. "I was within my rights to defend myself against Bryan's attack. Sloan may think he heard misstatements from me, but he'll soon come to understand that everything I said is in line with what truly happened."

Mother slaps her lap. "Oh, George, wake up! There are many on this island who already had knives out for you because of your speculating. I tried to warn you about that just yesterday. It almost doesn't matter what happened at the Bryan homestead last night. People will put this tragedy down to you regardless."

Annie turns back to the gap in time to see Father pluck a rag from the floor and spit it bloody. "Those ingrates are free to say what they will. It'll change nothing. Gossip has no standing in the law."

Mother is bursting to interject some nasty sentiment or other when Father tosses the bloody rag to the floor. "No chance this will ever get to trial. You'll see. No point in having powerful friends if you can't call on them at times such as this."

"You know I would never question your thinking on a subject as important as this, my love, and yet I cannot help but wonder if you're really planning on staying out of jail by calling on powerful friends?"

Father yanks a pillow from behind his head and tosses it to the floor. "That and a plausible story."

Mother leaps from the bench and snatches up the pillow, which she flings at Father, who deflects it. "Don't be so sure that'll be enough, my love. Why in heaven's name did you bring that revolver with you?"

"You know why."

Mother studies Father's face, then returns to the bench, where she attempts to smooth every precious wrinkle from her equally precious skirt. "I know why you said, my love, but what I don't understand is why you were so convinced Charlie had a revolver that he intended to use against you. Did Boyd tell you that? I never did trust that man."

Father draws a deep breath, then lets it out slowly. "Eleanor Bryan told me about the revolver when I looked in on her not two days past. Said Charlie was looking to set a trap that I couldn't help but walk into. That's when he'd use it."

Mother frowns. "I don't understand what you're saying, dear. Of all people, I would've thought Mrs. Bryan would've known her son didn't have the revolver anymore. A mother knows these things and, since Sloan seems to have known, it's hard for me to believe that he did and yet Charlie's mother did not."

Father chews the inside of his cheek for a moment. "Also hard to believe that Eleanor wouldn't have noticed a fiddle suddenly showing up. I'm sure I wouldn't know what passes for conversation in that household. But I'm thinking Eleanor knew the truth and told me a lie."

Mother narrows her eyes. "What exactly are you saying?"

At first, Father says nothing, he just stares into the air as if transfixed by a speck of dust until, finally, he grimaces. "I'm saying Eleanor needed to end her torment and didn't have the strength to do it herself, so she found a way to get me to do it for her."

Well now, that's a curious turn of events. Annie isn't quite sure what to make of a mother who would say a thing that would surely endanger her son. Father too seems to be struggling with this, for he bows his head. In contrast, Mother balls her fingers into fists and turns towards Annie's hiding spot. "Annie, darling, you can come out now."

Annie frowns, not quite believing Mother has sussed her out.

"My beautiful girl, please don't make me call you twice. You won't like how that ends."

Then again, maybe she has. Annie jumps up and smooths her dress, then strolls into the parlour as if out for a promenade on a warm

summer evening. Mother rises from the bench and crosses to the sofa where she kneels and dips a rag in a bowl of water. She wrings it out, then presses it firmly to Father's forehead. Not once does she look at Annie. "It's so lovely to see you, darling, and in such a pretty dress. Now go help Ellen with her chores until I say otherwise. I won't have you lazing around like some fatherless child when there's plenty of work to be done before this day is through."

Annie stamps her foot. "Mother, please, must it be me who does it? I'm absolutely certain this is why we have a servant."

"Annie, darling, I love you as only a mother can, but if you question me again you won't be able to sit for a week."

Mother slips the medicine from her pocket and takes a generous swig. Soon she'll be as placid as an early morning pond. Annie just has to wait her out, so she heads for the summer kitchen, fully intent on sashaying out the back door at her earliest opportunity, but as soon as she waltzes through the kitchen door, she stalls. "Not this again."

Ellen is rubbing the end of a sheet against the washboard. One basket is brimming with sheets she's already tortured the grime from, while a second is filling with the sheets she's just now working on. "Yes, this again, miss. There'll be more for you to hang the minute these are on the line, so you best be quick about it."

Annie rolls her eyes. "Did you not notice the calamity in our parlour?"

"Notice the calamity in your parlour near every day, miss. More blood than usual, I'll grant you that, but that only means more linens for us to scrub and hang. Now scoot."

Ellen kicks the basket sideways. It skids to a halt by Annie's feet and she blinks down at the crumpled mountain of whiteness. "Do you ever feel as though your life isn't working out the way God planned it?"

Ellen stops scrubbing and grips the sides of the boiler. "My hands are permanently chapped. My feet have so many callouses I can't figure out whether there are any bones left inside them. And I daily hear backtalk from an insolent girl who got a horse as a gift for no reason other than she was born. When you can say all those things, then we'll talk about

the waywardness of God's plans, miss. Now grab that basket and get to hanging or I'll report you to the missus."

Annie punts the basket all the way to the back door, then hoists it up onto her shoulder just as Ellen says the one thing guaranteed to make everything worse. "That preacher is stopping by for tea later today, so you best get a move on. We need to get you in your finest dress by noon."

Annie stomps out to the clothesline Ellen has strung between two towering birches. It takes two full hours for her to hang every sheet and shirt and apron Ellen has scrubbed raw, during which time she witnesses Doc Francis come then go twice. Now she spots him returning a third time with Mr. Boyd at his heels. There's no way she's missing this. Annie pitches the clothes pegs into the basket and sprints for the kitchen door. By the time she breaches the parlour, Doc Francis is perched on a footstool with his ear on Father's chest. He raises his head. "Mr. Amer, I am directing you to stay indoors for the next two weeks. The sun is no good for you in your present condition. It will only sap what little energy you have left."

Mother is hovering. "Thank you, Dr. Francis. I can't tell you how much we appreciate everything you're doing for my husband. Shall I continue with the compresses?"

"They are not likely to do any good. They are also not likely to do any harm, so please do as you wish."

As Doc Francis examines the stitches in Father's scalp, Mr. Boyd leans forward. The lawman has been standing at the foot of the sofa since before Annie exploded into the room and, as the doctor begins to wind fresh bandages around Father's skull, Mr. Boyd makes an observation. "Andrew Porter said something interesting out on the road."

It's not in the least bit clear who Mr. Boyd is addressing and so no one makes so much as a move to respond. "He said he ran into you, Doc Francis, when he was on his way to Manitowaning. He further said he told you the Bryan men had been badly injured and were likely to die. And yet instead of tending to them, you came here to attend Amer's wounds first. I'm wondering why that might be."

Doc Francis finishes securing the bandage. "I was summoned here by the elder Mr. Amer. It was and is my duty to tend to Mr. Amer as my first priority. Had the Bryans summoned me, I would have gone to them first. That is the custom. Since the Bryans sent no one to fetch me I saw no reason to alter my plans based on gossip I heard on the road. Mr. Porter said his piece, as he always does, but it did not escape my notice that he was on his way to fetch the law and not me. The only one to fetch me was Mr. Amer's field hand. So this is where I came first."

Mr. Boyd considers this. "But surely you had to pass by the Bryan place to get here."

"That is correct."

"And did you not see the commotion around their front door?"

"I did. Get up."

Father makes an elaborate display of struggling to his feet. Once upright, he sways and looks set to topple when the doctor grabs him by the arms and steadies him, as Father must surely have calculated he would.

Mr. Boyd presses on. "Surely you could figure both from what Porter said and from the commotion outside the Bryans' that someone in there must be in a bad way."

Doc Francis releases Father and slowly backs away. Father takes a shaky step forward and then another. It's not yet a success, but it's not a failure either.

Doc Francis turns to Mr. Boyd. "I saw to the Bryans directly after coming here. Much as I suspected, there was nothing for me to do there. Their injuries were too grave. I could have applied some stitches, I suppose, but those would only have served to comfort the women."

"And you knew all that before you attended them?"

"Mr. Porter was not sparing in his details."

"So your assessment is they're likely to die."

"Is it not yours? You have seen them. Surely you formed an opinion." Mr. Boyd turns away. "Not an educated one."

"It need not be educated. Your eyes can see as well as mine. Charlie Bryan is in a dying condition and will no doubt be freed from this life by the time I return."

Mr. Boyd watches Father shuffle across the parlour. When he reaches the far wall, he steadies himself before turning. Meanwhile, Mr. Boyd returns his attention to Doc Francis. "Did Charlie Bryan say anything to you?"

Annie is most interested to learn the answer to this question, so when Doc Francis tilts his head to one side like a dog that's not quite understanding his master's command, she takes not a single breath. "He said nothing to me nor would he have been able to say anything to anyone else with the sort of injury he sustained. He was likely insensible from the moment the bullet struck his forehead and anyone who says otherwise is telling stories for purposes I would not care to guess at."

"Are you sure about that?"

"I am sure that when I examined the boy, blood and brains were protruding from the depression in his forehead. When I probed the wound, I found the injury went clear through to the back of his skull. Those two things together tell me that his brain is no longer intact and what is left of it is swelling to a point no man can survive. There is no chance he had anything to say with such calamity inside his skull."

Mr. Boyd leans towards Doc Francis. "Dr. Francis, please mind your language. There are women present."

Doc Francis waves his arms in the air. "Women are always present. They have more of a stomach for these things than men like to think. Not one of them has fainted yet and it is not likely any of them are going to either."

Annie shifts her eyes to Mother, who doesn't look in the least like she's broaching a swoon, at least not on account of Charlie's protruding brain matter. Her many swigs of medicine are a different subject entirely. It's the other thing Doc Francis said that has Annie's brain in a swirl. Charlie is not likely to survive. Until this moment, Annie was certain that he would and that, in the fullness of time, he would join with her in the romance she'd been planning since the day of the sugaring bee when she had first seen him smile. It would've been discreet romance at first with them stealing glances at bees and socials and, whenever possible, arranging for rendezvous in the bush. But then, on a date most pleasantly decided between

them, they would flee their disapproving families to take up positions on the lake boats, she as a cook and Charlie as a deck hand up above. She had it all planned out and, in her mind, their future together was well on its way to taking shape. Annie is only just now coming to the realization that none of what she had planned will ever come true.

Mr. Boyd is clucking like a clock. "That being as it may, you're telling me that anyone who says Charlie spoke to them would be lying."

Doc Francis gives a brisk nod. "Not only is the younger Mr. Bryan incapable of speech, there is no reason to believe he is able to understand a single thing that is going on around him, not even his own death."

Annie takes this in. So does Father, who pauses mid-parlour. At first Annie thinks this is because he's run out of steam, but then she notices the intensity in his eyes and their focus on Mr. Boyd. "Does someone claim Charlie said something?"

Mr. Boyd bristles. "Dash it, Amer. I have no duty to answer that question. You know how the law works, or at least you used to. Anything that may've been said to me will go into my statement for the court. There will be no special privileges this time."

"Excuse me, Mr. Boyd, I don't mean to interrupt your fine words, but I can't help but wonder what Mr. Bryan has to say about this whole sorry affair?" It's Mother who asks this. The men stare at her as if she's a mermaid who's just now jumped from the sea. A minute goes by before Mr. Boyd directs his answer to Father. "He said not a word to me, although I gather he had a few things to say to Sam Sloan and Andrew Porter which may not be to your favour. But it's not just what he said that's of concern here. I was dispirited to discover he took an awful beating before he was shot and I believe he suffered a broken wrist, maybe some broken ribs, and his scalp is such a nest of cuts that I couldn't hardly count them all. I would further not be surprised to learn his skull is fractured, maybe even in a couple of places."

Mr. Boyd looks to Doc Francis for confirmation. "I would have to examine him further to say for sure, but everything you say could be true. Mr. Bryan took a terrible beating and I cannot imagine he was standing when the bullet struck, not from the angle it entered his body.

He must have been on his knees or even down on the ground. I am not sure what the point of shooting a man while he is on the ground is unless there was a need to ensure he never rose again."

Father rallies. "Neither of those men were shot. Their wounds were caused by a knot in the club. Best not let your imagination run wild."

The room falls silent. Annie can't fathom why her father insists on acting the fool by sticking with a lie that no one whose brain is properly screwed in could possibly believe. Does he really think he can change the facts to suit his version of reality? She would've thought he had more sense than that, but clearly not.

Doc Francis pulls himself up to his full height and swats the air. "It would be best if you did not repeat that assertion further. You forget – or maybe you do not yet know – that the bullets did not exit either man. They will be found on autopsy, so it will be better for you if you do not attempt to carry this lie forward. I will gladly testify that it is the head wound causing you to make such outlandish claims, but the court is not likely to believe me if you persist in your claims beyond what is reasonable."

This drops Father to the sofa. "Doc, how long have you known me?"

Doc Francis's lips move and his fingers dart, then snap. "I am inclined to say eighteen years or something close to it."

"Since we were both young men in Owen Sound."

"It might be a stretch to say we were young."

Father gives the heartiest of chuckles. "I'll grant you that. But here's my point: Have you ever known me to lie?"

Doc Francis stares at Father for such a long time that Annie fears his brain must surely have shut off. "Not that I can recall."

"So then why do you think I'm doing it now?"

Doc Francis swats the air twice, then tilts his head. He appears to be taking advice from his invisible companion before venturing a response.

Father does not wait for it to come. "I'm telling you, knotted wood is to blame for those holes. And let's not forget Bryan's age in all this. Old men commonly fall to troubles young men rise from. Hell, I'll wager Bryan would be stumping his fields right now if he were twenty years younger."

The look on Doc Francis's face is priceless. He waves his arms and snarls and just as he's about to scream something truly awesome, Mr. Boyd grabs him by the shoulders and shakes some caution into him. It's the lawman who ends up yelling the awesome thing. "For pity's sake, George, there are witnesses."

Father's hand flies to his forehead as if reacting to an invisible knife that's just now been punched through his eye socket. "I don't understand."

"I think you do. There are several people who saw the confrontation between you and the Bryans last night, so you best be careful how far you try to stretch the truth."

Father is shaking his head. "What people? Porter? Because he'll tell you anything that comes into his head if he thinks there's a possibility of scandal. Ask anyone. Ask yourself, for Christ's sake."

Mr. Boyd's voice grows sharp. "It's not just Porter. It's his sons also and Eleanor Bryan and her little boy and more besides. I have been here not two hours and the few stories I've heard don't match with what you've been saying."

"But do they match with what each other is saying?"

The expression on Mr. Boyd's face tells Annie that Father has correctly guessed that the neighbours are telling tales in conflict with one another. That would be a win for him. Annie's just not certain Father deserves to mark the win, not when one of the people who's likely to die is the boy she had set her cap for. She tries to will away that thought and all of the others that flood forth when she calls Charlie to mind.

Annie bows her head. She can't think about Charlie and the future she'd dreamed for them just yet because if she does, she'll be forced to think about something far more troubling: that she had known Charlie no longer had the revolver. He'd told her so yesterday and she could've conveyed that information to Father, only she'd chosen to remain silent. Why had she done that? Because she didn't want to alert Father to the fact she had met Charlie in the bush, that's why. It would've put all of her plans – her entire future – in jeopardy before she'd even had the chance to run it all past the boy of her dreams, and she couldn't allow that to happen.

Father is again speaking. "Come on, Boyd. This is me you're talking to. You can't possibly think I went over to the Bryans' for any purpose other than to retrieve my horses. I know the law. I don't attack men who've thieved from me. I report them to you and let you do what needs doing."

What needs doing. Annie takes this fully in, as does Mr. Boyd. "I allow that I warned Bryan just yesterday that his boy's temper was likely to bring about violence. It didn't appear to me then that he planned to heed me. It looks less so now, but I can't ignore the statements of those who claim to have witnessed a battle. However it may've started, two men have been fatally wounded and the two who helped to get them that way are still standing. That doesn't look good." Mr. Boyd looks around, frowning. "Where's Laban? I'd like very much to hear what he has to say about all this."

All eyes shift to Father. Annie can't wait to hear what his response will be. Surely not the truth, since the whole point of sending Laban into the woods was to conceal him from the very man who's seeking him now.

Father shrugs. "My guess is he's hiking up to Little Current to check on a shipment of tools that should be coming in this very day on a steamer from Collingwood."

As if Father ever needs to guess where Laban is. The silly goose always goes where Father tells him to go and often without question or resistance. Something inside Annie ruptures and, before she can rightly stop them, words come racing from her lips faster than she can think them. "Don't be silly, Father. You know full well that steamer isn't meant to arrive until Thursday, so Laban cannot possibly be on his way to meet it. I'm absolutely certain he must be elsewhere. I dare say Mr. Boyd should form a posse and go looking for him."

Mr. Boyd nods towards Annie, his eyebrow raised. "Do you often tell your daughter your business?"

Father's voice is as flat as she's ever heard it. "Never do. Ignore the girl. She has quite the imagination. Laban's like to be at the docks already. Possibly even on his way back, dragging a heavily loaded hopper. Would probably appreciate some assistance."

Mr. Boyd nods. "I'll go check, but for now we should get back to the Bryan place and see how things sit there."

By "we" Mr. Boyd means him and Doc Francis, who he just now taps on the shoulder. At first, the doctor hardly responds. He just stares at Father like he's trying to burn a hole straight through his chest. Then he pivots and storms out of the room, muttering and striking the air. Mr. Boyd lingers over his goodbyes and when he finally leaves, Father turns to Annie. "Thought you had more sense than to go against your kin."

"That's an interesting observation, Father, because I myself would have thought you had more sense than to tell a lie so easily exposed."

Annie braces for the blow. She deserves it and she knows it. Instead, Father shouts over her head. "Ellen, I want you in here now."

His bellow produces the desired effect. Ellen is instantly before him, her face and body full of fluster. No doubt she was listening by the door, as she always does. That is, after all, where Annie learned the trick and it's a good one. Annie would yet believe Father to be a far different man than he truly is had it not been for the secrets she's heard from the shadows.

Father takes Ellen by the elbow. "Lead Annie down to Michael's Bay. Only don't go the usual way. Head straight back through the bush to the Kennedy homestead. There you can pick up the Indian trail. Follow it to the fork, then back down to the regular trail. You know the way I mean."

Ellen's nod is stiff. The rest of her body follows suit when Father stabs his finger in her face. "Don't talk to anyone along the way. Be especially certain to keep clear of Mr. Boyd. When you get to the mill, instruct Lyon to put Annie on the first hooker heading to Owen Sound. Tell him I'll make sure he's handsomely compensated for the inconvenience."

Annie is set to protest, but Father cuts her short. "Not one word out of you. Thought you were a smart girl. Thought you could be trusted to keep the family's best interests at heart. Then you go and say things to Boyd that can't be unsaid. So be it. You're leaving the island and you won't be coming back until this matter is settled."

Annie turns to Mother, only to find her absently playing with a wisp of hair. Clearly help won't be coming from that direction. Indeed,

the only way Father can gain Mother's attention is by repeatedly snapping his fingers in front of her disturbingly blank face. "Write Emma Harrison a note asking her to care for Annie until such time as we send for her. Could be a week. More likely a year. Depends on how this whole thing plays out."

At first Mother looks confused. Then she floats over to her writing desk and scribbles several lines on a sheet of paper. She's blowing the ink dry when Ellen snatches the letter from her hand and hauls Annie to the summer kitchen. Annie allows her to do so but, once there, she yanks her hand free. "Ellen, please. You're not really going to do as Father says, are you?"

Ellen sets about snagging a loaf of bread and a generous chunk of meat, wrapping both in a bandana. Then she leans sideways and plucks a paring knife off a nest of peels and drops it into her pocket. "Believe you me, miss, if I had a choice I wouldn't be doing no such thing as this. There's ghosts in those woods. Powerful ones. Already stole the souls of the Bryan men and there's no reason to believe they're done yet. We'll have to be quick or we'll be next."

It's a foolish superstition, but Annie sees value in jumping on it. "I dare say we should head directly south and parallel the normal trail instead of looping up by the Kennedy homestead. If we go that way, I'm absolutely certain we'll avoid the ghosts in the north bush and still arrive at Mr. Lyon's dock in plenty of time to catch the afternoon hooker."

Assuming Annie doesn't succeed in losing Ellen in the cedar swamp first, which is currently plan A.

Ellen looks like she's considering Annie's suggestion, only then she grabs her charge by the elbow and drags her out the door. "Know this island better than you, miss. Walked every trail until my blisters blistered. Don't need to be told how best to get where we're going. We were told to go north and, by golly, that's what we're going to do. Anything else will cost me my position."

Annie tries to anchor her heels in the earth, but Ellen is as strong and determined as a rutting ox. She spins around, corkscrewing Annie's arm behind her back. "Stop fighting me, miss. The sooner we get to the

bush the better. Your father made it clear he wants no eyes on us and you know the consequences of defying him. Or maybe you don't. But now isn't the time to be pushing him any further than you already have."

Ellen is speaking in a brusque whisper, which is weird and presumably gratuitous. Annie scans the horizon but spots no potential eavesdroppers, although she can't discount Ellen worrying over otherworldly ones. She leans in close. "What do you know?"

Ellen clamps her lips shut and vigorously shakes her head.

"Don't give me that, Ellen. You know more than you're saying and if you want me to follow you without a fuss, you need to give me a good reason to do that or I'll run all the way to Mr. Boyd and tell him everything I know and not a whit of it will be about last night."

Ellen turns pale. She screws up her face, then she screws up her resolve. She slips her hand into her pocket and pulls out a key. Annie blinks, then makes a grab for it. "Who does it belong to? Surely not you."

Ellen swings the key behind her back. "I didn't steal it, miss, if that's what you're thinking."

It hadn't occurred to Annie that she had. "But you got it from somewhere, silly goose, and you are going to tell me where."

Ellen again clamps her lips shut and looks around with worry on her face. Annie knows what the servant is thinking: That they really shouldn't be standing out in the open like this. But if Ellen wants Annie to follow her into the bush, she'll have answer her question and the hired girl knows it. The silly goose bursts. "Mr. Amer gave it to me before going to Bryan's place last night. Showed it to me once many years ago and said it opens a chest stowed beneath the floorboards at his former place of employment in Owen Sound. Told me that if ever he foresaw a circumstance he wasn't like to survive he'd give me the key and I was to keep it safe until everything cooled down. Then I was to deliver it to the missus."

Annie mulls Ellen's confession. Without a doubt, Father should've also told her that under no circumstances was she to show that key to his daughter or tell her what it opens. "Did Father say what's in the chest?"

"Not my place to know such things, miss."

It's probably not Annie's place either, but there's not a hint of a chance that will be stopping her. As she starts working out the details of her new and improved plan, Ellen grabs her arm. Annie allows herself to be towed through the back fields, but as soon as they step onto the path that will take them to the Kennedy homestead, Annie latches onto a branch, making it impossible for Ellen to drag her forward.

"I dare say, Ellen, aren't you curious where Laban has hidden himself?"

That gets her. Ellen releases Annie's arm and together they listen for any sound that might give away her brother's whereabouts. They hear nothing. Well, they hear chirping and buzzing and a suspicious snap, snap, snapping that turns out to be twigs being crushed under a cow's hooves, but they don't hear a single human sound.

In truth, Annie doesn't much care where Laban is. She just wants to linger near the spot where she stood so many times spying on Charlie as he fired his revolver at anything that moved and quite a few things that didn't. She had dreamed of their future here on the edge of this path – the future that her father's actions ensured she will never get the chance to pursue – and was surprised on two occasions by Doc Francis, who came upon her on one of his many treks across the island. Neither time did he comment or give her presence away. He just tipped his hat and continued along the trail, his lips flapping and his arms flailing. Such a strange man. What's even stranger is that he should come to mind now.

Ellen reclaims Annie's arm and presumably her ever-loving senses. "Not really our concern where Laban's at right now, miss. Best stick to the fate that's been handed us and let others do the same."

That's Ellen for you, always a servant at the behest of her master, unlike Annie, who's growing increasingly irritated. "Have you ever noticed that a whole lot of things that seem desperately important are not our concern?"

"Notice only what I'm told to notice, miss."

That's not true. "Really, Ellen? Because I think you notice a whole lot more than that. I'm absolutely certain, for instance, that you noticed where Father hid his revolver last night."

Ellen maintains a steady stride. "Got no clue what'd make you say such a thing as that, miss."

Neither does Annie, but a quaver in Ellen's voice tells her she's right. "I'm even willing to wager a week's pay that it's hidden in the sack of flour underneath the kitchen table."

Ellen whips around. "How could you possibly know that?"

Annie didn't, but she surely does now. She shrugs and lowers her voice. "Because, Ellen, that's where Father hid his revolver the last time something like this happened."

Ellen furrows her brow. "This has happened before?"

Not to Annie's knowledge, but her dogged snooping has taught her that the flour sack is where Ellen stashes any item she's pilfered before transferring it to a more permanent hiding place at the edge of the front field or up a tree. It doesn't take a genius to figure out that when Father staggered into the kitchen last night covered in blood, Ellen offered whatever assistance she could, including hiding a weapon she knew would be trouble.

Ellen is waiting for a response.

Annie stands tall. "Is that really what's important right now, silly goose?"

Of course it is, but when Ellen thinks on it she solemnly shakes her head, just as Annie knew she would. "You can't tell no one about the pistol, miss."

Annie readily agrees. She won't tell no one. She'll tell everyone, starting with the Justice of the Peace in Manitowaning. It'll be the first of several letters she's going to write, all of them anonymous and all of them providing information that can be used to convict Father of killing Charlie. Annie has no real choice. Mr. Boyd may bluster, but he won't go against her father in a court of law. He'll consider it — all of Father's cronies will — but ultimately every last one of them will remain loyal. Because Father is right. A plausible story and the backing of powerful friends is all he needs to sweep this whole affair under the carpet. Annie knows that even if Mother doesn't. Someone has to do something to ensure that Charlie isn't forgotten in all this, even if it is only the girl he never got the chance to properly love.

Annie sets her mind, then she sets her jaw. "Let's get a move on. The last hooker leaves the dock late afternoon, so we'll have to pick up our pace if we're to have any hope of making it in time."

Annie tromps along the trail towards the Kennedy homestead. On her dumbest day, she could find her way without Ellen's assistance and Father knows it. The only reason he ordered Ellen to accompany her was so he'd have a witness to his habitually disobedient daughter getting on that boat.

Annie's rage grows with every step. When she spots a sturdy stick lying on the ground next to the path, she puts it to service as a walking stick. And she thinks about Charlie. She'd seen a different side of him on the day of the sugaring bee. One she liked. One that maybe, one day, she could love. Then yesterday, in the clearing, she made Charlie notice her, not as a girl, but as the woman she will one day be, she's certain of it. Then Father went and ruined it all with no thought to anyone's interests but his own. Well, to blazes with him.

Annie spins around, her walking stick raised high. She brings it down with all her might on Ellen's skull. The silly goose staggers backwards, then hits the ground on her hands and knees. She scrambles back up only to have Annie wallop her again, this time with a blow to the ribs. Ellen reaches for her pocket, but Annie remembers the knife and deals another blow. There's a loud snap like that of a stick breaking in two, only the sound hasn't come from a stick, it's come from Ellen's arm. Ellen hits the ground and rolls onto her back. Stunned and blinking back tears, she turns to Annie. "Why have you done this terrible thing, miss?"

Annie reaches down and fishes the knife from Ellen's pocket. Then she grabs the key. "Because I know in my heart that out there somewhere there are people who don't spend absolutely every waking moment behaving like beasts."

Ellen gazes at her, uncomprehending. "Where do you imagine that might be, miss?"

"You know, Ellen, I'm not really sure, but I need to find that place before Father finds me. I'm sure you can understand why."

Annie hurls her walking stick into the bush, then sprints up the trail towards the Kennedy homestead. When the trail forks, she takes the path heading away from Michael's Bay. The way she's got it figured is if she can steer clear of Father's spies, she's got a half decent chance of making it on to a fishing boat that will take her to civilization. Once there, she'll start writing the letters she hopes will find their way to people who can tell the difference between right and wrong. It may not work. A thousand things could go wrong, but at least she will have tried. She owes that much to Charlie and to the dreams she had for their future together that now will never come true.

AND SO THINGS WENT

On October 12, 1877, George and Laban Amer were convicted of murdering William and Charles Bryan. It would take close to a year for the Amers' legal team to exhaust all appeals and when they finally did, both men were sentenced to hang.

That didn't happen.

Anne Amer immediately set about campaigning to have her husband's and son's murder convictions quashed. She wrote letters. She got up petitions. She gained the support of every powerful man on Manitoulin Island as well as in Collingwood, Owen Sound, and Sault. Ste. Marie. Politicians signed on, as did doctors, lawyers, and merchants of all stripes. Anne argued, citing no proof, that her husband had been too poor to afford a proper defence, the jury had pre-judged the trial, the prosecution's witnesses had been seeking vengeance for her husband's unscrupulous business dealings and/or his illegal land speculation, and potential defence witnesses had refused to testify for fear of retribution. By far her most compelling argument was that eight-year-old Arthur Bryan had lied on the stand about having witnessed the murders.

The Governor General of Canada agreed and on August 12, 1878, he commuted George and Laban Amers' death sentences to ten years in the Kingston Penitentiary. Neither man would serve out his term. Soon after Laban Amer entered the penitentiary, his health deteriorated to

the point where he was not expected to survive and, just three years into his sentence, he was released to his mother on compassionate grounds. Returning to the homestead, he slowly regained his health and would run the family's farm operations until 1883 when, after many years of staunch support by too many notable men to ignore, his father received a full pardon.

Upon his release, George Amer quickly resumed his old ways, leveraging the law to gain whatever advantage he could over any man foolish enough to do business with him. He extended credit to anyone wishing to purchase a cow or a plough or a wagon and then repossessed the item along with anything else he could lay his hands on when the borrower could not pay the exorbitant interest. Over the coming decades, Amer would obtain legal title to several properties this way. Meanwhile, the ownership of the lots that formed the family homestead shifted between him, his son, and Oswald Hinds several times over the decades due to legal manoeuvring designed to keep those lots under George Amer's control.

By 1886, just three years out of prison, George Amer became clerk of Tehkummah Township. Two years later, he gave up all pretence of farming and took up residence in Manitowaning. Although his occupation would officially be listed as carriage maker, he continued to acquire, lease, and sell land on the island until his death in 1908 at the age of seventy-six. Laban Amer remained in his father's shadow for most of his life. He would be appointed the Tehkummah postmaster in 1885, holding that position until his father took over the job in 1888. Following George Amer's death, Laban would become an Assiginack Town Councillor in 1913 and would remain so until his death in 1917 at the age of fifty-nine. He is buried alongside his father in Hilly Grove Cemetery in Assiginack Township.

On the morning following the murders, Annie Amer was removed from the family home for reasons that remain unclear. We do not know what, if anything, she witnessed that night. Annie next pops up in the public record four years following the murders when she marries neighbouring farmer and dedicated lacrosse player Alex Brinkman

at the age of eighteen. A decade later, when George Amer decamps to Manitowaning, he and his wife take up residence next door to the Brinkmans. Although Annie and Alex Brinkman would have two children, both died before reaching adulthood.

After a flurry of activity to gain the release of her husband and son, Anne Amer fades from the historical record. It is unclear where she was living during the time George and Laban were incarcerated, but there's no suggestion that the lots in Tehkummah were leased to anyone else. Presumably Anne Amer continued to operate the farm, likely with the assistance of Oswald Hinds, until first her son and then her husband returned. A sumptuous picnic hosted on the farm just prior to Amer's release from prison in 1883 attests to it flourishing in his absence. I could find no record of Anne Amer's death and she isn't buried in the family plot alongside her husband, son, and daughter, so a mystery remains as to what became of her.

More is known about Eleanor Bryan, an enigmatic figure who alone witnessed the murders of her husband and son. It's an unfortunate sign of the times – and the legal standing of women in the Victorian age – that her firsthand account of what happened that night goes unrecorded. She does not testify at the murder trial or at the coroner's inquest that preceded it and there is no witness deposition in her name. The best insight we have into what she heard and saw that night comes from the testimony of her youngest son Arthur, who was not a direct witness to the murders but testified as though he was. Arthur no doubt gives the account his mother would have given had she been in a position to tell her own story.

And while Arthur was testifying in court on Eleanor's behalf, others were testifying about her. Andrew Porter, for one, denied during a heated exchange with George Amer's lawyer that he had told random neighbours and possibly even Charlie Bryan that Amer had been "too familiar" with Eleanor and if he had been in Charlie's place, Porter would have shot Amer. Charles Boyd further testified that on the morning following the murders, Eleanor had shown him bruises she claimed were the result of a beating by her husband and Charlie. Both men were trying

to paint a picture of George Amer, Porter with the intent of seeing him hang and Boyd with the intent of seeing him set free. Neither man offered proof to back his claims and both seemed not to care what impact their testimony would have on Eleanor in an era where reputation was everything.

Soon after the murders, Eleanor Bryan would leave the family homestead, never to return, which, considering the depths to which her neighbours were willing to sink, was probably a good thing. Widowed, penniless, and with limited options for earning her way in a world where women had few rights and even fewer opportunities, she would spend the rest of her life as a ward of her children. She and Arthur initially settled with her eldest daughter, Harriet (Hattie) Skippen, and her brood in Green Bay before resettling with her eldest son, William Bryan, Jr., and his young family on a farm in Sandfield just a few years later. Not long after that, Eleanor was living with her youngest daughter, Annie Skippen, Annie's husband Frank, and their two young daughters in Bidwell. And just a few years later, Eleanor would once again be living with Hattie. And so it went.

There are two photos of Eleanor taken later in life. Both show a stern woman with severely constrained hair and unusually large arthritic hands. In each photo Eleanor is wearing an unfashionable black Victorian dress and a facial expression that would alarm a felon. This isn't terribly surprising for a woman who was no stranger to strong opinions. Her great-granddaughter once recalled hearing Eleanor, who by that time was a very old woman, bluntly stating how she used to do things when she was living in her home, which was evidently far superior to how they were being done in whichever household she was living at the time.

Eleanor Bryan would never leave the island that had brought her so much sorrow and is buried in the Green Bay Cemetery.

Arthur Bryan would hop from family farm to family farm alongside his mother in his youth before eventually farming his own land in Spring Bay. In 1908, he and his wife moved to Gore Bay, where he became the proprietor of the Queen's Hotel, which he continued to operate until his death in 1938 at the age of sixty-nine.

The Bryan homestead would never again be home to any member of the Bryan family. In the years following the murders, it would be leased to a series of tenant farmers until 1896 when it was finally sold.

Dr. William Stoten Francis was living with his brother's family in Owen Sound in 1872 when he was commissioned by the government to attend to the medical needs of the indigenous community at Manitowaning. Dr. Francis was the only medical doctor on Manitoulin Island for several years. As such, he attended to the island's European settlers and tales abound of him assisting victims of gunshots, mill accidents, heart attacks, and infectious disease outbreaks. He would continue to work as a physician in Manitowaning until 1891 when he and his wife, Annie, moved to Gore Bay, where he took up a position as town clerk, an office he would hold until his death in 1901 at the age of sixty-seven.

Scottish-born Charles Boyd was a respected member of Manitoulin's early settler community, having moved to Tehkummah from Bentick, Ontario in 1873. Boyd soon purchased a second lot not far from the first and there are numerous suggestions he may have been involved in illegal lumbering. True or not, Charles Boyd helped found one of Manitoulin's first schools in 1876 and served as its trustee for many years afterwards. During his decades on the island, he oversaw road construction projects, served as Tehkummah town councillor and, in the months leading up to the murders, was appointed Justice of the Peace, a position he would hold for the rest of his life.

Boyd was also a staunch ally and supporter of George Amer, and court testimony implies he may have been a benefactor of Amer's shady business dealings. It's hard to determine, more than a century later, whether there is any truth to these innuendoes, but from the time George Amer was arrested, Boyd did everything in his power to get his neighbour released. He signed every petition that came his way. He wrote letters to officials. He was relentless. In sworn statements, Boyd would assert that on the day following the murders, Arthur Bryan claimed not to have witnessed them, despite later giving some of the most damning testimony against George Amer. Boyd would further

testify he'd overheard prosecution witnesses conspiring to fabricate testimony against George Amer with the intent of seeing him hanged.

It's possible that all of Boyd's claims are true. He was, after all, a Justice of the Peace and it's reasonable he would've felt it his duty to set the record straight if others were hell-bent on setting it crooked. We'll likely never know. Boyd died of the flu in 1898 at the age of sixty-seven. At the time of his death, he stood accused – not for the first time, but most certainly for the last – of illegal lumbering.

Andrew Porter came to Tehkummah from Greenock, Ontario in 1872 and there is plenty of evidence he and George Amer hated each other. Several of their disputes would catch the attention of the law. Porter variously tried to have Amer charged with placing a gate across the government road, illegal logging, and maliciously setting fires that damaged Porter's property. Not surprisingly, he testified against George Amer at the murder trial, claiming to have witnessed key parts of the fight. And yet there remains some question whether he could have seen and heard all that he claimed from the distance of his homestead. There is little question, however, that he coached the testimony of his young son. Some of things the boy claimed to have witnessed, which conveniently corroborated his father's testimony, seem unlikely unless the boy possessed supernatural powers.

Regardless, Porter, his wife, and their nine children appear to have prospered on the island and, as each of his sons came of age, Porter parcelled off portions of his land to them. Everything appeared to be on track for the family to establish a dynasty on Manitoulin Island, and yet by 1892, no Porters resided in Tehkummah and all of the lots that had once been in the family name were now owned by others. Some, if not all, of the Porter family appears to have relocated to Hannah, North Dakota, in search, no doubt, of greener pastures.

Sam Sloan arrived in Tehkummah in 1873 as a first-time land owner, having previously worked as a farm labourer in Manvers, Ontario. He would struggle to earn a living on Manitoulin Island while he and his wife, Mary Ann, raised their nine children. He made ends meet by taking in lodgers, including George Amer during his early days on the

island. In 1888, Sloan's debts finally caught up with him and he was forced to sell off one of the two lots he had purchased fifteen years earlier. The second lot was put up for auction that same year and although Sloan succeeded in retaining ownership, he would ultimately end up forfeiting his land. Sloan died in 1920 at the age of seventy-five and is buried in Hilly Grove Cemetery.

Born in Mono Township, Ontario, Ellen Sim was brought to Manitoulin Island by her stepfather, Robert Sim, as early as 1868, making her one of the first permanent European settlers on Manitoulin Island. She spent her early years living with her mother, stepfather, four brothers, and a sister in Michael's Bay, where Robert Sim made his living labouring in the local mill and working in the notorious lumbering camps. He spent his free time ferrying new settlers from the mainland to Manitoulin Island. His stepdaughter entered the Amers' service as early as 1873 and was living and working in their home at the time of the murders. In her deposition, she claims not to have witnessed the murders, but her testimony appears to have been heavily coached, possibly even coerced. She disappears from the public record soon after the murders. Like so many women of her era and class, her life went largely unrecorded.

ACKNOWLEDGEMENTS

I'd like to thank the Access Copyright Foundation for providing research funding for this book through the Marion Hebb Research Grant. Without that funding, this story would have been short many key details.

Several books were instrumental in helping me to understand what life on Manitoulin Island would have been like for these early European settlers. By far the most valuable were two self-published titles by Derek Russell: *Tehkummah: A History* (2011) and *Michael's Bay: The Rise and Fall of Manitoulin's Forgotten Town* (2016). Both books are included in the historical records at the Little Schoolhouse Museum in South Baymouth.

Also valuable were W.R. Wightman's *Forever on the Fringe: Six Studies in the Development of Manitoulin Island* (University of Toronto Press, 1982), Paula Mallea's *From Homestead to Community: A Women's History of Western Manitoulin* (Scrivener Press, 2013), and Shelley J. Pearen's *Exploring Manitoulin* (University of Toronto Press, 2001).

Records relating to the murder trial of George and Laban Amer were located at the Archives of Ontario. They contain witness testimonies that helped me to understand who these people were and the extent to which they were willing to lie in order to secure (or prevent) the convictions of George Amer and his son. As a result, we will never really know what happened on that fateful night in June 1877.

Records relating to the appeal of the murder convictions, including signed petitions, letters of support for George and Laban Amer (and a few of acrimonious dissent) and other materials associated with Anne

Amer's dogged and ultimately successful efforts to get the convictions of her husband and son overturned are located at Library & Archives Canada. Also found there were records relating to the births, marriages, and deaths of many of these settlers as well as the nineteenth-century land sale records of the Manitowaning Agency, which give excellent insight into when these settlers arrived in Tehkummah, when they left (if they left), and what their financial and legal realities may have been.

I'd like to thank the staff of the Centennial Museum of Sheguiandah for allowing me and my assistant to spend half a day in their back room, sifting through binders full of family histories, local censuses, cemetery records, and many other documents compiled by the Manitoulin Genealogical Society. I'd also like to thank the staff of the Little Schoolhouse Museum in South Baymouth for being generous with their time and memories and for granting me access to records compiled by the Michael's Bay Historical Society.

Important insights into George Amer's character came courtesy of an 1861 *Globe & Mail* article I found at the Toronto Reference Library. Entitled "The Proton Murder," this article gives salacious details about the lengths to which George Amer, then a constable with the Owen Sound police, was willing to go in arresting a murder suspect. Violent, ruthless, and scurrilous, his behaviour on that occasion was never far from my mind when contemplating what really happened on the night William and Charles Bryan were killed.

Owen Sound: The Port City by Paul White (Natural Heritage Books, 2000), details what life would have been like in Owen Sound during the decades that George Amer resided there and includes an anecdote about rampant counterfeiting that had been going on for more than twenty years. The rumoured involvement of city leaders and the inevitable crackdown by Ontario's Attorney General came around the time George Amer abruptly relocated to Manitoulin Island. What, if anything, Amer had to do with any of this is unclear. But he served as a constable in Owen Sound during the counterfeiting years and was elected to the town's council just months before his abrupt relocation to Manitoulin Island. It's likely he would have been aware of the crimes,

the corruption, and the crackdown even if he was not an active partici-
pant. But chances are he was involved, and his sudden departure for
Manitoulin Island was likely an attempt to avoid the consequences of
his crimes.

Most importantly, I'd like to thank my family for bringing me this
story. William and Eleanor Bryan were my great-great-great grandpar-
ents, a fact I would not have known if my grandmother's cousin, George
Skippen, hadn't had a lifelong fascination with these murders. He is
the sole source for many of the more interesting details of this story. It
was George who first shared this story with my grandmother, who then
shared it with my mother, who shared it with me.